S0-BSI-614

ART AS THEOLOGY

Cross Cultural Theologies

Series Editors:
Jione Havea and Clive Pearson (United Theological College, Australia); Anthony G. Reddie (Queen's Foundation for Ecumenical Theological Education, Birmingham, UK)

This series focuses on how the "cultural turn" in interdisciplinary studies has informed theology and biblical studies. It takes its leave from the experience of the flow of people from one part of the world to another.

It moves beyond the crossing of cultures in a narrow diasporic sense. It entertains perspectives that arise out of generational criticism, gender, sexual orientation, and the relationship of film to theology. It explores the sometimes competing rhetoric of multiculturalism and cross-culturalism and demonstrates a concern for the intersection of globalization and how those global flows of peoples and ideas are received and interpreted in localized settings. The series seeks to make use of a range of disciplines including the study of cross-cultural liturgy, travel, the practice of ministry and worship in multi-ethnic locations and how theologies that have arisen in one part of the world have migrated to a new location. It looks at the public nature of faith in complex, multicultural, multireligious societies and compares how diverse faiths and their theologies have responded to the same issues.

The series welcomes contributions by scholars from around the world. It will include both single-authored and multi-authored volumes.

Published

Dramatizing Theologies:
A Participative Approach to Black God-Talk
Anthony G. Reddie

Global Civilization
Leonardo Boff

Forthcoming

Black Theology in Britain:
A Reader
Edited by Michael N. Jagessar and Anthony G. Reddie

ART AS THEOLOGY

FROM THE POSTMODERN TO THE MEDIEVAL

Andreas Andreopoulos

LONDON OAKVILLE

Published by
UK: Equinox Publishing Ltd., Unit 6, The Village, 101 Amies St., London SW11 2JW
USA: DBBC, 28 Main Street, Oakville, CT 06779

www.equinoxpub.com

First published 2006

© Andreas Andreopoulos 2006

All rights reserved. No part of this publication may be reproduced or transmitted in any
form or by any means, electronic or mechanical, including photocopying, recording or
any information storage or retrieval system, without prior permission in writing from the
publishers.

British Library Cataloguing-in-Publication Data

A catalogue record for this book is available from the British Library.

ISBN-10 1 84553 170 1 (hardback)
 1 84553 171 X (paperback)

ISBN-13 978 1 84553 170 6 (hardback)
 978 1 84553 171 3 (paperback)

Library of Congress Cataloging-in-Publication Data

Andreopoulos, Andreas, 1966-
 Art as theology: from the postmodern to the medieval/Andreas
Andreopoulos.
 p. cm. -- (Cross cultural theologies)
 Includes bibliographical references and index.
 ISBN 1-84553-170-1(hb) -- ISBN 1-84553-171-X (pb) 1. Art and religion.
I. Title. II. Series.
 N72.R4A53 2006
 701'.08--dc22
 2006009193

Typeset by S.J.I. Services, New Delhi
Printed and bound in Great Britain by Lightning Source UK Ltd., Milton Keynes
and in the United States of America by Lightning Source Inc., La Vergne, TN

Contents

Acknowledgements

I owe special thanks to my friends Bronwen Neil, Mika Törönen and Marios Ioannidis, as well as to my Greek friends in Durham, UK, for their feedback and encouragement.

I also wish to thank my former professors David Booth, Joyce Wilkinson, Ronald Silvers and the late Richard Courtney for their guidance and support.

Special thanks to Andrew Louth who followed my writing with an open mind and a challenging intellect.

Introduction

The original idea for the present study was conceived about ten years ago in Toronto. Then it was a sketch for a dissertation at the Ontario Institute for Studies in Education, University of Toronto. The path that led to its completion at the Theology Department of the University of Durham, UK, under Fr Andrew Louth, was certainly not full of the kind of intellectual and spiritual tribulation that one is thankful for, in hindsight. To be sure, no one would be more surprised than me if by any magical way I were to get a glimpse of the future back in 1994 or 1995, and see myself working in the field of Theology. From the beginning I was aware that I did not know where the examination of art I was attempting would take me, but I had trusted and accepted the fact that *something* within me, a part of my thought, hidden from my conscious self, claimed a deeper and clearer knowledge of my purpose, and would gradually lead me there. I could only place my trust in this something and accept the fact that this work would require more than academic dedication and systematic study.

From the beginning I had a double approach towards art. Working as a musician for the last ten years, it was not enough to examine art as a theoretical, abstract phenomenon of cultural importance; my direct experience was too strong to permit me to proceed in this manner. On the other hand, the practice of art experienced from the inside, whether it happened to be commercial or classical, proved to be a constant intellectual stimulus for me, and it often motivated me to find additional perspectives in the problems of contemporary art, the role of the artist and, generally, the function of art. Beyond my own experience as a musician, I was lucky enough, or rather privileged, to be surrounded by accomplished artists immensely better than myself, who faced similar intellectual challenges in their work, and to be able to participate vicariously in their concerns, their problems and their insight. I should mention here my late friend Charis Polatos, who died in a tragic car accident on the 8th of May 1992. A self-taught musician, who covered almost all genres of music with his extraordinary talent, Charis was showing me in his way why art matters, through his incessant exploration of the possibilities of art. Although he had educated himself in classical music, he had no connection to the academic artistic establishment; he did not even have a formal musical training. Yet, he had an amazingly direct connection to art itself. Music for him was a language he knew extremely well, that gave him the ability to express anything, even feelings, concepts and ideas for which verbal language and thought does not have the vocabulary. What was unique about

him, and has immensely influenced my personal quest, was that his approach to the issues and the concerns of contemporary music and art was completely guileless; he was never interested in making a name for himself, and he never sought any kind of recognition for his many contributions. In a way I often think of Charis as a saint of art, and my poor attempt to understand and sketch the dimensions of his talent is not truly doing justice to his memory.

The other path of inquiry, my academic development, was quite unusual. My undergraduate interests included studies in psychology and education, as well as a cinema studies programme with a strong basis in semiotics. It was, perhaps, because of the combination of art, semiotics and psychology that my research methods still resemble the methods of a creative psychoanalyst; it is not enough for me to accept things at face value, and I always feel compelled to analyze them further, to discover deeper meanings and hidden subtexts, and to attempt unexpected connections. In addition to this, during my graduate studies I had started trying to integrate my artistic experience into my studies, and the person who was most helpful to me was Dr Ronald Silvers from the department of Sociology in Education, Ontario Institute for Studies in Education, a phenomenologist as well as an art photographer. My thought became more personal and more indebted to a process of synthesis, but what was more interesting was that the act of writing itself evolved into an introspective research for me, as it was essential to acknowledge my personal biases or influences and then attack them or build upon them. How was all that possible through the study of art?

The tension between my professional experience and my academic education was somehow beneficial for both, as they became something like a testing ground for each other. I was facing every day most of the problems of contemporary art, both commercial and classical. Such a problem was the opposition between classical and commercial art and their respective social answerability. Several state channels, such as arts councils, are called to fund and promote or deny any assistance to ensembles of contemporary classical art. Increasingly shrinking budgets in the 90s in Canada and the USA placed the future of the support for the arts, and in some cases the arts themselves, in grave danger. This was a reality I witnessed daily as friends of mine and people I knew were losing their jobs from classical orchestras or state-supported ensembles, or were in dire financial straits because their work used to depend heavily on state grants which were being curtailed. It seemed it was increasingly difficult to be a classical artist. Larger-scale phenomena were also showing how contemporary life can be hard on the arts: certain arts organizations, music, opera and ballet companies could not cope with the new reality, and declared bankruptcy. On the other hand, how could it be possible to

isolate the financial problems of the arts from a larger tumultuous economy that, recently, led to the reduction of the number of hospitals in Ontario, and toughened welfare regulations? Who could really decide that the arts should survive, if the price has to be paid by the already suffering lower socioeconomic strata, which may not have a taste for classical art anyway?

Popular commercial art, on the other hand, was facing entirely different kinds of problems. The commercial system itself is not threatened at all; in fact it is hard to say whether big corporations who control the arts industry, especially the music and movie industries, have ever been so powerful before. Popular art cannot be reduced to its commercial aspect that easily, however. The fact that it was able to sustain itself and thrive in difficult times is an indication of a corresponding genuine demand for it. The problem is that for many years, mostly because of its success and the commercial machine that supported it, popular art had remained conceptually stagnant. It had succumbed to the process of industrial planning to such a degree that commercial art, conforming to the formal criteria that allow the art industry to repeat a successful formula over and over in music, the movies and television – traditionally the most lucrative arts – is not necessarily genuinely popular anymore, at least not in the deeper meaning of the word.

How was I to understand the problem of the duality of culture? It was rather obvious to me that both classical and popular art had equally valid contributions to make. I had to understand more about their nature in order to understand what was happening to them. I chose to employ a gaze from without, corresponding to semiotic analysis, and a gaze from within, corresponding to phenomenology. Both routes finally led me to a quasi-psychoanalytical approach and methodology: first as the extension of the examination of *what is* and how it relates to human nature; second as the introspective examination of my own motivation and my fascination with it, as a performer.

The methodological problem was quite difficult to deal with. By the time I attempted the first sketches of the study I had discovered and had come to accept two things: first that the study was a lot more unpredictable than I had initially anticipated and was transforming in front of my eyes as I was attempting to penetrate its elusive object, and second that my personal motives themselves had to be researched because they, although only gradually revealed to me, were more responsible for the study than any purely academic choices I had made.

Art became more than an object of examination; it became a research method and a way of knowing. In many ways, as my experience showed me, a part of artistic communication takes place in the space of the unspeakable and the unnamable, codifying a kind of knowledge that eludes

the systematic rational classification of oral and (especially) written speech. This type of history is not that much evident in the representational arts, which can up to a point be analysed in terms of symbols and allusions; it is even less evident in literature which relies largely on the subtle combinations of meaning and expression, because the very medium of those arts is, in both cases, dissectable, but it is quite different in music, which is the area my active rapport with art has mainly taken place in. Music, perhaps more than the other arts, cannot be easily interpreted in terms of ideas. Ultimately, every kind of musical rule or established tradition eludes rational analysis more easily than in, say, poetry, whose words can be mined for a symbolic meaning that can sometimes reveal rational structures. Claude Debussy used to say characteristically that the rules are not important in music; in fact there are no rules, what matters is only "pleasure".

As a professional musician I was intrigued by the success of a relatively new kind of music, which was usually grouped with new, and sometimes unusual – as in the case of the music of Hildegard von Bingen – recordings of medieval and early Renaissance music. The choir of the Benedictine monks of Santo Domingo de Silos, Gorecki's *Symphony No. 3*, the music of Arvo Pärt and John Tavener, and also explorations of popular music into tradition (found, for example, in the music of Dead Can Dance, Ross Daly, Loreena McKennitt, etc.), elicited a response that baffled music critics and academics. This emerging music culture is defined by a few things: a spiritual ambience, a very simple and unemotional, yet somehow intense, quality of sound, and an occasional echo of distant, half-forgotten cultural memories, consisting of the use of medieval instruments, voice arrangements reminiscent of Byzantine or early Western choirs, references to medieval and early Renaissance sources of reference, etc. I was rather suspicious of the "spirituality" of this artistic generation, because it was initially grouped with the flaky Kitsch of the New Age (which I could perhaps see as an interesting sociological movement, but certainly not as an artistic one). It seems that professional musicians and music academics could not accept this music as easily as the audiences, and to a great degree they still cannot. I found this intriguing, especially as I became more familiar with the new music. Could it be possible that it was actually successful because it was religious?

At the same time, the decline of the arts everywhere else, and my own puzzlement about the answerability of art and the question of the existence of high culture in a world with great social problems, seemed to create a very interesting background for the new religious art. Here we are at a time of financial recession, when government support for the arts has dried up, perhaps understandably so, yet out of nowhere a new kind of high art has appeared, one that can support itself, and also address

some of the most profound questions that have appeared in mainstream art since the Middle Ages. The concept of the "death of art", as it is presented here, was formulated within my thought by this contrast.

The "death of art" is a question and a proposed hypothesis. The premise behind it is based on the postmodern condition, as it is expressed in (the philosophy of) art: what we experience in the visual arts, literature, and music, is the end of the formal history of the arts. There is no solemn declaration of such an auspicious idea anywhere; it can be perhaps inferred from the discourse on postmodernity, the collapse of the "grand narratives" and the re-emergence of ethnic and religious traditions all over the world, found in the writings of philosophers such as Foucault and Lyotard, but it is not a point that has to be proven scientifically, at least as far as art is concerned. Art without geographical borders, the success of institutions and organizations, such as WOMAD, which promote the influx of ethnic music into Western culture, and many other examples, can be observed daily. The notion of an artistic tradition that develops in a more or less linear fashion, not unlike science, even with occasional stimuli from another culture, has been practically abandoned. At the same time, "originality" has been reduced to a great degree to a choice among a number of cultural styles. Postmodernity in art is practically synonymous with wide eclecticism and a return of the traditional. A phenomenon of our time, it is absolutely possible and not surprising to see an Arab taxi driver in Paris or New York listening to Russian medieval hymns arranged with flamenco guitars or synthesizers, or perhaps with both. The end of formal history of art does not mean that there is no development in art whatsoever; it just means that the concept of art has been as distanced from the formal history that used to account for the shape and evolution of Western art, popular and classical, in the same way the Western concept of history (starting with the Greeks and including Marxism) has been distanced from the postmodern relativism which opposes the identification of the development of the human species with the history of white educated men.

I have to add here that there is a reason for the examination of medieval painting and contemporary music in this study. My initial interest and my first observations about the "death of art" came almost exclusively from the area of music. It would be fruitful to examine the other arts in this context as well, and this is one way to pursue the object of this study even further, but I think that music is a quite good example of the phenomenon of the death of art, perhaps because it can combine immense popularity with as sophisticated tradition as any of the fine arts, and thus cover the entire social spectrum. Issues such as the popular and the classical, as well as the sacred and the profane, can be observed very easily in contemporary music. On the other hand, the theory of sacred art can be

found mostly in the history of representational arts, as well as in litera-
ture. Issues like the representation of God in the Jewish and the Christian
tradition have repeatedly defined the role of sacred art. Trying to connect
contemporary art with medieval sacred art, and music with iconography,
was not without precedent: several contemporary artists very often refer
to their musical works as "icons in sound", suggesting that there can be a
common basis for music and painting, in a way that reveals their possibil-
ity to express the sacred.

My academic question could be expressed simply as that: "What lies
at the end of formal art history, which we are experiencing at the age of
postmodernity?" And my hypothesis, born out of intuition, but also from
the observation of, and perhaps faith in, the new religious classical cul-
ture, is: "The death of art as we know it, and its reincarnation as a spiritual
practice: something that, in different ways, was part of medieval aesthetics".

I felt I was lacking something in my academic approach. I could not
approach spirituality as an uninvolved observer, and my profession as a
musician made it more difficult for me to (want to) be "objective". I was
familiar with the discourse of subjectivity within contemporary culture
and criticism, perhaps even with its metaphysical extensions from a so-
ciological and philosophical point of view, but, having been educated
within a scientific academic framework that praises the objectivity of knowl-
edge and the distance of the researcher from his object of study, save for
some writings inspired by phenomenology, I had never expected my own
subjectivity to enter the picture. My convictions, my social and moral
responsibility as an artist, and my faith, were becoming part of what I was
studying; spiritual art has no meaning without them. I discovered that I
could not continue my study under my former academic guidelines. Soci-
ology and philosophy could not easily provide a framework that would
include the spiritual self. A leap of faith was necessary: I decided to
change the field of my study and continue my research in theology. It is a
choice I have never regretted.

The shift to theology would not mean that my academic methods
would be radically changed. Theology was a safety valve for me, once I
had realized that in my working hypothesis art is the transient and spiritu-
ality the timeless. I felt safer knowing that my arguments could be meas-
ured against the tradition of the study of the spiritual, and I felt freer
knowing that I could extend my thought to the roots of our social and
psychological background. Art in my research was becoming, as perhaps
it was also the case with the new religious art, the pretext to enter some-
thing much more important, which one could get to only by sacrificing
what led one there: This is what the "death of art" stands for.

1 A Religious View of the History of the Arts

The origin of the arts can be traced to the book of Genesis, where we read that Jubal, the son of Lamech, "was the ancestor of all those who play the lyre and the pipe".[1] The other two sons of Lamech, Jabal and Tubal, contributed to the history of civilization by inventing herding and metalworking. The following chapter of the book of Genesis presents a genealogy after Adam that differs somewhat from the genealogy of chapter 4, and without an account of the introduction of the arts and crafts. Lamech was born six generations after Adam according to Genesis 4, and eight according to Genesis 5. Genesis 6 presents the account of the enigmatic Nephilim or Nephthalim who were born of the "daughters of the people" and the "sons of God". Admittedly, the canonical Bible is, sometimes, quite confusing about the number of generations after Adam, but this does not diminish the power and the significance of the events it describes. As far as the introduction of the arts and crafts is concerned, and for the purposes of the present study the introduction of the arts specifically, we could wish to have some more information. For this reason we may examine other sources that describe those events with more details, perhaps giving more weight to their theological significance.

According to an early source of Judeo-Christian history, the origin of art can somehow be related causally to the Fall of the angels. The pseudepigraphon, yet highly respected, *Book of Enoch* mentions that some dissident angels, led by Samiazaz, taught the arts and the sciences to the human race, a story that may correspond to the account of the descent of the "sons of God" into humanity, in Genesis 6. It was because of those actions of theirs that they were expelled from Paradise and subsequently became known as the fallen angels. Art then, according to this version, was either an invention of Satan (although we do not have any proof for this argument, as those angels were at the side of God when they taught the arts to the people), or a present from God, something to make life on Earth easier after the expulsion from Paradise.[2] This idea is corroborated by the other end of the religious human trajectory in this tradition, the book of Revelation. In one of the last eschatological stages, just before the marriage of the Lamb to the Woman, we are told that the "voice of the minstrels and the pipers and the musicians stops and will never be heard again".[3] The entire story of the Fall and the creation of New Jerusalem in Heaven indicates something we could have suspected anyway:

BRIDWELL LIBRARY
SOUTHERN METHODIST UNIVERSITY
DALLAS, TEXAS 75275

our present inability to accept the world in our present, imperfect condition, without a need for a parallel reality, such as the one provided by art.

It is interesting to note, discussing the two events, that the participation of man in both cases seems only secondary. In the first case it is the angels who take the initiative to reveal to the humans the secrets of Heaven and Earth, all sorts of knowledge including astronomy and sorcery; and, in the second case, the eschatological drama takes place in the realm of the divine, after the entirety of human history has been traversed. Should we take this as an indication that human volition is not very important at the birth of history and at the eschatological conclusion of humanity? In that case one could argue that human history is a plaything between a benevolent God and a malevolent Devil, and man's actions make no difference whatsoever. On closer examination, however, we can see that the trajectory between the first and the last moment is almost entirely placed at the hands of humanity, even if it does not originate from within humanity, and the arts and sciences can be seen, from a theological perspective, as educational tools at the disposal of humanity, which can be used in order to fulfil their eschatology. Besides, we should not forget that the book of Revelation does not foreshadow the fate of humanity as a whole, but differentiates strongly between the fate of the just and the fate of the unjust, the ones who have worked towards their salvation, and the ones who have not. At any rate, the arts, regardless of their dubious origin and eschatology, are closely interrelated to both the conscious and the unconscious mind. Furthermore, they apply equally to the individual and to the collective. In this view it makes sense to treat the history of the arts as a metaphor (or as a symbolical procession) of human consciousness. It would then be useful to put aside the discussion of the theological implications of this issue for the moment and concentrate on the examination of the arts between the initial and the final moment of human history.

It is fascinating to note how the initial and the final boundary of human life on earth are connected with the existence, birth and death, of the arts. Regardless of whether we accept the arts as a result or a cause of the Fall of man or the Fall of the angels, we can be sure that they are of no use whatsoever in the paradisal state of existence. Moreover, the exclusion of art and artists from Paradise or Utopia is by no means particular to the Judeo-Christian religious tradition. Several classifications of the citizens of a state give the artist a very low social standing. In a classification from sixth century Byzantium which divided the civilian part of society into ten groups, the artists (charioteers, actors, musicians) rank at the bottom, even below the servants and the useless (the old, the infirm and the insane).[4] Aristotle accepted, somewhat reluctantly, the usefulness of artists and artisans in his *Politics*, but refused to admit them as full citizens,

whereas Plato in the *Republic* banished them in principle from his ideal utopian state, allowing for martial and religious art only. This example demonstrates, however, that even in the rational Greek tradition where the artists did not enjoy a very respectable status, there was an implicit distinction between religious art, as we would understand it today, and secular art. Religious rituals had little to do with the secular art of the time.

In the Judeo-Christian tradition, on the other hand, the character and the function of the arts was predominantly religious from the beginning. It would be interesting to divide this tradition into several stages and study the importance of art and its connection to religion in each stage. One should keep in mind, however, that a full analysis of the evolution of the arts in a religious context would be a titanic undertaking, worthy of a lifetime of study, and could certainly not be exhausted or developed in one book. What I hope to do in this chapter is to comment on certain instances where the artistic was particularly indebted, inspired or drawn by the religious, in an ontological rather than decorative manner. By no means should the examples I present be regarded as the only or the stronger ones *vis-à-vis* the ontological relationship of art and religion. I have tried, however, to select instances that correspond to characteristic stages in the development of art and of religious consciousness. More-over, I have limited this analysis to the Judeo-Christian tradition, which was also influenced by Greek thought. In a somewhat simplistic way, I tend to detect two contrasting modes in the religious feeling of an era or a people: one takes the universe as a place with two distinct realms with not much interaction between them, whereas the other accepts that the division between the tangible and the transcendental is more or less tem-porary, and not as prohibitive. This is very important for the study of art, because the distinction and union between two different realms is as much a question of religion as it is of art. This book attempts to capitalize on this striking similarity between art and religion in various ways, whether what is discussed includes the physical and the metaphysical, left- and right-brain thought, Heidegger's *Welt* and *Erde*, or popular and classical art.

Somewhat arbitrarily, and not always corresponding to historical truth, but certainly not without good reason, in this chapter I locate the first mode primarily within ancient Greek culture, where the pantheon of the Olympian gods was anthropomorphic to such a degree that it was far removed from what we could call metaphysical; especially within Pla-tonic tradition, the realm of the gods does not necessarily coincide with the highest degree of existence. The *Ev* (One) of Plotinus is not at all anthropomorphic, and even if it were, it would have to be thought of as a distant god, a *deus otiosus* rather than as a God-Father.

Conversely, I identify the second mode with Jewish monotheism. The exclusive relationship of Yahweh with his people, and also the Messianic

promise, a feature that is amplified even further in Christianity and its eschatology, express something completely different from the rigid division between the physical and the metaphysical of Greek culture.

As noted above, this generalization has to be taken with a grain of salt, for the sake of the argument. The goal of this book is to investigate the condition of contemporary art and its particular rapport with spirituality and religion, and the present chapter wishes to explore the archaeology of religious art, examine some of the critical stages it has gone through, and perhaps contribute something to our contemporary understanding of art. It should not be taken as a presumptuous attempt to exhaust the study of the development of religious art. As it will be discussed later in detail, art can work in two fundamentally opposite ways: it can either create little autonomous parallel universes or, in a function not essentially too different from the function of religion, it can attempt to transcend the fragmentation of the universe and assist us in bridging the gap between the two worlds. I think the two ways correspond to the two opposed ways of religious practice mentioned above, and this is why I used this generalization.

The Religious Background of Art in the Jewish Tradition and in Greek Philosophy

In many ways Judaism is a tradition of words. Representation of God is strictly prohibited, representation of other beings is, often, suspicious. The *Torah* is the word of God, and the Ten Commandments are the legacy of the Supreme Being given directly to the Jewish people. The Word of the Bible is what kept these people together through centuries of diaspora. It would be possible to argue that the books of the Bible constitute a form of art, but the boundaries between artistic creation and pure history, or divine legislation, are unclear in most cases. What is more, rabbinic tradition attaches a symbolical meaning to the words that can be correctly interpreted only through the prism of theology. Nobody can deny the artistic dimensions of books like the Song of Songs, yet even what seems just another beautiful poem to the uninitiated, can assume immense symbolical extensions for the initiate. A short phrase from the Song of Songs, such as "Sustain me with raisins, refresh me with apples; for I am sick with love"[5] may seem like an inspired verse of erotic poetry, with an aesthetic intent, to anyone not familiar with Jewish symbolism. It can have quite a few interpretations within the context of biblical exegesis, though:

a. Raisins, dried in the sun, stand for fire, heavenly and earthly. The verse "sustain me with raisins" connotes the fire above, the heavenly fire, and the fire below, the fire of the altar.

b. The two fires refer to the fire of Torah in writing and the fire of Torah in memory.

c. The raisins refer to many fires, the fire of Abraham, the fire of Moriah, the fire of the burning bush, the fire of Elijah, and the fire of Hananiah, Mishael and Azariah.

d. The fires refer to the well-founded laws.

e. "Refresh me with apples": the apples refer to the lore, the fragrance and taste of which are like apples.

f. "For I am sick with love": said the Congregation of Israel before the Holy One, blessed be he, "Lord of the world, all of the illnesses that you bring upon me are so as to make me more beloved to you".

g. Or, in another interpretation, "Lord of the world, all of the illnesses that you bring upon me are because I love you".

h. Another interpretation: "even though I am sick, I am beloved unto him".[6]

We see that what seems to be simply a Jewish literary tradition when approached from the outside, cannot be separated from its theological background. An aesthetic, or even a literal, interpretation would be not only beyond the scope of the way this tradition explains itself, but it could be contrary to the real meaning of the verses, even blasphemous.

It is the primacy bestowed to spoken word over various modes of communication, however, that led to its subsequent identification with thought and the withdrawal of all other ways of communication and senses to the domain of the arts. The word, as this brief example demonstrated, has multiple layers of religious significance. Yet, even the Jewish tradition which values so much the word and the book, does not start with it, but with what was the form of art *par excellence* in Greece and the Western world: theatre.

One of the earliest biblical writers is known to us by the code name J (Jahvist). He wrote the core of Genesis, Exodus and Numbers.[7] It is generally accepted that the contribution or book of J was written some time in the tenth century BC, by someone who lived at the court of Solomon and that of his son and successor, Rehoboam of Judah.[8] The book of J is the first testimony of monotheism in religious history.[9] What is particularly interesting for us is that the book of J, as one of the earliest extant testimonies of the dawn of the Jewish nation, reveals, as some scholars argue, a ritual drama created by Joshua, the Moses Festival Play. Ritual plays may be traced in many ancient civilizations, including the Greeks, the Hittites, the Egyptians and the Canaanites. What makes the rituals of

the Israelites extremely significant for us, however, is the central position of Yahweh, making them the first monotheistic rituals in history, with perhaps the exception of the cult of the sun in the court of Akhenaten; several writers suppose that there was a direct connection between them. The Israelites conquered Canaan c. 1250 BC, but their rituals were not recorded until J, some 300 years later.[10] The book of J, as an ancient piece of writing, bears the traces of an oral tradition, which was not yet divorced from dramatic action. In addition to the historical, cultural and religious importance it had for the ancient Jews, it also has to be acknowledged as a sophisticated work of art, which influenced deeply all subsequent Western art.

It is especially important for the present study that the structure of the book of J, which can be thought of as the earliest document of the Jewish religion, suggests that a kind of codified artistic practice was employed by the ancient Jews as the medium for religious meaning. This may be evident in other parts of the Bible as well, such as the Psalms, but the outstanding importance of the book of J lies in its position in time. To realize the importance of the book of J, we may compare it, or rather the ritual drama it reveals, with the Thespian drama of ancient Greece. In spite of their similarities, they have to be compared on the basis of how they developed over time: the former led to the Bible, the latter to theatre.

Bloom presents J's Yahweh as a literary character comparable to Shakespeare's prime characters:

> Perhaps J and Shakespeare resemble one another most in the endless newness of their imaginative worlds. Despite Yahweh's curiosity and his power, his creatures are made free to invent and reinvent themselves constantly, and that is the law of being for Shakespeare's protagonists also.[11]

Richard Courtney goes even further, although he acknowledges that certain Old Testament scholars rely more upon the subsequent writers P (Priestly Author) and R (Redactor) and deny the historical value of J. He is convinced, however, that modern scholarship (Courtney cites mostly Bloom and Vatwer) corroborate his views.[12] One of the latest overviews of the relevant literature, Ernest Nicholson's *The Pentateuch in the Twentieth Century*,[13] presents most of the difficulties modern scholarship faces in its attempt to organize biblical material, and it shows that while the view that takes J to be the oldest document of the Bible is generally accepted, it would be inaccurate to say that Old Testament researchers are unanimous on this issue. That may be so, but one has to keep in mind that Courtney is not only an academic writer, but also a dramatist; even if the historical information concerning the book of J is questionable, its dramatic features, as identified by Courtney, are quite convincing:

Dialogue – J's main style is dialogue (*dramatic speech*). Indeed, we could equally well describe Shakespeare's style in much the same way.

Irony – J is the master of irony: the incongruity between [a] an event and [b] the effect of the adjacent words and actions – understood more by the audience or readers than by the characters. This is *dramatic irony*, as seen in playwrights as distant as Sophocles, Shakespeare and Synge.

In other words, *internal evidence indicates that the book of J records the early Festival ritual drama of the Israelites.*[14]

Artistic practice at the time was not at the fringe of social or religious life or opposed to it in any way: it was the very way religion was practised and the core of social life. This is the reason the discussion on Jewish symbolic poetry and the book of J has been somewhat detailed. Here we have a coincidence of the artistic and the religious, which is not circumstantial: religion was initially expressed using the language of the arts. This moment of co-existence of art and religion is essential for the later development of both. We can generally see that art belongs more to the religious than to the secular realm, the further back we go in time. It is perhaps when a tradition or culture needs to define itself in contrast to another culture it comes in contact with that these balances are disturbed, something that can be said for the relationship of the Jewish and the Greek culture, as well as for the Christian and the Jewish. The Old Testament is full of images of singing and dancing, in contrast with the almost complete absence of such images from the New Testament. One reason for this must be that traditional art of the time was too closely related to the religious practice that underlay it; Christianity initially could not ignore this connection, just as it could not ignore circumcision and kosher food, yet it eventually forged its own distinct artistic language.

We have to make here a far-reaching comparison between Jewish drama and Greek tragedy. Tragedy, according to the Aristotelian definition, is the "imitation of an action that is serious and also, as having magnitude, complete in itself...with incidents arousing pity and fear, wherewith to accomplish its catharsis of such emotions",[15] whereas the Jewish drama and its descendant, the Christian Mass, are in essence not a mere re-enactment of any important historical or mythological events but a ritual reliving of the covenant with God, the celebration of the presence of God in the community. The tragedy provides a channel for catharsis of the "unclean" emotions of pity and fear; the viewers can subsequently return to their ordinary lives, having been freed of their heavy emotional baggage. The tragedy is therefore situated at the margins of social and religious life. The Jewish drama, on the other hand, reminds the participants of the continuously open channel between Heaven and Earth. The tragedy opens a window to the world of

imagination, sometimes inspired by the divine space (especially in Aeschylus, less in Sophocles, even less in Euripides), but not identified with it. Jewish ritual drama affirms the unity of human and divine space. This is very important in the comparison between the two genres, because the Jewish view postulates the notion of art as fundamentally connected with the religious practice, and the Greek view presents art as something that may emanate from religiosity but is embedded within the ethical rather than the religious mode.

The key difference between Jewish and Greek art in our study is the question of unity or separation between the present world and the divine realm. We must not forget that Greek cosmology followed a declining path, according to the five deteriorating ages described by Hesiod. The Jewish people, during the formative time of their religious system, on the other hand, had just been liberated from Egyptian rule; they had been given the consciousness of a chosen nation, and were being constantly reminded that they were not alone, but always under the gaze of a strict yet loving father with an eschatological agenda for them.

Further differences between Jewish and Greek art can be found in the representational art of the two civilizations. Representation of Yahweh is not possible, because the power of the image is such that it immediately evokes the represented. To utter the name of God, either in language or in painting and sculpture, is to invoke the presence of God. For Plato, on the other hand, art in general, including music and dance, is mimetic,[16] whether the imitation reflects something of the visible world in a realist manner[17] (in fact imitation has a central position in Platonic philosophy[18]), or whether it attempts to capture a glimpse of the ideal world.[19] Plato sees inspiration as a gift from God: "God takes away the mind of these men, and uses them as his ministers, just as he does soothsayers and godly seers, in order that we who hear them may know that it is not they who utter these words of great price, when they are out of their wits, but that it is God himself who speaks and addresses us through them."[20] There is a striking similarity between the Platonic poet and the Old Testament prophet here. Both receive their inspiration and their guidance from God, whether this is the Muse or Yahweh, but there is an important difference:

> The Platonic Muse, being a true Greek god, does not know about love. Having touched the poet's mind in its ecstasy, she does not care about the further adventures of her message. The poet can only meet his god when being in an abnormal state, and this god leaves him as soon as he returns to sanity. So he is not only entirely left to himself as to the real meaning of the revelation, but his interpretation is a mere guess, because it refers to something fundamentally inaccessible to rational understanding. Accordingly, Plato admonishes his readers to distrust any interpretation of poetry.[21]

Yahweh, on the other hand, was speaking the truth, and was guiding his people through his prophets and through his Bible.

Platonic and neo-Platonic philosophy posits, in general terms, a hierarchical order of the world. As is widely known, there are two levels of reality for Plato, the intelligible realm, το νοητόν, and the physical, sensible realm, το ορατόν or το αισθητόν. The lower realm reflects the higher one, but other than that there does not seem to be a lot of communication between the two worlds. Plato's divided line, as it is described in the sixth book of the *Republic*, is a quite static model, unlike the analogous models of the neo-Platonists, which saw two fundamental kinds of movement between the two worlds, an ascending and a descending one. In the Jewish tradition, on the other hand, God has a very personal relationship with his people – to the point of jealousy. The position of the gods of Olympus, towards which veneration is due, is quite problematic within Platonism; these gods seemed to be as susceptible to human passions as everyone else, and as such cannot possibly be placed on the same metaphysical level as the intelligible realm. Zeus was certainly not the Great Creator, and he was not even credited with reigning at the age of prosperity. The gods of Olympus were rather ignored by the Platonic tradition, perhaps as not genuinely metaphysical beings, but were, nevertheless, expressing the dominant religious feeling. Yet, Plato and ancient Greek philosophy were much more interested in religious matters than the average citizen. The sociological dimensions of this issue suggest that everyday life and its problems had little to do with the metaphysical realm. Michel Foucault, commenting on life in ancient Greece and its meaning, wrote:

> What strikes me is that in Greek ethics people were concerned with their moral conduct, their ethics, their relations to themselves and to others much more than with religious problems. For instance, what happens to us after death? What are the gods? Do they intervene or not? – these are very very unimportant problems for them, and they are not directly related to ethics, to conduct.[22]

The metaphysical realm was not at all remote in the very theistic, Jewish understanding of the cosmos, but it was rather continuously manifested in the Jewish people's everyday life, sometimes with very dire consequences. Communication between the two realms was possible: Yahweh was, quite obviously, a God who cared a great deal about the fate of the chosen people, and governed it through his prophets. Furthermore, two humans did what was unthinkable for even the gods of Olympus: Enoch and Elijah crossed over completely, with their bodies, to the metaphysical realm. The point is that whereas the structural centre of religious practice for the Greeks was on the earth, at the most at the summit of Olympus, for the Jews it was in the world of the invisible.

The special position of art in Jewish tradition is underlined by the two aforementioned episodes at the beginning and the end of Judeo-Christian trajectory, in the books of *Enoch* and Revelation. It is rather clear that a fulfilled soteriology of any kind would not tolerate the existence of a parallel reality, such as the one postulated by Platonic imitation, as this would undermine the perfect status of the God-given (or re-instated) reality. For this reason we have to identify the difference between Greek tragedy and Jewish ritual drama as representative of the split between religious and secular art, which is still meaningful today.

I think of Christian iconography primarily as a descendant of the Jewish rather than the Greek conception of art, although it has certainly assimilated characteristics from both. I make this differentiation for reasons that refer to the psychological rather than the formal debt of iconography to the two traditions, something that will be explained further shortly. There is, however, an archeological find of the early twentieth century that broke our previously unquestioned certainty on what we thought the artistic views of the Jews of the third century AD were: the synagogue of Dura-Europos, found in 1932.

The synagogue of Dura-Europos is something of a scandal within Jewish artistic and philosophical tradition, because it is decorated with visual representations from the Bible. Moses, Aaron, Jacob, and other figures are depicted in an unprecedented manner. Moreover, pagan figures, such as the figures of Ares supervising the Exodus from Egypt, or the three Nymphs guarding the infant Moses, blend with the traditional biblical characters. A cultural syncretism may be observed; many figures are represented with Persian or Greek clothes.

Dura-Europos is not the only site where such evidence of Jewish religious representations was found. A series of archeological discoveries in the 1930s unearthed similarly unexpected finds, which forced Jewish scholars to rethink their, until then, unquestionable belief in a Jewish iconoclasm. The remains of a sixth-century synagogue from the community of Bet-Alpha were found in 1930, where, among other representations, there was a painting of the hand of God reaching down to Abraham. Furthermore, there is the less famous case of the second-century excavation of the city of Sephora in Palestine, which is also decorated with scenes from pagan mythology. Unfortunately, there is a gap in archeological findings due to the persecution Jews suffered. The oldest extant synagogue, built in the eleventh or twelfth century, was destroyed by the Nazis,[23] and our historical knowledge of the development of Jewish religious art is incomplete.

It would not be prudent, however, to interpret such findings as conclusive proof that the use of religious paintings had been adopted by all or most medieval Jews. Modern scholarship is quite divided on that issue.

Carl H. Kraeling saw the paintings of Dura-Europos as an expression of normative Judaism, directly influenced by the Targum and the Midrash in an "illustrative rather than definitive" way.[24] He reads Jewish religious paintings as a direct extension, rather than a mystical interpretation, of the Jewish religious tradition.[25]

Erwin Goodenough, on the other hand, sees the paintings of Dura-Europos as a mystical interpretation of the Torah. In his view, the Babylonian Jews who built the synagogue were not participants in the "established traditions of Judaism",[26] but they had formed something like a cultural ghetto, deeply influenced by the dominant Hellenistic culture, and they should not be taken as reflecting the ideas and practices of the Jewish world at the time.

Still, the location of the synagogue of Dura-Europos inside modern Syria makes the archeological discovery invaluable. Relatively outside the sphere of Hellenistic influence, Dura-Europos was very likely a synagogue of normative rather than Hellenistic Judaism. If true, this is an important indication that normative Judaism had, indeed, accepted the use of images.

What we can say with some certainty is that the Hellenistic era saw the use of religious paintings both by Jews and Christians. Sister Charles Murray, examining the art of the early Christian Church,[27] shows that the attitude of early Christians to religious paintings, once thought to be rather negative, is also a quite complex affair. A link, however, can be observed between Greek painting and Judeo-Christianity. We must not forget that the early Christian era coincides with what is often regarded as the classical age in the development of Judaism. This is the time when Jews, having lost their state, their temple and priestly cult, defined the ritual life of Judaism, and when the most important postbiblical documents in law, lore and liturgy (Mishna, Talmud, Midrash, Siddur) were compiled.[28]

It is interesting that this unclear position concerning religious painting is shared by both traditions. It became possible to envision Christianity, a religious heir to Judaism, with an iconic background that, although Greek in origin technically speaking, included at least a portion of the Jewish tradition. This perhaps facilitated the appropriation of Greek painting by Christians. Certainly the possibility of the use of paintings was available to both religions. Goodenough's observation that the representation of Moses in Dura-Europos and the representation of Moses in Santa Maria Maggiore must have shared a common ancestor[29] is noteworthy.

Icons: The Religious Art of the East

Byzantine medieval art is usually seen through the perspective of the last few centuries of Western art and thought, that is, as an early stage of art

that prepared the way for the Renaissance in the West, and ultimately, for modern art. Any persistence in the ways of medieval iconography at the present would be seen, from the point of view of modern art, an incomprehensible anachronism, or a particular religious activity that does not belong to art proper.

We have to note here that the art of the Byzantine tradition was not limited to the Middle Ages, but survived mostly within the tradition of the Eastern Orthodox Churches. Iconography is as much an art of the twentieth century as it was of the seventh. Its theory was developed in the Middle Ages, and its style has not changed much since then, at least compared with the rate of development of Western art. It would be a mistake, however, to interpret this as an uncritical conservatism. Iconographers and iconologists such as Photis Kontoglou and Leonid Ouspensky, whose writings have been used extensively in this chapter, keep reminding us that the icon is not out-dated as long as the basis of its art is the truth and the connection to the divine, as understood within the Orthodox Church: the Church, in this way, guarantees the unity between medieval and modern iconography. Ouspensky's *Theology of the Icon*,[30] an important source for this study, may contain many historical inaccuracies, but it expresses exquisitely the unity of vision, or what the icon intends to represent, within iconography. As we shall see later, it is impossible to separate this vision, which is informed almost exclusively by a theistic view of the world, from the iconographic style of all ages. The style of the icon is not a question of taste as it is understood in modern art; to make stylistic changes that do not correspond to the religious function of the icon would betray its sacred character, and its function. Ultimately, this is a question of spiritual perspective. Iconography and Eastern religious tradition look back to the Middle Ages as a time of spiritual peak, the same time which for modern non-theistic West is known as the "Dark Ages". Characteristically, in a view that is shared by many, the modern Serbian iconographer Milich Stankovitch said "the Middle Ages are a bright phase of human history, when the problems of the world were solved with spiritual alchemy. I see the Middle Ages as a carrier of light, not darkness."[31] Furthermore, we can add that Kontoglou and Ouspensky, as well as other iconographers, instigated a revival of tradition within contemporary iconography, trying to clear the Western influences that had found their way into it in the eighteenth and nineteenth centuries. This can be seen, among other places, in Kontoglou's criticism of the eighteenth-century iconographic manual of Dionysios of Fourna, in *Ekphrasis*, his own iconographic manual.[32] Modern secular painting has also been influenced greatly by this revival; Yiannis Tsarouchis, for instance, perhaps Greece's most well-known contemporary painter, studied and worked for

a few years with Kontoglou, and incorporated many iconographic elements into his own art.

From an Eastern point of view the secularization of art would be incomprehensible for reasons that are understood only too well in the present age. The art of sacred icons, as we shall see in this section, connects the unconscious and the numinous in such a way that the *presence* of the divine is manifested or implied through it. The separation of the sacred from the psychological would mean, on a theological level, a further separation of man and God, something like a second Fall, and a fragmented aesthetic, where beauty is reduced to earthly, superficial, subjective or psychological beauty. This could be described in Platonic language as the cult of forms instead of the cult of ideas, or in psychoanalytic terms, the fixation on the fetish displacing natural pleasure. For these and many other reasons, the secularization of art would seem an anomaly of the history of the arts, even as early as the late Middle Ages, an evolutionary line as it were, eventually destined to reach a dead end. These are, indeed, some of the problems of modern aesthetics.

Hans Belting argues that art as we understand it today, "art as invented by a famous artist and defined by a proper theory",[33] begins some time after the iconoclastic Reformation, although signs that point towards this direction can be seen much earlier. Icons in the West lost their sacred function, and art became the domain of the artist. The birth of art, or its separation from religion, brought about new ways of dealing with images, and new problems, a new *raison d'être*:

> Aesthetic mediation allows a different use of images, about which artist and beholder can agree between themselves. Subjects seize power over the image and seek through art to apply their metaphoric concept of the world. The image, henceforth produced according to the rules of art and deciphered in terms of them, presents itself to the beholder as an object of reflection. Form and content renounce their unmediated meaning in favour of the mediated meaning of aesthetic experience and concealed argumentation.[34]

In this section we shall explore the semiotics of the icon and its connection to a psychological and religious economy. The basic argument in this presentation is that since the integration of Jewish metaphysics and Greek philosophy in the Hellenistic era, since the advent of Christianity, art could only be formed according to the rules that defined iconography. The icon as the "mirror of God", a notion that will be explored in psychological terms and in patristic writings, is the *par excellence* Christian art, and the deviation from the premises of iconography and sacred art is seen, from a religious point of view, as the exploration of a sterile path, which, as we shall see in the following chapters, is reaching its end.

A semiotic view of the icon

Byzantium inherited many cultural elements from both Judaism and the Greek world, and, despite indications that Judaism had shown some signs of compromise in its mostly iconoclastic practice, as in the case of the synagogue of Dura-Europos, the dichotomy between Greek (secular) and biblical (metaphysical) art was passed on to the Christian era. I believe that the balance between the two modes favoured mostly the Jewish mode, at least in religious art. This would mean that although the technique of early Christian art was almost exclusively derived from Hellenistic art, its metaphysical basis was very much indebted to the Jewish concept of unity between Heaven and Earth, and this section describes exactly the liturgical and psychological function of the icon in a way that shows that it was the spiritual descendant of the Jewish mode, even if it is also related to Greek art, formally and technically speaking. The existence of religious art is associated with a specific function to such a degree that we can say that the icon, for the most part, did not have the artistic aura of the Greek statue or painting, but, as a form of art, it was totally submitted to its religious function. The very title of a signal work examining the history of icons, Hans Belting's *Likeness and Presence: A History of the Image before the Era of Art*,[35] accepts the unity of artistic and religious practice in the Middle Ages, in a way that made it impossible for the object of art to exist on its own merit as such, instead by virtue of the religious function it was assuming.

This is not to be taken as suggesting that art did not exist outside the religious realm in Byzantium, although we cannot really know what the ratio of religious and secular art was. Secular buildings that we know were heavily decorated, such as the Great Palace in Constantinople, were destroyed after the Ottoman conquest, to be replaced by buildings erected by the conquerors, whereas many churches did not share the same fate. We know of the existence of secular art, not only from the few surviving paintings, but also from the secular folk songs that date from the Byzantine years, some of which are still part of the living Greek tradition. Several secular paintings were said to exist in Byzantine monuments such as the arch of Milion that marked the starting point of the great highway running across the Balkan peninsula which was said to have representations of hippodrome scenes.[36] Furthermore, according to an account of the time, the Emperor Theophilos put up secular paintings such as paintings of shields and weapons, animals, trees and men picking fruit in the imperial Palace itself.[37] One should also not forget the long list of secular Byzantine writers that included, for instance, Mousaios, Efstathios Makrembolites and even Theodoros Ptochoprodromos. The status of the secular artist and secular art altogether, however, was quite low in Byzantium, as can be attested in a variety of sources, such as the writings of

St John Chrysostom[38] that condemn theatre as a particularly lewd and indecent place. It would be wrong, however, to take this argument too far. Certain kinds of secular art were highly respected in Byzantium—architecture, for instance. Procopius in his *On Buildings* describes a number of buildings erected by Justinian, whom he eulogizes on account of the buildings' beauty and usefulness. Secular art, however, was at the fringes of artistic creation in Byzantium, at least as much as aesthetic theory was concerned. The function of religious art needed to be defined in the iconoclastic period, and this is why we have an extensive body of a religious artistic discourse, while nothing like that ever needed to be done for secular art. The distinction between religious and secular art was known in Byzantium, as it can be seen as early as in the Seventh Ecumenical Council:

> This art [iconography] was not created by artists. On the contrary, it is a sanctioned institution and a tradition of the catholic Church... Only the artistic aspect of the work belongs to the artist; the institution itself is obviously dependent upon the Holy Fathers.[39]

In a way that shows the liturgical connection of the icon to Jewish ritual drama, the icon is "not merely provoked or inspired by the liturgy: Together they form a homogeneous whole. The icon completes the liturgy and explains it, adding its influence on the souls of the faithful."[40] The implication of such statements is that the purpose of the icon is not aesthetic pleasure, at least not as we would mean it nowadays, but a quite specific function of visual communication aiming towards religious experience instead. Contemplation of an icon by the believer suggests a personal and profound practice that can be compared to liturgical practice and not to artistic enjoyment and appreciation. In that sense theology incorporates the study of beauty as a concept subject to theological doctrine.

Indeed, the primary concern of the Byzantine artist was how to represent theology in a precise way that would reflect religious orthodoxy, a concern shared by modern iconographers in exactly the same way. The role of the icon as the gospel of the illiterate, demonstrated by sayings of Fathers like St Basil the Great "that which the word communicates by sound, the painting shows silently by representation",[41] or St Nilus of Sinai "the illiterate who are unable to read the Holy Scriptures may, by gazing at the pictures, become mindful"[42] is a recurring issue in patristic writings. The icon held its place in Byzantine religious tradition because of its meaning, which was an issue important enough to divide the Church for two centuries. Today we have two ways to approach this issue. One way is the historical examination of iconoclasm, as well as the icon and its discourse in the context of the iconoclastic wars. There is a second method,

however, which could enable us to illuminate what was perhaps implicit, and therefore not articulated, at the time. An examination of the icon for what it is and what it can tell us itself, can go beyond historical information. A semiotic approach may reveal additional layers of meaning beneath the surface, and in this way we could approach the mysteries of iconography with the tools of contemporary understanding. Semiotic analysis can often enlist psychoanalysis and its techniques in order to give meaning to the discourse surrounding the examined object. It is quite fruitful, therefore, to examine the semiotic function of the icon and iconography, as well as the role of the Byzantine iconographer.

Icons were usually not signed. It is only some time in the thirteenth century that we come across names of artists and patrons[43] (in the Russian tradition icons are still not signed), and even when this happens, the most common way to sign is "διὰ χειρός..." (by the hand of...). The implication is that it may be the hand of the painter that physically created the image, but it was the Holy Spirit that engendered it. The artist is only a medium of divine expression and not a creator in the modern sense. It is interesting to note that this attitude has survived to date in iconography. This is an excerpt from a letter of one of the most famous contemporary Greek iconographers, Photis Kontoglou, to a young iconographer:

> Work with fear of God, keeping in mind that the Lord gave you the ability to fabricate His divine likeness, and the likeness of the Theotokos, the angels and the saints. A great and awesome undertaking! Those works are made with the grace of the Holy Spirit, and our hand becomes its instrument. This is why we sign 'By the hand' and not by our imagination or our own ingenuity. The more devout an artisan who entered the mystery of iconography is, the more fragrant of spiritual fragrance his works become.[44]

This idea and its implications on the relationship between God and the artist is also expressed marvellously in an extract from the rule of the monastery of Kosmosoteira in Pherrai, Greece, written by Prince Isaac Komnenos:

> One can only praise the artist [τεχνουργός] who received from the first creator of the world [δημιουργός] the wisdom of painting.[45]

How are the roles of the artist and the creator to be understood in relation to each other? Their distinction is seminal in our account, because artistic creation here does not appear to be independent of the work of God the Creator; it rather seems to intend to somehow participate in the work of God. The role of the artist is to assist God in the continuing creation according to His plan, rather than to become a creator in his own virtue. The artist here does the work of God, which can be seen as a spiritual quest or exercise rather than as a material undertaking.

In that sense, the real artistic event takes place elsewhere, not on the surface of the icon, but rather in the soul of the iconographer and the viewer.

Within the tradition of iconography, as it is still practised today, the production of an icon is an exceptionally spiritual act. The icon is a religious artefact that, as we shall see later, is supposed to be a window between Heaven and Earth: its value is that it consists of a material as well as of a spiritual side. The creation of an icon has to do with colours, materials, etc., but with its spiritual nature as well. An icon is inspired by the Holy Spirit as much as a sermon is: Photis Kontoglou wrote a technical manual of iconography, discussing the materials used by the iconographer, choice of colours, traditional patterns of representation, etc., but he often reminds the reader (the book is written as if to be read by a novice iconographer) that he has to pray for the assistance of God and the Holy Spirit often, to cross himself, and to keep in mind that the character of iconography is "liturgical and doctrinal",[46] and it cannot be treated in the same way as secular painting. Many iconographers still fast before they begin a major work.

There is an old traditional story which describes a contest between Chinese and Byzantine painters, organized by a powerful Sultan. The two groups worked on different parts of the same wall, and a curtain separated them from each other. The Chinese painters emerged every now and then from their curtain, and demanded more colours and more brushes, whereas the Byzantine painters were not seen at all. At the end of the contest, the curtain was removed and the Sultan admired the work of both teams; however, he expressed his curiosity as to why the Byzantine painters had asked for nothing at all during the course of the contest. Their response was that they spent the better part of the contest cleaning the wall before they actually started painting. The Byzantine painters meant that, according to the iconographic tradition, the Byzantine artist has to clean his soul before he paints.[47] This didactic story is still circulated among iconographers, as it reflects their views on the spiritual quality of iconography.

Similar views are found in the Russian tradition of icon painting: "The artist does not compose the image from his own conception, but merely removes the covers from the already existing and unique image. He does not superimpose the paint on the canvas, but as it were clears away its extraneous coatings, the incrustations concealing its spiritual reality."[48] In Russian icon painting terminology, the master "reveals" (*raskryavat*) the figures in the icon, and the paint which he uses for this purpose is called the "revealer" (*raskryska*).[49] What both the traditional iconographer story and the Russian testimony demonstrate is that it is essential for the iconographer to put his own self aside and submit to the guidance of the

Holy Spirit. The iconic forms are similar to the pre-existent Platonic ideas, which can be recovered by the iconographer only if and when his soul is ready to receive the guidance of the Holy Spirit. This not just a generic designated method of painting, although it is conceivable that a religious painter would feel a similar need to suppress his ego and pray for inspiration before painting a secular work, but it is essential that in the creation of an icon its spiritual, as well as its material part, is addressed.

Debates over what exactly is represented in an icon have been of great importance in the Church and the iconographic tradition. Iconoclasm questioned the orthodoxy of the iconic depiction of Christ, and this is when a theory of iconography needed to develop. It has to be noted, however, before we discuss the details of the iconoclastic controversy, that the Jewish restriction on the representation of God the Father was carried through in Christianity for a long time, especially in the East. A local council of Moscow in 1553–54 accepted the representation of the Father on the grounds that it had already been introduced into the practice of the West. The Great Council of Moscow in 1667, however, considered the issue from a different angle, asking whether, in spite of its widespread use, this image corresponded to Orthodox teaching. It concluded that this practice was unacceptable, and the depiction of God as a venerable old man in the sky, or any other depiction of the first person of the Trinity, had to be forbidden.[50] Still, this restriction common to Jewish and Christian art has to be interpreted as the recognition of the profound religious and psychological power of representation, and not as a general opposition to art. It is because of the significance ascribed to icons and statues that the Second Commandment and the iconoclastic controversy make sense within a tradition that thrived on artistic splendour and religious devotion. The limits of art had to be clearly defined, with the same importance that was given to theological writings.

The historical antecedent of the Christian icon is, formally speaking, Hellenistic and Egyptian painting, as well as the Roman art of the catacombs, although influences can be traced to Indian and Oriental art as well. The burial portraits found in Fayoum, Egypt share many stylistic characteristics with the icon, but they are painted in a way that could almost be called naturalistic in the modern sense. It is noteworthy, however, that the naturalist perspective, the naturalist approach in general, gradually gives way to an unnatural depiction of space and figures, the echoes of which are found as late as in the art of the Renaissance and the elongated bodies in the art of Domenikos Theotokopoulos. There is a very good reason for this, because the ancient Graeco-Roman portrait was trying to preserve the physical likeness of the dead for eternity, or even an idealized physical likeness, yet decisively physical, nevertheless. This kind of preservation corresponded with the attempt to preserve

(mummify) the physical body, or at least its most important parts, after death. Although the concept underlying the artistic practice has its roots in Egyptian metaphysical beliefs, the technique used is most certainly Greek: space perspective and the idealist representation refer us to ancient Greek rather than to ancient Egyptian painting and sculpting, as well as to the pictorial ideal of καλός καγαθός (beautiful and good). The functional role of the icon is fundamentally different. Preservation of physical likeness or beauty is not an issue in iconography, because according to church tradition, Christ and the saints have already reached spiritual fullness; it is transcendental beauty that needs to be denoted in the painting, not temporal and ephemeral. The semiotic significance of the Hellenistic portrait is entirely different from that of the icon, because the respective concepts of ideal representation and ideal being were entirely different, and it is only on the basis of such an investigation that we can understand how the painters of an advanced naturalist tradition suddenly began painting in a quite unnatural, even deformed way, which is how the icon appears when seen from a naturalist perspective. In addition to the aforementioned difference in the meaning of representation between the Hellenistic portrait and the icon, we should list two other factors that shaped the Byzantine icon:

First, the practice of icon worship is quite different from the process of aesthetic pleasure and response that can be evoked from a work of art. The icon can never be gazed upon without due theological consideration; it never claims to be a complete and independent creation, and icon viewing cannot be an artistic event by itself. The metaphysical background is present at every moment, in a way that goes beyond formal semantics: the believer does not only know who the depicted persons are, but is also expected to connect what is particular about them – their lives, martyrdom or spiritual quest – to the larger issues of Christian ethics, and contemplate the mysteries of faith. The icon is only a point of departure for divine contemplation, in many ways similar to Buddhist *mandalas*, compilations of sand and pebbles the very making of which constitutes a spiritual exercise. This kind of connection, then, between the viewer and the icon, presupposes an entirely different environment than that of the aesthetic portrait, and this inevitably influenced the technical development of iconography.

The second factor is of a more practical nature: the Orthodox church is built so that people do not necessarily stay in one place during the service. It is interesting that here we see that icons were painted and placed in such a way that makes them an object to be gazed upon. The wall paintings, traditionally and semiotically not distinguished from portable icons, cover the entire inside of the church, separated from each other by natural borders such as squinches and niches, or ornamental designs such

as vines and meanders. The believer can thus have visual contact to many icons simultaneously, which are for this reason painted so that they may be viewed from a variety of angles and from a changing viewpoint.[51] One has to bear in mind that medieval churches did not have pews or chairs, and the believers were usually standing or even walking inside the church. Their position in relation to the icons was, therefore, always subject to change. For this reason there is no fixed distance, or assumed distance, between the icon and the viewer; the effectiveness of natural perspective would be diminished in this case. Moreover, the icon is not only an object to look at, it is also an opening from which the believer himself is looked at: the icon is not only a window *to* another world, but can be said to be a window *from* another world as well, and the eyes of Christ and the saints are reminding the believer that he is always subject to the gaze of God. Prince Isaac Komnenos describes the icons of Christ and the Mother of God as "appearing like living beings who seem to speak graciously with their mouths to all who look at them".[52] There is additional information that suggests the existence of a gaze of reverse direction in iconography, as if there is an eye at the other side of the icon. Illumination of figures and faces seems to be coming from the inside, unlike in naturalist painting where a source of light has to be included in the painting or even indirectly suggested. But the most striking piece of information on this issue is the custom of Byzantine and Russian painters, who as late as the nineteenth century used to paint the so-called "Great Eye" on the painting and write the word "God" beneath it, before they started painting the icon.[53] This phenomenon can be traced to Egyptian art, but survived through the Middle Ages.[54]

Inverted perspective

Not every critic agrees as to the uniformity of what has been termed the *inverted perspective* of the icon, and there is a very good reason for this: no set of formal or technical guidelines from the Middle Ages that would account for the official adoption of inverted perspective has survived. The earliest of those guideline rules is probably the *Painter's Manual of Mount Athos* written by Dionysios of Fourna[55] in the middle of the eighteenth century. The issue becomes more complex when we consider that inverted perspective was only one of several pictorial devices used in iconography. Even if we accept that inverted perspective is invariably used in iconography, we still have to remember that figures of major importance do not follow the usual rules of spatial perspective, naturalist or inverted. The relative distortion of shapes, even buildings, is dictated by their semantic importance: Nature is usually represented in the form of "icon hillocks". Secular buildings are usually extremely distorted – often represented by the characteristic broken-off basilicas, which border the

painting's background. Finally, churches are presented with very few distortions.[56] In addition to this semantic distortive hierarchy, certain figures appear distorted or even doubled for reasons of pictorial narrative. Many icons dedicated to a saint, for instance, include events from the life of this saint on the same plane, and the viewer can infer the temporal connection between the depicted scenes.[57]

Commentaries and other writings on icons from before the Renaissance are concerned with issues of representation according to orthodox doctrine, or with the ability of painting to depict the divine nature of Christ, rather than with aesthetic issues of style. Many art critics (such as Hans Belting) simply avoid the question of inverted perspective, probably because they feel there is not enough evidence, certainly not any medieval source, to prove that there was such a thing as an inverted perspective. On the other hand, a semiotic examination of icons can reveal certain common characteristics that constitute a specific style, which can be explained in terms of the inverted perspective. After all, the semiotic approach is at the heart of the iconoclastic crisis, where the issue was not only the nature of representation, but also the attitude towards the sign. As Fr Pavel Florensky writes:

> Art is 'recollective' according to the teachings of the Fathers of the Seventh Ecumenical Council. Our contemporaries, positivistically minded, readily allude to these teachings, but in modernizing the word 'recollectiveness' by elucidating it in the sense of subjectivism and psychologism, they are committing a grave historical error. One should always bear in mind that the terminology of the Holy Fathers is that of ancient Hellenic idealism and is generally coloured by ontology. In this case it is not at all a question of the subjective recollectiveness of art, but of Platonic 'recollection', ανάμνησις – as the manifestation of the *idea* in the sensible: art leads out of a subjective seclusion, bursts the boundaries of the conventional world, and, beginning with images and through the medium of images, brings us to the archetype."[58]

In the famous formula of St Dionysios Areopagite, "phenomenal things are in truth the icons of invisible things".[59]

Florensky's account is particularly interesting as it connects the icon and the Platonic anamnesis, but one has to keep in mind what the nature of the iconic anamnesis is. The archetype he refers to cannot be identified with the Platonic archetype, because the latter could be conceived only through pure intellect. There is an additional factor in the contemplation of an icon, which eludes intellectual contemplation, namely the experience of faith. Similarly, perhaps the difference between Platonic anamnesis and iconic (or Christian) contemplation could be said to be analogous to the difference between philosophy and theology. Metropolitan Bishop John Zizioulas, echoing the thought of the Fathers, presents an interesting opposition between the Platonic and the Christian view, in

a chapter of his *Being as Communion* that examines the "iconic" approach to Truth, commenting on a passage from Maximus the Confessor:

> The things of the Old Testament are shadow (σκιά); those of the New Testament are image (εικών); and those of the future state are truth (αλήθεια).[60]

This "progressive" revelation of the truth that we find in the Fathers, starts, naturally, with the distinction among shadow, image and the future state of things as we find it in Hebrews 10:1 ("the law, having a shadow of the good things to come, and not the very image of the things, can never with these same sacrifices, which they offer continually year by year, make those who approach perfect.") Maximus' thought has often been contrasted to the thought of Origen in relation to such matters. His most famous "correction" of Origenism is that whereas Origen saw the beginning of the world in an inert, perfect state, Maximus placed the perfect state at the end of time.[61] Zizioulas identifies a Platonic streak in Origenism, and combines the above thought with the theology of the icon, as he distinguishes between the Origenist school and the (majority of the) Greek Fathers. As we shall see later on, in the discussion of man as made in/after the image of God, the theological meaning of the icon is quite different for Origen; according to his view, at least as Zizioulas reads him, an icon does not reveal fully the truth of what it represents. The icon in this context can be thought of not as a memory from the past, but as a prefiguration of the future (perfection):

> The idea of εικών in the Greek Fathers is often understood along Platonic lines. The passage of Maximus quoted above shows clearly that this is wrong. In the Platonic way of thinking, the image must not have its reality in the future; it is always the past which is decisive, making truth a matter of ανάμνησις, a connecting of the soul to the pre-existing world of ideas. The authentic Greek patristic tradition never accepted the Platonic notion – adopted by Origen and St Augustine among others – in which perfection belongs to the original state of things. The Greek patristic tradition also showed no tendency to understand the εικών in a retrospective psychological sense, and at the Council in Trullo explicitly rejected symbolism in iconography. In this crucial passage, Maximus shows once more that truth in Greek patristic thought is very different from that of Platonism. We must search elsewhere for the roots of the iconological language of the Fathers.[62]

One wonders if this "inverted" memory, the memory of the future perfection that the icon expresses, attests to a psychological connection with the inverted perspective of iconography. The true iconic perspective is not the privilege of the viewer, but it is reserved for the "eye of God", the converging point of inverted perspective, in the centre. The psychological interpretation of iconography and the inverted perspective are of central interest in this study, and will be discussed in some detail in this chapter: the icon is a point where art, theology and psychology converge.

Technically speaking, inverted perspective does not represent a figure or object in a particular setting, but the space as a whole and the figure or object in it.[63] An object in a picture that is painted according to the rules of direct perspective can be seen in the same way as part of the picture or if it is extracted and viewed separately. Its correspondence to the object it represents is based on similitude, which applies in the same manner to all figures or objects in the painting.

On the other hand, an object in a picture painted according to the rules of inverted perspective does not make a lot of sense if it is taken out of its iconic context. Any visual distortion it may exhibit can be interpreted by its position within the entire space of the icon, and its importance in relation to the other figures or objects. The dynamic space of iconography corresponds as a whole to the world where the artist assumes a real, changing perspective, instead of a fixed one. No individual viewpoint can be assumed here. This can also be demonstrated in the way objects occasionally appear distorted so as to present surfaces that a fixed gaze would not see, such as the inside and the outside of a building. This principle is similar to the cubist principle of a painting-in-time, where the artist is, nevertheless, placed outside the space of the painting. An icon represents a *space* instead of a *viewpoint*, and this is important in a religious painting whose centre coincides with the "eye of God".

A dynamic relationship is underlying the principles of spatial organization here. Moreover, since the icon is concerned with the representation of a unified space, it cannot be conceived from the outside, but only as if the artist (and the viewer) is part of the represented space.[64] Objects appear inverted as in a mirror and, therefore, what is right and left is usually determined as the right and left of the artist *as if* he is in the picture. The "left part" of the icon, therefore, is the one that appears to our right, and vice-versa. The entire perspective is distorted compared with the rules of naturalist representation: a conceptual focal convergence can be traced at the centre of the icon. This means that, all other factors being equal, the further figures and objects of similar order or importance are from the centre of the icon, the smaller they look. The world is depicted as if surrounding the artist and not at an objective distance from him. This is not particular to Byzantine iconography only. Similar mirror effects can be seen in the palace of Sennacherib in Nineveh (Assyria, eighth century BC) and in the art of ancient Egypt (cf. the mural from the tomb of the Vizier Rekhmira, New Kingdom).[65] One can, therefore, see in the icon a mirror that reflects the real world back to the viewer, revealing something more at the same time. Why is this distinction so important? What is the semiotic significance of a mirror?

The mirror of God

Jacques Lacan, drawing material from Freudian psychology, describes the *mirror stage* of the psychological development of the child, between the sixth and the eighteenth month.[66] This stage takes place before the Oedipal complex, and, in some ways, underlies it. What happens during the mirror stage is a gradual identification of the child with his image on the mirror, as he is held by his mother or even standing on his own, the conclusion of which is the establishment of a "relation between the organism and its reality, between the *Innenwelt* and the *Umwelt*".[67]

The identification of the self at the mirror stage occurs within a Gestalt encompassing the image of the child's own body and his surroundings. The duality between the child's sensory perception and its identification with the image on the mirror, however, produces what Lacan calls the imaginary, which creates an environment for any future relation to any *other* (with a small o), or any object. This environment quickly assumes a symbolic nature, and an ideal ego is formed; any *other* can represent the original experience of identification of *other* only metonymically, and thus ego and other are subjected to an even deeper sense of otherness, denoted by Other (with capital initial) in Lacan's writings.[68] This absolute Other is always elusive, and its nature is always unconscious: it is *the* unconscious. The Oedipal stage begins at this moment, or even during the mirror stage itself, when the mother holds the child in front of the mirror and is recognized by him.[69] The child can now be conscious of the presence or absence of the mother. Interestingly enough, Melanie Klein's account places at more or less the same time the recognition of an object as good or bad, starting from the very fact of presence/satisfaction of oral pleasure or absence/negation of this pleasure (the good and the bad breast).

It is important to realize here that the mirror stage is a metaphor employed by psychology to describe a quite complex stage of development, which involves not so much an actual encounter with a mirror, but the psychological stage of the emergence of self-identity, and the differentiation between the self and its surroundings. The mirror may not be a mirror at all, but a body of water, or, for that matter, the face of the mother, really anything that may serve as a point of reference to the developing sense of identity and otherness. The hypothetical first mirror experience is a metaphor for distinguishing the reflection of the self from the reflection of the (m)other. Despite this disclaimer, however, the psychological significance of the mirror, as well as the metaphor of locating the self in a mirror and then inside an image – or identifying with characters or points of view within an image – can be applied quite successfully in our semiotic examination of images.

How is the psychoanalytic discourse on the mirror stage relevant to iconography? This kind of painting resonates with parts of the psyche that

reach down to our primordial or most basic understanding of the world and our relationship with it. Some neo-Freudian[70] theorists, such as Georges Bataille,[71] have traced the birth of the opposition between good and bad and, therefore, the birth of the religious instinct, to the basic satisfaction of the instincts of hunger and possession. The examination of the icon as a religious object, however, takes us to even more primal stages of the development of the self. The recognition of otherness, and the subsequent renunciation of the Other, signify the acceptance and the memory of a loss of unity between the self and the others, which has its theological/mythological analogous in the expulsion from Paradise and the loss of indirect communion with God. In fact, this memory and the desire to return to God transcends gender differentiation which occurs only at the subsequent Oedipal stage, and therefore has to be considered as an earlier and more basic part of human psychogenesis. The icon appears as a mirror hiding the Other behind it, who can see us but cannot be seen. One immediately thinks of the famous passage from the first epistle of St Paul to the Corinthians: "we now see enigmatically through a mirror".[72]

The image and metaphor of the mirror can be identified as one of the most interesting ways in which neo-Platonist philosophy has described the relation between God and the human being. One of the earliest references to the significance of the mirror can be found in an Orphic story[73] where the mirror was one of the toys used by the Titans to lure Dionysus as a child, tear him to pieces and eat him. After that, Zeus destroyed them with his thunderbolts and men were made out of their ashes. Humans, therefore, contain a Titanic, earthy element, as well as a divine Dionysian one, which can be released by purification. The story is alluded to by Plotinus, who takes the mirror as a symbol of the attractiveness of the material world and, thus, as the symbol of the soul's descent into it, but later neo-Platonists worked out an elaborate allegorical interpretation, where the division of Dionysus by the Titans corresponds to the division of the divine power in the material world.[74]

Plato discusses the mirror in an appendix to the *Timaeus*.[75] According to him, what happens when we see an image in a mirror is that the light from the eye meets the light from the reflected object seen on the surface of the mirror, and these two sets of light form the perceived image on the surface of the mirror. In that sense the reflection is as real as any object, not a visual illusion, and it owes its existence to the prototype and the light of the sun.

The acceptance of the reflected object as a real object is quite important in Christian writers who picked up this concept from Plato. St Athanasius likens the soul to "a mirror in which it can see the image of the Father".[76] Similarly to the orphic myth of the mirror which suggests purification of the soul, Athanasius says:

> So when the soul has put off every stain of sin with which it is tinged, and keeps pure
> only what is in the image, then when this shines forth it can truly contemplate as in
> a mirror the Word, the image of the Father, and in him meditate on the Father, of
> whom the Saviour is the image.[77]

St Gregory of Nyssa used the metaphor of the mirror in a way quite
compatible with the meaning analytical psychology ascribes to the sym-
bol of the mirror. Gazing at the mirror suggests a kind of introspection: the
following excerpt describes the purified soul that looks onto itself and
recognizes its archetype, the likeness of the divine:

> The soul will go back to itself and see clearly what it is in its nature, and through its
> own beauty it will look upon the archetype as if in a mirror and an image. We can
> truly say that the accurate likeness of the divine consists in our soul's imitation of the
> superior Nature.[78]

The role of the mirror has been undertaken, according to Athanasius'
statement, by the Word. Visible to humans, Christ himself is an image of
the otherwise invisible Father. As an image he is born from the archetype,
the Father. The mirror was created for humanity to see God, although
there is something in the image that reminds humankind of the archetype
of his own self. Humankind is, after all, fashioned after the image and
likeness of God, and in that sense it can be argued that it is humankind
who took the form of Christ and not Christ the form of man when he was
born. Yet humankind is placed under a double field of gazes: on the one
hand we are always under the gaze of God (the all-seeing eye), but Christ
is given to humanity as an image to be seen by humankind. This meta-
phor resonates in the capacity of the icon as a double mirror, which al-
though submits its surface to our gaze, it assumes the presence of God's
gaze from the other side.

The premise of the eye of God gazing upon us from the other side of
the icon, although subconscious, gives an unprecedented semiotic di-
mension to the practice of art. During prayer one addresses God as di-
rectly as possible, by placing oneself voluntarily under the gaze of God,
and in that sense the icon can be seen as an aid to prayer. The viewer is
placing himself in front of the symbol of the unknown and engages in the
only possible (under normal circumstances) contact he may have with it.
This renders prayer, among other things, as the most profound form of
introspection, which is directed towards God through our deepest and
most elusive self. It is not prudent, however, to identify God with the
Lacanian Other: that would be to reduce God to the human unconscious.
Yet, it is fair to say that the Other, or rather the conscious Other, corre-
sponds to the primordial condition of man before the Fall, before the
differentiation between the secular and the numinous within human con-
sciousness, and that its contemplation includes both the Platonic

anamnesis of the undifferentiated condition of Adam, still present in the collective unconscious, as well as the acceptance of divine Grace and the wish for transcendence of the Fall. How are these two different from each other?

We must keep in mind that the icon as a sign is very closely connected to Christology, and that the iconoclastic arguments echo strongly the arguments of the Monophysites. The arguments of the iconoclasts were directed specifically against the representation of Christ, although their practice had a much broader scope and was directed against the representation and the veneration of the relics of saints, as well. One of the main positions of the defenders of icons was, as expressed by John of Damascus, the acceptance of the "circumscription" of God in the person of Christ. God had become incarnate, assuming all the characteristics of man, without ever losing anything of his divinity. The issue of the representation of God lies at the heart of the significance of the view of St Athanasius, who described Christ as the mirror in which the uncircumscribed God can be contemplated. The psychological and religious function of the icon was to maintain an open channel to the numinous world. This was denied in the monophysitic views which could not accept the dual nature/energy of Christ and held his humanity to be "a drop of honey dissolved in the sea of his divinity", as the monophysitic view often put it; it was also denied in the iconoclastic views which could not accept that the icon can be accepted as, as we would describe in contemporary language, a "metaphor" for the presence of Christ and the saints among us.

The Son is at the same time an icon of the Father: according to the Johannine gospel, "Anyone who has seen me has seen the Father",[79] as well as the archetype of man. The latter can be understood in two different ways that, nevertheless, complement each other. As already mentioned above, Christ was the prototype for man, ontologically speaking. This statement, however, has a psychological counterpart, beyond its theological and historical dimension. Christ can be seen as what C. G. Jung described as a psychological "symbol of the self",[80] or rather an ideal model of the self, and can thus express and guide our striving to actualize the image of God within us.

Christ, as the second Adam, is a second beginning for humanity. He is, as Adam was when he was created, a pure image of God, of which Tertullian wrote:

> And this therefore is to be considered as the image of God in man, that the human spirit has the same motions and senses as God has, though not in the same way God has them.[81]

The semiotic identity of Christ is of tremendous importance, because in his person the image of God coincides with the image of man. Patristic texts on the creation of man in the image and likeness of God often touch upon this issue. According to Origen, the image of God, which is imprinted on the soul and not on the body, is an image of an image: "for my soul is not directly the image of God, but is made after the likeness of the former image".[82] The Son, in his theology, is the true image of the Father ("the Saviour is the figure of the substance or subsistence of God").[83] The Son is also viewed in the light of the rhetorical question: "what else therefore is the image of God after the likeness of which man was made, but our Saviour, who is the first born of every creature".[84] Then The Son is also "the image of the invisible God is the Saviour"[85] after whose likeness our inner man is made "but that which is made after the image and similitude of God is our inner man, invisible, incorporeal, incorrupt and immortal".[86] The Godhead, according to Origen, reveals itself inside us through prudence, justice, moderation, virtue, wisdom, and discipline.[87]

A different line of thought on the relation of the image and the prototype starts with Plotinus. His central idea of how things came to be is the emanation from a higher source, which in turn is emanated from an even higher source, and so on; everything can be ultimately traced to the εν, the One, the great Source and Principle. The metaphor of the image is a way to describe the relation between the source and what proceeds from it: the latter is an image of the higher source. At the top of his hierarchy we can see how the concepts of the One, Cosmic Intelligence and Cosmic Soul are related: Intelligence is an image of the One, and Soul is an image of Intelligence. Each rung in its descending hierarchy is a little *less* than the previous one, of which it is the image. It is important to note that the image proceeds directly from its prototype, and it ultimately seeks to return to the prototype. The image needs to know its archetype, so that, by contemplating the archetype, the image can return to it. The contemplation itself is the act of return.

Nevertheless, Plotinus' understanding of this image hierarchy is very close to Origen's views. Both writers accept that there are certain orders of images, and that an image of the second order, an image of an image, is not as good or accurate as an image of the first order. Such views are not surprising in Plotinus, who thought of the entire Cosmos as a hierarchy derived from the εν, and in spite of Origen's Christian background, they are not surprising in his thought either, because his view of the man Jesus as one of the λογικοί, and divine only on account of his participation with the Son, λόγος, the true image of God the Father, shows something similar to the thought of Plotinus. The image of God is Christ, who does not necessarily have to be taken as a consubstantial image. Image and identity seem to be mutually exclusive, while for later Fathers, such

as Maximus the Confessor, Christ is at the same time God and the image of God.

A change of this position can be seen with Augustine, or more precisely, with the difference between the early and mature Augustine, as shown by Andrew Louth.[88] Although the early Augustine, like Origen and Ambrose, accepted that man was a second-order image of God, Augustine later combined the Plotinian idea of an image as something that reflects what created it, with the argument that Christ is not a mere image of God, but shares his substance, and concluded that man is the image of God (an image of the first order), as he is the immediate creation of God, with no intermediate rung between them. Nevertheless, the nature of the image relationship in Augustine seems to have been influenced by Plotinus' views of the Divine Intellectual. For Augustine the image of God has to be located in the rational part of man. A certain analogy he used seemed to confirm his hypothesis: God is Trinitarian, and man's rational self is also trinitarian:

> And in these three, when the mind knows itself and loves itself, there remains a trinity, mind, love and knowledge; and it is confused by no mingling; although each is singly in itself, and all are wholly in one another, whether one in both or both in one, and so all in all.[89]

There are two basic problems with Augustine's approach. The first problem is that such a trinitarian analogy would be, to say the least, foolhardy, if not flatly wrong. Even now, in the beginning of the twenty-first century, we still know so little about the way the mind works. We certainly do not "know" what love is, and, in spite of the recent development of cognitive psychology and philosophy, we do not know much about the nature of knowledge, either. The Trinitarian nature of God is an even larger mystery, and therefore it does not seem prudent to draw an analogy between the two triads. Moreover, it seems very possible that in drawing such analogies we project some of our limited understanding of ourselves onto the nature of the unexplainable God, anthropomorphizing him inexcusably. This is one of the problems that apophatic theology attempted to address, focusing on what God is *not*, or what God is *beyond*.

The other problem with Augustine's approach, which is also evident in Origen's writings, is the exclusion of the body from the image of God within man: "*Imago Dei intus est, non est in corpore... ubi est intellectus, ubi est mens, ubi ratio investigandae veritatis est, ibi habet Deus imaginem suam*"[90] (the God-image is within, not in the body... Where the understanding is, where the mind is, where the power of investigating truth is, there God has his image). Origen had presented a similar view in *Contra Celsum*: "Το κατ' εικόνα του κτίσαντος ψυχή μεν χωρεί, ουδαμώς δε το σώμα"[91] (the image of the Creator is imprinted on the soul, not on the

body). This obviously corresponds to the rational part of the self, Augustine's *anima rationalis*, a concept that has been seen[92] to have a strong resemblance with the επουράνιος άνθρωπος of St Paul.[93] Christ in Augustine's thought, on the other hand, is identified with the image of God, as opposed to having been created in/after God's image: "*Unigenitus...tantummodo imago est, non ad imaginem*"[94] (the only begotten...alone is the image, not after the image). We have to note here, however, that Augustine formulated different views on this issue during his lifetime. In the previous excerpt he expresses an opinion that is in agreement with most Greek Fathers.

Two points of high psychological interest can be deduced from the above. First, that the ideal self is situated within man, rather than in a remote and unapproachable world. The struggle towards the Good can therefore also be situated within man. Second, that the image of God is not identified with the entire self, but only with its spiritual part. This view can also have a negative side. If one part of man is made in the image of God, what can we say about the other part? Is there a divine and an anti-divine image within man, fighting against one another? This would directly imply a dualism, since the part of the soul that is excluded from the *anima rationalis* and, therefore, from the image of God, consists of the uncontrolled wishes and desires, which often prevail upon the self. Still, we may be somehow assured that this is not what Augustine had in mind when he spoke of the rational soul, because his writings in other places express a deep personal divine longing, a quite "irrational" passion for God. It would be important to recognize, then, that the language of Augustine was different from that of modern philosophy and psychoanalysis, but the supremacy of reason on theological grounds, which echoes similar views in the neo-Platonic tradition, influenced greatly the development of Western thought. Certainly the models of Plotinus and Origen give the intellect a privileged position, which was counteracted by Tertullian's *sacrificium intellectus* on the other extreme. The confession "*Credo quia absurdum est*" (I believe because it is absurd) is attributed, probably wrongly, to Tertullian,[95] but it reflects more or less his attitude to faith and reason, for he at least wrote "*Et mortuus est dei filius, prorsus credibile est, quia ineptum est. Et sepultus resurrexit; certum est, quia impossibile est*"[96] (And the Son of God died, which is immediately credible because it is absurd. And buried he rose again, which is certain because it is impossible). At any rate, reason became the influential principle. The concept of a separate, wholly and consciously good part would suggest a fragmentation of the self, a predictably unstable condition. The suppression of a part of the self, as opposed to its integration, would lead to a catastrophe, according to Jung's psychological rule that says that "when the individual remains undivided and does not become conscious of his

inner opposite, the world must perforce act out the conflict and be torn into opposing halves".[97]

The scorn for the body is also expressed in the suppression of sexuality and its (direct or indirect) identification with evil. Augustine seems to be rather embarrassed by the fact that generation in this world cannot take place without "a certain amount of bestial movement" and a "violent acting of lust". The fact that sexuality is not under the control of reason is a result of the Fall, and in this, Augustine would be indeed supported by psychological information, if he accepted that "sexuality" is a notion as tainted by the Fall as "reason" is. By identifying, however, the one part of the self with God and the other with the "animal nature of man" (that part which does not reflect the image of God within man), we enter into the perilous trajectory of sexual suppression, guilt, shame for our "bestiality", and a kind of psychological dualism that has haunted our culture after the liberal, relatively guilt-free disposition of the ancient Greeks.

The Eastern approach to the question of sexuality, expressed among others by St Gregory of Nyssa and St Maximus the Confessor, accepted that all bodily needs, including sexuality, are not part of humankind's natural condition. They were superimposed on human nature after the Fall, something that is signified in the "garments of skin" made by God for Adam and Eve in Genesis 3:21. In that sense, and although Eastern (monastic) practice has often tried to transcend the limitations of the superimposed condition, one cannot feel more shame for one's sexuality than for one's hunger and thirst. There is no permanent evil lurking inside humanity. Nevertheless, in the East and the West alike, the problem of evil is very much connected with (psychological) dualism.

The Church's fight against dualism made it necessary to deny the existence of evil as an entity real, separate, and as powerful as the good. Fathers like Origen, Athanasius, Basil and Augustine formulated the doctrine of the nature of evil as an absence, a deprivation of good, known as *privatio boni* or στέρησις αγαθού (εκτροπή αγαθού in John Chrysostom). This doctrine created almost as many problems as it attempted to solve, because it questions the eternal damnation of Satan and the sinners who follow him, both in Heaven and on Earth. Final restoration of all, αποκατάστασις πάντων, seems, under this light, an enchanting idea, which quite effectively eliminates any doubts about the character of monotheism in Christianity. One has to keep in mind that a theological doctrine cannot always correspond to a psychological truth, because the object of the two disciplines, although comparable, is not always the same, something which is reflected in the division of theology into θεολογία and οικονομία. The doctrine of the non-existence of evil was never understood or adopted by the masses, and the psychological reason for this could be the formulation of the doctrine itself, or at least its interpretation

through the identification of *ratio* with good inside man. According to Jung's psychological rule mentioned above, it was exactly the suppression of the irrational part of the self that gave substance to evil as a psychological, although not metaphysical, reality. Furthermore, the formula "everything good comes from God and everything evil comes from man" is also problematic in relation to *privatio boni*, because if man is to be credited with the practice of evil through the exercise of his free will, he would also have to be credited with the practice of good. Yet, what the writings of Augustine and the other Fathers indicate is that there is something inside man, wherever this is located and however it is identified, which still preserves the ανάμνησις of the divine image, which can thus be re-built. This view is further supported by the contemplation of the λόγοι, the "principles in accordance with everything in the cosmos was created through the Word of God, the λόγος",[98] according to some Fathers like Origen, Evagrius and, foremost, Maximus the Confessor. If the soul can discern the λόγοι, it will be able to "see its own radiance",[99] revert to its natural condition, and, like a crystal mirror, it will reflect the divine image faithfully, clearing the mirror in St Paul's metaphor of our contemplation of the Father as the elusive Other. Christ, as the second Adam, the true image of God, expresses the true condition of man, the mirror made of perfect and unblemished crystal. Surprisingly similar, with the soul likened to a mirror that, under certain circumstances, can reflect the divine, is Plotinus's view of the higher part of imagination or πρώτη φαντασία.

The model of evil as a distortion of the good circumvents the problems posed by the identification of the divine image with the *anima rationalis* in humankind, discussed above, because evil can be denied separate and real existence only if the good cannot exist (in us) separately, either. Evil as the distortion of truth does not constitute a force complementary to the good, in the sense of the opposition/completion of yin and yang, which has to be conquered and suppressed, but as the opaqueness as it were of the soul-mirror, or, according to the thought of St Gregory of Nyssa, as what the mirror chooses to reflect.

The metaphor of the mirror is also found in Gregory of Nyssa, but he applies it to the human nature as a whole. Free will directs humankind towards good or evil, which is in turn reflected in him:

> When you put gold in front of a mirror, the mirror takes on the appearance of the gold and because of the reflection it shines with the same gleam as the real substance. So too, if it catches the reflection of something loathsome, it imitates this ugliness by means of a likeness, as for example of a frog, a toad, a millipede, or anything else that is disgusting to look at, thus reproducing in its own substance whatever is placed in front of it.[100]

For Gregory, then, the entire human is capable of good and evil, or in other words, the mirror of human nature may reflect good or evil. It is in this context that he sees the likeness of God in humankind. His view of the human nature as a whole is quite high, and he makes sure when he discusses the *wisdom of the flesh*[101] to associate it not with the body given to us by God when humanity was created in the first place, but with the garments of skin[102] given to us during the expulsion from Paradise. Subsequently, if man avoids the wisdom of the flesh, the likeness of God will be restored in him. This model proposes a psychological balance perhaps not found to such a degree in other patristic writings. Gregory's concepts distinguish between matter *per se* and the material condition, and his thought is closely connected to the Platonic tradition of the image and its "participation" with the prototype. For Gregory, moreover, the "natural" condition of the human mirror is good. This is quite significant in relation to his mirror theory, because it suggests that the mirror of human nature, the entire human nature, will eventually turn to good and will reflect only good.

Christ is, according to Maximus the Confessor, who expressed a view most helpful in the contemplation of Christ and iconography, a symbol of himself:

> He accepted to be unchangeably created in form like us and through his immeasurable love for humankind to become the type and symbol of Himself, and from Himself symbolically to represent Himself, and through the manifestation of Himself to lead to Himself in His complete and secret hiddenness the whole creation, and while He remains quite unknown in his hidden, secret place beyond all things, unable to be known or understood by any being in any way whatever, out of his love for humankind he grants to human beings intimations of Himself in the manifest divine works performed in the flesh.[103]

Christ is something of a semiotic paradox: being the image and therefore the symbol of the one eternal God, he is at the same time God himself. His image is a *mysterium coniunctionis*, uniting the "circumscribed" and the "uncircumscribable", to use the language of the iconoclastic controversy. The word "symbol" here denotes, like in "Σύμβολον της Πίστεως", a truth that cannot be fully understood or articulated, and can thus be expressed only through a symbol. The original meaning of the word "symbol" means a sign or token by which one knows or implies something. Originally σύμβολα were the halves or corresponding pieces of a bone or a coin, which two contracting parties broke between them, each keeping one. A symbol, then, expresses a broken unity and the promise of a reunification. The parts take their significance from each other, and the contract they signify must some day be fulfilled.

Ysabel De Andia writes that "the symbol has always a reference to a missing part, which can be material or intellectual: the absence of a

person or of a world, but also presence of another world behind or above the one which we perceive, like the visible behind the invisible and the intelligible behind the sensible".[104] Christ, as a symbol of himself according to Maximus, is at the same time the fulfilment of the contract the word "symbol" denotes. He is no ordinary symbol, because unlike the "absence of a world" ordinary symbols refer to, he embodies the presence of both worlds. Moreover, as the second Adam he is the symbol of the future of man, his eschatological fulfilment. In the person of Christ the unknowable God and the knowable human are united in a way that cannot be accounted for from within the Jewish tradition, which held that "nobody can see God's face and live".[105] He is, for that reason, a scandal for the Jewish understanding of the image of God. As God-on-earth, however, he chose to be born in the Jewish culture and to bring into completion the issues and the questions inherent in it. The Incarnation is, among other things, a semiotic event that legitimated the representation of God and the paradoxical transcendence of his hiddenness, but as such an event it could be meaningful only on the basis of the Jewish concept of the uncircumscribable God. It would not constitute a semiotic paradox in pagan cultures, where gods were routinely represented. Christ could only be seen as the fulfilment of the symbol if the absence of the "other" and the need for the symbolic are understood. Interestingly enough, St Paul noted the significance of the "Unknown God" of Athens as a God that could now be revealed to the world by an act of grace. The "Unknown God" was an empty sign, perhaps the closest analogue of the formless God who cannot be represented in carved (and painted) images in Greek theo-mythology. This represents an entry point that draws our attention to the importance of the elusiveness of the Other in Lacanian analysis. The revelation in the person of Christ and the Incarnation can be effective only inasmuch it reaches the unconscious and even beyond, and makes knowable what was always central in the psychological and spiritual life of a culture but had always remained unknowable.

The paradox of the image of Christ seems to be, at any rate, one of the reasons that led to the iconoclastic controversy, although it is difficult to locate and identify all the reasons that led to it. Many religious cultures faced similar issues that resulted either in an iconoclastic denial of images altogether, or a confirmation of the importance and the significance of the image and its veneration as a religious practice.

It might initially seem irrelevant to proceed with a brief discussion of Muslim views in this examination which so far has focused on Christian art. We have to consider, however, that what we call conveniently "the Byzantine world" was a complex society that consisted of many ethnic

and religious groups. The discourse of religious art we are interested in had, indeed, little to do with those religious minorities, but insofar as we are interested not only in official doctrine but also in the psychological background of this discourse, it would be useful to approach Islam as a "sister culture" that shared a lot of its religious mythology with Judaism and Christianity, and developed in the same place, at the same time, with them. This brief exploration of Muslim ideas is, indeed, a sidetracking venture, but the presence of characteristics and views on religious art that can also be found in the Christian world would strengthen the position of these similarities within the main exploration of Byzantine religious art.

Although the Koran does not contain a direct prohibition against images, the prohibition is stated quite directly in several *Hadiths* (selections of the words of Mohammed that belong to the Islamic Holy Tradition), such as this: "Artists, the makers of images, will be punished at the Last Judgement, for God will impose on them the impossible task of resurrecting their works." Nevertheless, some tolerance for painted images exists, but there is no acceptance whatsoever for an image that "casts a shadow".[106] Islamic tradition shares the Jewish taboo of representation of God, for God is as uncircumscribable and indescribable for Muslims as he is for Jews. No created image could even attempt to describe the uncreated God. The created world should not be represented either, because such representations could be seen as a demonic "mimicry".[107] It is conceivable that Islamic influence was one of the factors that started the iconoclastic movement, as the iconoclastic, or rather uniconic, Arabs were expanding quite successfully in the seventh and eighth centuries.[108] Islam faced the question of religious representations more or less at the same time as Byzantium, and in a way went occasionally even further than the Jewish tradition in that even the written word of Mohammed constitutes a necessary temporary *other* which will disappear just before the end of time. According to Shi'ite Muslim eschatology, the Mahdi, or twelfth Imam for Shi'ite Muslims, will appear shortly before the end of the world to govern the earth, and then the copies of the Koran will turn into blank pages,[109] having become unnecessary and obsolete by the presence of the infallible Guide. What is at stake here, as well as in the iconoclastic disapproval of icons, is the position of God within human history and society, and the ability of sacred art to express his presence. The deeper difference between the acceptance or rejection of religious art, that is, the acknowledgement of the presence of the *Other* and the subsequent veneration of religious art, or its denial, parallels the divide between mystical theology and social ethics, which can be observed both in Islam and Christianity. In that way art demonstrates a mystical quality, which is quite evident in the traditions of the Islamic sect of Mawlana or Mevlana dervishes, founded by Rumi in the thirteenth century. Their rituals are such a

wonderful example of religious art that they deserve a brief reference, even though they are ostensibly outside the Judeo-Christian tradition.

The dance of the whirling dervishes has a cosmic and theological character, strongly reminiscent of neo-Platonic philosophy, which represents the final union with God. Its shape "represents the planets turning around the sun and around themselves. The drums evoke the trumpets of the Last Judgment. The circle of the dancers is divided into two semi-circles of which the one represents the arc of descent, or the involution of the souls into matter, and the other the arc of the ascent of the souls to God."[110] The writings of Rumi describe a direct connection between humanity and God through sacred art:

> In the musical cadences is a hidden secret; if I were to reveal it, it would overturn the world... We have all descended from the body of Adam, and we have listened to these melodies in Paradise. We recall a little of them to ourselves, even though the water and the clay have covered us with doubt.[111]

The views of the dervishes are quite interesting, as they ascribe a very special role to sacred art, or rather, to the art of the sacred. Yet, although the Mawlana may be seen as particularly liberal *vis-à-vis* religious art within Islamic tradition, the ascent towards God seems a human affair, an ascetic or mystic movement of the soul which has no counterpart in the side of God beyond the revelation through the words of the prophets. The unique significance of the Christian icon is the presence of God among humans manifested in the Incarnation and the divine Passion, which transform the icon into a field of a double movement, from both sides of the mirror: the divine *Other* has made itself visible and circumscribable. This can be seen as a first step towards the final divine apocalypse: a face has appeared on the surface of the mirror, although it is still "enigmatic", being the premonition and the promise of the time when the image will be clear and the communication will be direct, "face to face". The significance of the icon, therefore, can be thought to be closely interrelated with Christian eschatology. A signal question that naturally arises from the discussion of the icon as a mirror is whether the aforementioned human and divine movements parallel each other in any way, like the movement of an object and its reflection on the mirror. It cannot be denied that it would be a little dangerous to suppose that there is an unequivocal and automatic relationship between the two, because it would seem as if the one could cause the other, as a reflection that follows the movement of the original. The danger here is that one could assume that a divine movement could be caused by a movement from the human side. Nevertheless, the iconoclastic debates never went as far as to follow this perilous line of thought, and, to my knowledge, this idea has not been approached in patristic writings. Fortunately, it would be inconceivable

at the time to argue that the use of the icons could affect our perception of the divine. On the other hand, it is easy for us to conceive how divine acts can elicit human action.

The art of prayer

In the centuries following the iconoclastic movement and the restoration of the icons, a difference in the style of icons can be observed. It is reasonable to assume that the religious painting was consciously and officially elevated as an art form, as its narrative and religious functions were widely proven through the wars of the icons. At the same time, its stylistic evolution has been interpreted as one of the first signs of the Renaissance. Some of the last Byzantine paintings, such as the mosaics and the frescoes in the Chora monastery in Constantinople from the early fourteenth century, although quite Byzantine in style, can be compared only to the works of Cavallini, Giotto and Duccio[112] inasmuch the change in the representation of space and the change in the features of the figures, which appear less stern, are concerned.

The so-called "new style of icons" is, technically speaking, characterized by two things: more refined presentation of the figures and more elaborate pictorial syntheses, something that constitutes a conceptual evolution from the simple representations of Christ and the saints as they were made during the previous centuries. In addition to these stylistic features, post-iconoclastic art seems to have an altogether more carefully defined role. Captions became a necessity; it was more important that the represented saint was identified correctly. Repetitions of an icon in the same church, something that was happening in the pre-iconoclastic era, do not occur any more. Instead, a system of syntagmatically consistent features, such as the degree of movement of the represented persons or the viewing angle, seems to be pointing to a hierarchy among the icons of a church. Particular saints assume a standard way of being represented, with certain features which identify them consistently in any context.

These changes reflect more than an evolution in the representational language of the time. The status of the icons had been firmly asserted and their power clearly defined after the iconoclastic crisis, therefore their function as objects of veneration became more specific. The great semiotic difference is that the weight had shifted from the icon as a material object of veneration to the icon as a way to pray and venerate God, Christ and the saints. It was made clear that veneration was due to them because of their representations, and not because of their inherent supernatural powers. The representation itself then became, in some cases, more elaborate in order to portray their theological content more clearly. This can be observed in representations of Christ, for instance,

which became more detailed and more expressive. Icons of Christ intended to demonstrate Christ's dual nature, his divinity and his humanity, and representations of his life and passion were meant to be accessible to the viewers who would direct their prayer to them. It was quite important that Christ's representations reflected events that were meant to be taken as unique and very specific, as opposed to representations of saints, which intended to demonstrate the generic circumstances of the saints' lives, with which the viewer could identify "from the inside", and contemplate the universality of the special persons who had divine παρρησία (proximity).[113] The nature of prayer was different in those two cases and the nature of the icons was reflecting exactly this. Therefore, whereas icons of Christ tended to become more complex, icons of saints became simpler. Icons depicting the miracles of St Nicholas, for instance, one of the more popular saints in Byzantium and Eastern Christianity, often omitted many of the persons directly associated with the miracle or the action in question, such as the three daughters of the pauper aided in secret by St Nicholas, who do not appear in any icon, although they are quite central in the account of the event.[114] In contrast, icons of Christ, such as the Crucifixion, or even more so the Lamentation (which, not being included in the canonical Gospels, makes up by providing more actors than required by the canonical story), often include a number of unnamed and unimportant characters.[115] Their only role in the icon is to intensify its dramatic quality. The viewers are expected to feel as if they were included in the icon, and identify with those unnamed characters who witness the Crucifixion or mourn over the body of Christ,[116] whereas in the case of the elliptical icons of the saints they are expected to address the saint directly, as the saints were intercessors to God. Again, this shows that although the content of each category of icons was quite different, the icon was based on its function as an aid to prayer.

It has been suggested[117] that this particular development in style was instigated by the increased influence of literature and hymnography on iconography. It is not easy to evaluate the significance of the integration of the narrative expression into iconography, because one could present equally valid and profound arguments on both sides, arguing in favour or against it. It can be argued that the introduction of what was based conceptually on the written word into the mirror of God and the domain of the unspeakable was a backward step, because it reduced the psychological significance of its predecessor, the "pure" icon, and, in a way, prepared the way for Renaissance art and the subsequent rationalization of art. On the other hand, the icon, or any other medium, can effectively assume the psychological weight of the mirror only so far as it also assumes its properties and reflects accurately and convincingly the world and the person(s) in it, otherwise the recognition of the self and the

Other through the mirror is not possible. It would then be reasonable to assume that the icon-as-mirror had to take a little more into account the rational part of the psyche as well, which was finding a renowned interest and expression in the East and the West. In that sense the new style of icons and the subsequent Eastern and Western humanism are justified as formal advancements in the development of sacred art. The question that arises is whether art in general, in its new capacity as a more precise mirror, still acted as the metaphysical mirror/door-to-the-other-world it had been.

At any rate, the new style of icons shows an evolution in the understanding of the icons. We should not be surprised by the affinity of the post-iconoclastic icon and the sermons or the hymns of the time, because after the iconoclastic debates iconography was recognized as an art that can be equally valid, effective and serving God as the art of words. This led naturally to the comparison and the interaction of the two genres, and iconography, eager sometimes to present itself as a sermon in colour, drew material from written sources.

The problem with this procedure was the challenge it was presenting to the function of the icon as the mirror of God, because two opposing elements appear simultaneously, although perhaps initially in a balanced way. Rationalization and a degree of illusionist or naturalist aspirations were counter-weighted by the stressed importance of prayer and the use of art for spiritual ends. It is true that in the late Middle Ages we can detect an increasing humanism, something reflected in the transition from anagogy and the theocentric universe to the heliocentric, anthropocentric universe of the Renaissance. Still, to describe the situation more accurately in the East, we would have to acknowledge the presence of the balancing trend: while interest in the classical legacy, the sciences and learning in general had never subsided since the days of the early Roman Empire in the East, the spiritual realm, or "heaven", was as immanent in the fourteenth century as it had been centuries earlier. We may see this, for instance in the theology of hesychasm, the major theological force in fourteenth-century Byzantium, which stressed the possibility of experiencing God and participating in him through his energies even in this lifetime.

Regardless of the reasons we may list to account for the change in the style of icons during the late Byzantine period, we have to acknowledge the underlying change in religious expression. After the exoneration of the icon through the iconoclastic wars and the doctrinal definition of its liturgical function, we see that the attention shifted from the mere presence of icons to the prayer they elicit. Everything in the new style of icons points at this change, and the hesychastic movement in late Byzantium and Russia gave a new *raison d'être* to the icon.

The hesychastic tradition is based on the continuous repetition of what is known as the *Jesus prayer* or *prayer of the heart*: Κύριε Ιησού Χριστέ, Υιέ Θεού, ελέησόν με (Lord Jesus Christ, Son of God, have mercy upon me). This short prayer was repeated to such a degree that it became internalized; hesychast monks could even feel themselves praying during sleep, something expressed in the phrase "καθεύδω και η καρδία μου αγρυπνεί" (I sleep but my heart is awake).[118] It is hard to say exactly when hesychasm started. Although certain allusions to the "remembrance" or "invocation" of the "Holy Name of Jesus" can be found in the correspondence of St Nilus of Ancyra[119] in the early fifth century, the first Father to assign a central role to the Jesus prayer was St Didachus of Photike in the fifth century.[120] The writings of St Didachus discuss prayer and contemplation of God, but also awareness of the intellect and the heart. This, as well as many older patristic sources, is consistent with the spirit of hesychasm, but perhaps what links St Didachus with hesychasm as a practice is his occasional use of the phrase "το Κύριε Ιησού" (the O Lord Jesus), which suggests that a prayer identified as the Lord Jesus prayer was fairly common by the fifth century.[121] Later references to the Jesus prayer and hesychasm can be found in several sources, but Nikephoros the Solitary in the thirteenth century was the first to describe the methods of hesychastic prayer in his treatise *On the Care of the Heart*,[122] which are strongly reminiscent of Indian meditation techniques.

Although the hesychastic tradition flourished for many years in Mount Athos (one could also note Gregory of Sinai in the thirteenth/fourteenth century who spoke of the *memory of God*,[123] an idea surprisingly close to the Platonic ανάμνησις, but in an inverted sense), it only developed into an apologetic theology with St Gregory Palamas in the fourteenth century, when its basic concept of the possibility of seeing and uniting with God was challenged by Barlaam, a Greek monk from Calabria, who represented the "humanist" views of the time[124] and the belief that God can only be known indirectly, through his works and through symbols. After a series of animated conflicts between Palamites and Barlaamites, the Orthodox Church finally officially adopted the hesychastic doctrines in the Councils of 1341, 1347 and 1351. Hesychasm subsequently spread to Romania, Eastern Europe and Russia. After the fall of the Byzantine Empire, it survived mainly in Russia, and exerted a great influence within Russian theology between the fifteenth and seventeenth centuries.

Several techniques are associated with hesychastic prayer. A certain way of breathing, a correct posture, an appropriate rhythm and an inward exploration are methods the hesychastic tradition has employed, but it would be wrong to identify the prayer with these methods. Gregory Palamas made it clear that the external methods are of secondary

importance, and could be of use to a beginner, but the real focus of the Jesus prayer is "the inner and secret Invocation of the Lord Jesus".[125]

There is something common to hesychasm and iconography. After the iconoclastic controversy it became clear that the icon could not be thought of as an object of worship (but as an object of veneration), although the grace of the υπόστασις it shares with the represented saint is extended to the material of the icon as well. Nevertheless, the religious use of icons, their *presence*, can only be put to use if they help the communion of the believer with Christ or the saints. Icons, relics and prayers would be useless if they do not correspond to the movement of the heart and the soul. The theological content of the veneration of icons and hesychasm is similar in this way. The icon and the Jesus prayer can be compared to a Buddhist mandala or mantra (there is some literature comparing the Jesus prayer with techniques from Yoga and Sufism[126]), in that in both cases the artefact or the technique is an aid the believers use in order to enhance their contemplation of the divine, in a very conscious and directed way. Hesychasm can be seen as the art of contemplation, an art very similar to iconography. Instead of colours and figures, it uses certain techniques, which lead to something much deeper. Contemplation of God in the hesychastic tradition is similar in many ways, especially from a psychological point of view, to the contemplation of the iconographic *Other*, although there are certain differences between them, which will be discussed later.

The inner technique of the Jesus prayer can be described in three interpenetrating rather than successive stages: prayer of the lips (oral prayer), prayer of the intellect (mental prayer), and prayer of the heart (or of the intellect in the heart).[127] This describes an inward journey that begins with a mechanical repetition, but ends in something that transcends the mind. The word "heart" here is not to be confused with the exclusively emotional content given to it in contemporary culture. As Bishop Kallistos Ware points out:

> 'Heart' in this context is to be understood in the Semitic and biblical rather than the modern Western sense, as signifying not just the emotions and affections but the totality of the human person. The heart is the primary organ of our identity, it is our innermost being, 'the very deepest and truest self, not attained except through sacrifice, through death'.[128] According to Boris Vysheslavtsev, it is 'the center not only of consciousness but of the unconscious, not only of the soul but of the spirit, not only of the spirit but of the body, not only of the comprehensible but of the incomprehensible; in one word, it is the absolute center'.[129] Interpreted in this way, the heart is far more than a material organ in the body; the physical heart is an outward symbol of the boundless spiritual potentialities of the human creature, made in the image of God, called to attain his likeness.[130]

The goal of the hesychast monk is union with God, deification, something that is based on writings of a number of Eastern Fathers such as Gregory of Nyssa and Maximus the Confessor. The end of the journey is the participation in the divine energies, sometimes evident in the uncreated light the hesychast is graced to see. The goal of the journey is the realization of the "likeness of God", and it can be achieved through a difficult integration of the mind and the heart:

> To accomplish the journey inwards and to attain true prayer, it is required of us to enter into this 'absolute centre', that is, to descend from the intellect into the heart. More exactly, we are called to descend not from but *with* the intellect. The aim is not just 'prayer of the heart' but 'prayer of the intellect in the heart', for our varied forms of understanding, including our reason, are a gift from God and are to be used in his service, not rejected. This 'union of the intellect with the heart' signifies the reintegration of our fallen and fragmented nature, our restoration to original wholeness. Prayer of the heart is a return to Paradise, a reversal of the Fall, a recovery of the *status ante peccatum*. This means that it is an eschatological reality, a pledge and anticipation of the Age to come – something which, in this present age, is never fully and entirely realized.[131]

The "intellect in the heart" is one of the closest things we may think to refer to an all-encompassing convergence of opposites and psychological completeness, a *coincidentia oppositorum*. The psychological trajectory towards union with God is comparable to the contemplation of the icon: in both cases we are talking about a *presence*, the presence of God either by the invocation of his Name, or by the representation of his human form. To find one's "centre" through the movement of the intellect in the heart is to find, or rather to re-awaken, the image of God within man. It is no surprise, then, that Ouspensky claims that the Russian and Byzantine iconography after the fourteenth century reflects and is engendered by the theology of hesychasm.[132]

Having analysed two different kinds of religious art, we come to wonder about the two modes, the icon as a mirror and the icon as an aid to prayer and how they work. We have to remember that the first style of painting found its interpretation in the psychological stage of the child's identification in the mirror, which takes place from around the sixth to around the eighteenth month. There is a great difference between the mirror and the icon, however: the child sees his own image in the mirror, and it is through this image that he can identify the correspondence between iconic reality and the objects around him. Through the mirror he realizes that he is also an object to be seen, and that others see him in the way he sees his own image in the mirror. Yet in the icon his own image is missing. The adult who gazes at the icon has passed through the mirror stage and can grasp the symbolic meaning of representation. On the other hand, an infant of that early age would certainly not be able to

understand what an icon is, let alone comprehend its deeper religious meaning. Iconography is then, by definition, already at the symbolic stage. The viewer knows already who the depicted persons are and what their importance for religion is. What can we say has replaced the image of the self in the mirror? With what can the viewer identify?

The self cannot be perceived on the surface of the icon; it is only the *other* that is being perceived. The viewers have withdrawn into a perceptually privileged space where he is not perceived but all perceiving. When we look at an icon we employ a dual kind of perception: on the one hand we know that we are perceiving something which is not really there (Christ or St Nicholas), and this is why we can look at the terrible images of the Passion and the Crucifixion and not let them disturb us as they would if we physically witnessed them, but we can use this distance in order to contemplate their religious significance instead. On the other hand we know that we are the subject of the looking act; we know it is the *I* that perceives the images. We know that we are actually contemplating an icon, that there are some external stimuli there, such as the shapes and the colours chosen by the iconographer. This dual knowledge enables the viewer to construct a perceptual field that includes both the icon and himself in their respective roles, and finally identifies with himself as the *perceiving self*.[133] As this identification takes place, the viewer implicitly realizes that he has entered the discourse of the icon at the expense of perceiving it "objectively" from without. The engagement with and acceptance of the symbolic presence of the depicted person ultimately instigates the absence of the viewer, or rather his absorption into the realm of the signified.

The icon is a reminder, or a manifestation, in symbolic/psychological terms, of the continual presence of Christ and the Holy Spirit in this world. Although the Incarnation occurred only once, its echo is still resounding within the religious soul in the same way its icons are there to allow us to enter that event again and again. This is not inconsistent with the social dimension of religious practice: every year we celebrate the birth of Christ, the divine Passion and the Resurrection, that is we observe *circular* religious time, without losing track of the *linear* ascent towards God. This, however, is the very difference between the two modes of religious artistic expression. The icon-as-mirror is a continuous statement of the proximity of the invisible world, and at the same time a reminder of our creation in the image and likeness of the Creator, a reminder of our relative position to Christ and the divine.

The second mode of iconography focuses on the transition of the viewer to the world of the invisible. We could argue that the icon assumes a somehow social function, which is expressed by the iconography of the church. The prayer icon, on the other hand, commences where the

social function ends, with the withdrawal of the self and its absorption into the numinous world. In this case we have a transcendence of the icon as symbol, a kind of withdrawal of art in favour of the signified, which renders the signifier obsolete. As long as an icon is a prayer and meditation aide, we cannot forget that it is only secondary to the ascending course of the soul.

In this section we examined some semiotic issues in iconography, with special references to the inverted perspective. The idea of the icon as a mirror that implies the presence of the divine, emerged in a psychological extension of the semiotic discussion of iconography and the inverted perspective. Several central theological issues, such as the image of God within man, are closely connected to iconography and the religious/psychological premise of the icon as the mirror of the divine. As a device that facilitates the connection of humanity and God, the icon has been also compared to the art of prayer and the hesychastic tradition.

It is fair to say that iconography reflects the theology of the Eastern Orthodox Church on a very profound level. It is probably the sacred art that fulfils its religious task in the best possible way, at least within the Christian tradition. Yet, from a religious perspective, we can note that the art of prayer, regardless of whether it is practised through iconography or not, fulfils the religious and psychological role of sacred art better than the art of icon-as-mirror, although this does not mean that these two kinds of art have to be mutually exclusive. This simply indicates that iconography is an art that prepares one for the contemplation of the divine, and if there was to be an evolutionary step beyond it, from a religious point of view, it would involve an even greater contemplation of the divine, a tighter unity of art and the sacred, something consistent with Maguire's views on the new style of icons and the enhanced role of prayer it implies.

Unfortunately, what transpired in the West was exactly the opposite. The de-sacralization of art and life brought about several problems that will be addressed in the following chapters. We will need to remember Belting's assertion of the loss of the sacred character of art, and the emergence of art in its modern form, after the Reformation. It is very likely, however, that the point of departure can be pinpointed much earlier than the Reformation.

"Mirrors" and Aesthetics in the Western Middle Ages

The West followed a distinctly different religious and cultural development from the East after some time in the eleventh century, although

differences can be observed as early as the fourth century. The year of the Great Schism (1054) between the Orthodox and the Roman Catholic Church is something of a conventional, somewhat arbitrary, landmark for this divide, even if it is difficult to say when the actual separation took place. The thirteenth century provided many chances for cultural interactions, but it also delivered a quite powerful blow to the psychological unity of East and West, with the disgrace of the fourth crusade and the occupation of Constantinople by the crusaders in 1204. Furthermore, we have to keep in mind that several European kingdoms, which influenced greatly the future of Western Europe, were increasing in power; these had never really been in close cultural contact with the Byzantine East, at least not to a degree that would allow us to say that they had any common religious, cultural or psychological heritage. At any rate, the West had always been indifferent to, or even somehow mystified by, the worship of icons in the East. The iconoclastic war was exclusively an affair of the East, although it is true that certain popes like Hadrian took a stance against iconoclasm; there does not seem to be any evidence, however, to suggest that the people in the West shared the sensitivities of the iconoclasts or the defenders of icons. Furthermore, and this is even more pertinent to the present analysis, Western mysticism did not develop something comparable to the hesychast movement. Some interesting differences between Eastern and Western thought can be described as the difference between the hesychast East and the rational West (although this is hardly an accurate generalization). Yet several writers have characterized the famous conflict between Barlaam of Calabria and Gregory Palamas as a difference between the spirit of the West, which, between Aquinas and Ockham, was abandoning the hope for a unity between Heaven and Earth, and the East, the spiritual elite of which was focusing on experiencing this very unity.[134] We can then say, with a great degree of certainty, that the kind of art which found its spiritual justification in prayer had no counterpart in the West. An opposition between devotion and art can be found in teachings like those of Bernard of Clairvaux. The tension between Cluniac and Cistercian monasticism has often been portrayed in terms reminiscent of the tension between the defenders of icons and the iconoclasts, as the following passage from a study on twelfth-century architecture demonstrates:

> The more the Cistercians, under the lead of St Bernard affected to despise the plastic arts, the more refinement did the Clunisians put into their constructions, their furniture and vestments; the dispute grew warm, and the Clunisians, like all men who arrive at a high degree of civilization in the midst of a rude state of society, saw in their rivals the merest barbarians, and fought against their extreme Puritanism by filling the popular mind with the love of art as far as it was practicable.[135]

A full analysis of the analogy between iconoclasm and the Cistercians would be an interesting task, but not really within the scope of the present study. Certainly the iconoclastic puritanism of Bernard of Clairvaux was not as extreme as the iconoclasm of the emperor Constantine V, but one may suspect that some of the sensitivities behind the official arguments were similar. A thorough analysis on St Bernard's theory of art[136] argues that the Cistercian view was, in principle, as much fond of art as the Cluniac view, but, echoing Augustine's writings on art, it made it a point not to tolerate deviation from what was supposed to be the true task of sacred art. Not as extreme not to tolerate any artistic innovation at all, since St Bernard himself was the composer of a "new" *Office of St Victor*,[137] the Cistercian view held that the aesthetic should be subjected to the devotional.[138] The similarity with iconoclasm ends here, because there is no evidence of the iconoclasts reacting against something like the "secularized" character of icons. Quite the opposite; it seems that they rather wanted to prevent images from attempting to depict the supernatural. As far as the transcendental character of art is concerned, it would be more likely for a defender of icons in the Byzantine sense to sympathize with the Cistercian rather than the Cluniac view. The former did not exclude art altogether, but made provisions for the kind of art whose character was truly devotional, whereas the latter anticipated the secularization of the icon.

The pursuit of a philosophical or psychological continuity behind the major doctrinal disputes of the Church would be a major undertaking worthy of many years of study and many volumes of writing. Jung occasionally touched upon such a venture, for example in his seminal work *Psychological Types*, where he delineated the problem of psychological types in the history of Classical and Medieval thought.[139] In this work, he sees the ancient opposition between the Ebionites and the Docetists as the precursor of the conceptual opposition between the Arians and the Monophysites, then the disagreement between Eriugena and Radbertus on the issue of transubstantiation during the Eucharist (although Jung was mistaken on this one: writings on the Eucharist believed to be written by Eriugena, as it turned out, were not written by him), and finally the contrast between nominalism and realism. One could feel tempted to connect this line of analytical thought to the iconoclastic war and its probable transplantation in the West of the twelfth and the sixteenth centuries. The issues at hand, however, are rather complicated for a straight comparison between East and West, to begin with. Moreover, the psychological and philosophical luggage of art has a quite focused nature, which is perhaps not explored in the best possible way with an approach as broad as the examination of the psychological types. It would be more sound, methodologically speaking, to seek a departure point common to the

artistic/religious understanding of East and West, and follow the separating branches of thought. Certainly, by the twelfth century there appears to be a gap between the role of art as it was understood in the Cistercian or Cluniac West, and Byzantium, yet we have to assume that there is a common psychological inheritance between them. Therefore, we have to look for a common course at some point long before that stage. Not having any serious indications that the West had developed a separate understanding of religious art before the iconoclastic wars, we can assume that it shared the stage of the icon-as-mirror with the East.

A work that will prove to be very helpful in the study of the representational art of the western Middle Ages in the current analysis is the *Mirrors* by Vincent of Beauvais, the great encyclopedist of the thirteenth century. The work is divided into four parts, studying four kinds of "mirrors" that can be used metaphorically to order the knowledge and the artistic understanding of the time: the *Mirror of Nature*, the *Mirror of Knowledge*, the *Mirror of Morality*, and the *Mirror of History*.[140] The *Mirrors* reflect principles of representation, which have to do mainly with the decoration of the Western European cathedrals of the late Middle Ages.

The *Mirror of Nature* reflects the created order of the world, organized according to the six days of creation. Natural elements, minerals, plants and animals are enumerated and described one after the other. The human being, as the work of the sixth day, is placed at the top of the order. The entire natural world is seen as reflecting the thought of God, and is charged with multiple layers of meaning that can reveal God's thought to us. Contemplation of the created order can lead to contemplation of the invisible world and God himself. Nature is seen as one of God's ways to teach us. A symbolic meaning is found even in animals or plants. Hugh of Saint-Victor saw the dove as a symbol of the Church:

> The dove has two wings, just as, for the Christian, there are two sorts of life, the active and the contemplative. The blue feathers of the wings signify thoughts of heaven. The wavering nuances of the rest of the body, colours as changeful as an agitated sea, symbolize the ocean of human passions on which the Church makes its way. And why does the dove have eyes of such beautiful yellow gold? Because yellow, colour of ripe fruits, is the colour of experience and maturity. The yellow eyes of the dove symbolize the look, full of wisdom, with which the Church considers the future. Finally, the dove has red feet, for the Church advances through the world her feet deep in the blood of martyrs.[141]

This symbolist tendency, however, was only up to a point charged with theological meaning. Medieval artists gradually, but as early as at least the twelfth century, as noted by Viollet-le-Duc in his *Dictionary of French Architecture*,[142] took the liberty of representing flowering buds, then flowers, branches, rose stalks and vine shoots, with no particular concern for a symbolic underlying meaning. This decorative trend made no effort to

interpret the mystery of the Fall and the Redemption, in contrast with the austere and always intentionally symbolic use of flowers in early medieval art. Flowers and images of the spring in icons of the Annunciation, for instance, are juxtaposed with the Virgin in order to express the idea that she is the life-giving source (ζωοδόχος πηγή),[143] but in the case of the (mostly) Gothic stone flora the artists took a decorative rather than symbolic interest. This is quite important, because here we can observe one of the early cases where secular art acquires an existence independent from theological meaning, anticipating the emergence of the art object on its own.

The *Mirror of Knowledge* is based on the idea that humanity can work towards redemption through knowledge and the seven liberal arts, which correspond to the seven gifts, granted by the Holy Spirit. According to Vincent of Beauvais, the work of humanity's redemption starts with manual labour and the acquisition of knowledge.[144] Manual labour mostly means agriculture. Its representation was usually arranged in representations that followed the yearly cycle of agricultural work, and we therefore see representations of June as the month of mowing, July as the month of harvest, and so on. Of course, diverse regions followed different patterns in their representations, according to their climate, and thus February, for instance, is a cold winter month when nothing much happens in northern France, whereas in Italy the peasants already prune their vineyards.[145]

The representation of knowledge included, except the seven liberal arts, the representation of Philosophy. At the cathedral of Laon the representation of Philosophy is inspired by its description by Boethius in the *Consolation of Philosophy*:

> The features of her face inspired the deepest respect. There was light in her glance, and one felt that it pierced deeper than any mortal gaze. She had the colouring of vigor and youth, though one was well aware that she was full of days and her age could not be measured as ours is. As for her height, one could form no very clear idea of it, for sometimes she reduced her stature to human proportions, sometimes her head seemed to touch the sky, and sometimes it seemed to pierce beyond the sky and disappear from the curious gaze of men. Her garments were woven with great art, of delicate and incorruptible threads; she told me later that she had woven them with her own hands. But time, which dulls all works of art, had dimmed their luster and obscured their beauty. On the lower fringe of her gown was woven the Greek letter π, and on the upper border the letter θ. To go from the one to the other there was a series of steps resembling a ladder, leading from the inferior to the superior elements. One could see that the garments had been rent violently by hands which had torn away all they could. In her right hand she carried books, and in her left hand a scepter.[146]

Indeed, the statue of Philosophy at Laon follows this description strictly, except for the Greek letters, which are said to represent the practical (π)

and the theoretical (θ) aspects of Philosophy.[147] It is important to observe that this representation contrasts with the criticism of philosophy as the "outward" or pagan wisdom for Byzantine theologians from St Basil in the fourth century to St Gregory Palamas in the fourteenth. This is an indication of how widespread this difference between Eastern and Western thought had become by the late Middle Ages. We only have to remember that the series of confrontations between St Gregory Palamas and Barlaam of Calabria, one of the central issues of which was exactly the contrast between inward and outward wisdom, took place in the fourteenth century. Knowledge and philosophy are, in a sense, the continuation of the apotheosis of the mind as the *anima rationalis*. By that time the interpretation that was given to the supremacy of the mind was quite evident.

The *Mirror of Morality* does not differ much from the *Mirror of Knowledge*, insofar as they both comment on the human effort towards perfection. The former, however, focuses on the specific knowledge of Virtues and Vices according to their anthropomorphic description in the *Psychomachia* of Prudentius[148] and, in that sense, it is much closer to the "inward wisdom". We can detect an important change since the *Psychomachia*, however. The Virtues are still represented anthropomorphically, as seated women, but the Vices do not enjoy the same status, and are represented through the depiction of human actions. Discord, for instance, is represented by a man beating his wife, and Inconstancy is represented by a monk leaving his monastery. The placement of good and evil within the domain of human action is an important psychological step, as it illustrates a more responsible approach to morality. Perhaps echoing the patristic aphorism "everything good comes from God [from outside] and everything evil comes from man [from inside]", the Vices in the *Mirror of Morality* are treated in a more mature way, being identified with human passions and not represented as independent demons who prey on the innocent; but the Virtues are still represented as external agents, almost beyond human control. This one-sided representation projects a rather negative view of the concept of morality. According to it, one needs to subdue the negative side of the self and conquer one's passions, but there does not seem to be an analogous positive side to the moral work that would somehow balance the account; the battle against evil and the Vices is what one *does* actively, whereas Virtue seems to merely *happen* to one. This is a break from the earlier ascetic tradition where the negation of evil and the progression into good assumed equal importance. John of Damascus, on the other hand, wrote in the eighth century on the Virtues and the Vices, and presented them both as conditions of the soul, which one has to actively avoid or actively pursue.

Examining these issues in relation to the *Mirror of Morality*, it is hard not to see the connection to the troubled doctrine of *privatio boni* and its connection to the privileged position of reason. Since evil does not have an existence separate from the good and is its mere absence, it is rational to assume that to subdue what is evil means to walk towards the good. The problem with this assumption is that although evil does not have a real existence in the metaphysical world (something like this would not only cast a considerable doubt on monotheism, it would also suggest that man has to fight – in vain – against an adversary much more powerful than him), it does in the psychological world. This seems to be Jung's main objection to the doctrine of *privatio boni*: it is not corroborated by the experience of the psychoanalyst, quite the contrary. Jung seems eager to accept the metaphysical truth of the *privatio boni* in works like Aion, but in his capacity as a psychoanalyst he states that "psychological experience shows that whatever we call *good* is balanced by an equally substantial *bad* or *evil*".[149] What we see in the *Mirror of Morality* is perhaps an earlier stage of the discrepancy between metaphysical and psychological truth on the nature of evil. As I argued earlier, the problem was not in the doctrine itself, but in its connection to reason as the only *locus* of the image of God in the human nature. Reason alone cannot assist us in the exploration of the numinous, but observation of the kind of rational arguments articulated in the late Middle Ages suggests that what was taking place was not the emergence of the pure rational mind, but an orientation towards it, of rather psychological content. Arguments such as Anselm's ontological proof for the existence of God[150] may not have much value as rational structures, but they are quite indicative of a trend to incorporate reason into faith. Such an attempt must have seemed quite alluring at the time, because it could promise the final victory of good over evil. If there is no doubt whatsoever for the existence of God, if his existence can be proven in the objective, scientific terms of a rational argument, man would easily subdue his irrational self. In that sense, reason as it was conceived and given to the religious tradition by Origen and Augustine would succeed in transforming man into the true image of God. The problem is that it is, and was, debatable whether reason alone can contribute towards knowledge of God. Of course theologians such as Thomas Aquinas have generally supported the power of the rational mind, arguing that it is possible to prove the existence of God by reason, whereas others, such as William of Ockham, insisted that logic alone cannot prove it. Now it would be a massive task to review the theological literature on this issue, but at least from a psychological point of view we can see a connection between the writings of Origen and Augustine, and the subsequent importance given to reason, which is too complex to be explained as a kind of theological or philosophical continuity alone. Yet,

since the issues of *imago Dei* and *privatio boni* were translated into a practice that went beyond official doctrine, and contributed to the psychological development of Western culture, logic surfaced again in the late Middle Ages after the re-discovery of Aristotle, as the highest, holiest part of the self, for reasons that cannot be explained on the basis of theological argument alone. In a kind of dramatic irony, I think that the motives behind the domination of reason in the time after the Middle Ages are more of psychological rather than of rational nature.

The last *Mirror* to be examined by Vincent of Beauvais is the *Mirror of History*. It follows naturally after the more general view of the world, and it presents the history of humanity, sometimes choosing virtue and sometimes choosing vice. History of the world means, for Vincent of Beauvais, the history of the Church, which includes the Old and the New Testament, as well as the history of humanity since the Incarnation. Pagan history exists only marginally, to the extent that it can be somehow connected to the history of the Church.

The *Mirror of History* interprets the Old Testament more or less through the New Testament, as its prefiguration, and places a lot of importance in allegory. In the words of Émile Mâle:

> that which the Gospel shows men in the light of sun, the Old Testament showed them in the uncertain light of the moon and stars. In the Old Testament truth is veiled, but the death of Christ rent that mystic veil and that is why we are told in the Gospel that the veil of the Temple was rent in twain at the time of the Crucifixion. Thus it is only in relation to the New Testament that the Old Testament has significance.[151]

The image of the veiled truth of the Old Testament is as old as Origen and Augustine's *City of God*. We see no deviation from the medieval view in principle as far as the importance of the Old Testament is understood exclusively through the Gospels. The way this prefiguration was expressed, however, reveals a split which, although by no means a product of the late Middle Ages, is quite evidently manifested here, as early as the third century. There is a difference of opinion as to how is supernatural biblical imagery to be interpreted. Origen was probably the first writer who supported a metaphorical or "allegorical" interpretation of the Creation, whereas St Basil in Εξαήμερον maintained that the book of Genesis has to be understood literally. Origen, characteristically, asked the rhetorical question "who is stupid enough to believe that God like a gardener made plantations in Eden, and really placed there a tree named the tree of life which could be seen by the bodily eye?"[152] This view was taken up by writers such as Hilary, Ambrose, Augustine, and Gregory the Great, and it is fully manifested in the "pure" Western art of the thirteenth century, although Roman Catholicism eventually decided against it at the

Council of Trent.[153] At this point we can witness the flourish of the alle-
gorical, especially in conjunction with a more realistic view of the life on
earth as it was described in the agricultural life of the *Mirror of Knowledge*.

It is interesting that the *Mirror of History* includes a large portion of
apocryphal writings, mostly the ones that relate to the New Testament.
The *Gospel of Nicodemus*, for instance, has been used extensively in the
East and the West as a source of inspiration for the events surrounding the
divine Passion and the Resurrection, and certainly for the Byzantine im-
age of the Resurrection. Gothic art showed, on the other hand, a prefer-
ence for the *Gospel of Pseudo-Matthew* and the details pertaining to the
Nativity.[154] The Adoration of the Magi, described in later sources such as
the *Golden Legend* of Jacobus de Voragine[155] also became a favourite
theme of the West, perhaps reflecting the submission of temporal to
ecclesiastical authority, although it would be foolhardy to conjecture a
simplistic interpretation of what is actually a rather complex issue. In the
Golden Legend it is related that the Magi were also kings, and thus the
image of their Adoration assumed a different meaning. The difference of
opinion as to the theological pre-eminence of the Nativity or the Resur-
rection in the East and the West, however, has been alluded to in other
parts of this study, but putting the theological arguments aside for the
moment, we may observe that the taste of iconography was drawn to-
wards the depiction of the visually impossible, the representation of the
victory of Christ over Hades, whereas later art attempted to expand on
the images that resonated with a kind of familiarity with the everyday
human experience. We may remember at this point that the contrast
between the Jewish and the Greek concept of religiosity was expressed
earlier in this chapter by the view that the centre of religious conscious-
ness was *there* for the Jews and *here* for the Greeks. The same kind of
contrast may be observed in a comparison between the Middle Ages and
the Renaissance which was based, after all, on the rediscovery of the
Greek tradition.

Having considered the four *Mirrors* of Vincent of Beauvais, we can
wonder about the psychological line that started with the icon as the
mirror of God, and concluded with the cathedral art as a detailed mirror
of nature, knowledge, morality, and history. What are the differences or
the similarities between the two cases?

A fundamental difference is that iconography attempts to reflect what
is beyond the visible world, to somehow imply the uncircumscribable
through its relation to the circumscribable. Western cathedral art, on the
other hand, seems to be quite focused on everything but the world of the
invisible. The four *Mirrors* reflect the visible world, perhaps stressing how
much it was shaped by God and his actions, but the focus lies undoubt-
edly on the earth and not in the world of the invisible. What we find in

the art of the Gothic cathedrals is an expansion on biblical stories in a way that aligned them with the popular understanding of the universe. What could be seen and experienced in this world was, especially after the controversy surrounding the thought of William of Ockham and its contrast to the thought of Thomas Aquinas, the only possible testimony of God we may have in this life, whereas the East allowed for the possibility of a more direct connection with the divine. It is not important that deification and the contemplation of the uncreated light could be achieved by only a small number of hard-praying monks. The mere possibility of such divine grace was enough to suggest a model of the universe where the visible and the invisible exist side by side. Maybe God could not be viewed directly, but, as another Medusa, he could at least be viewed indirectly, through a mirror. The mirror of the soul could be turned directly towards God, and this is exactly what the icon tried to accomplish. A mirror, however, always reflects what is in front of it. The mirror of the West initially reflected the world as it appeared from the outside, but later the reflection was extended to the internal, psychological world.

It is obvious that the *Mirrors* demonstrate what is known as the anagogic view of the world. Nature, Knowledge, Morality and History are all interpreted through the presence of God, and this is characteristic of the Middle Ages. We examined the four *Mirrors* in some detail here, because they illustrate an important moment in the development of religious ideas. The universe was still very much theocentric, but art had started to posit some rules and demands of its own, something rather different from Byzantine iconography, even the iconography of the so-called Renaissance of the Paleologians. To make the connection with the psychological significance of the icon as mirror of the soul, behind which the divine Other was seeing the viewer as much as the viewer was seeing the icon, we see that in late medieval art, the art described by Vincent of Beauvais, in the *Mirrors* of Nature, Knowledge, Morality and History, does not have the same psychological-religious content. Nothing that can be described in religious terms exists behind the mirror. The Other behind the mirror of art was reduced to its psychological dimension, and it continued to exist in this dimension until now. Anagogy, in science and in art, was a device used by the people to better understand the world as a creation of God, but it was a mirror turned towards the visible, tangible world only.

An iconographer once told me that the study of old icons shows that Byzantine iconographers sometimes used more colours than the ones the eye can distinguish – but always with an austere style, never resulting in explicitly multi-coloured fancy paintings. Although I was not able to verify this piece of information, I have to say that it sounds plausible on the grounds that the colours used by Byzantine iconographers, as well as the particular mixes between them, often had a deeper religious meaning

that corresponded not only to the colours, but sometimes also to the materials.[156] Perhaps not even the iconographers themselves could tell the difference, but this intriguing piece of information describes very effectively the essence of iconography, regardless of whether it is true or not: icons were not made to be admired by human eyes for their art, as much as they were made to correspond to the invisible, supernatural world, which they never attempted to represent in a naturalist manner. There is a huge artistic gap between this kind of art and the art of Western medieval cathedrals, and unfortunately most histories of Western art start with the latter understanding of art, ignoring the art of icons, or dismissing it naively as "symbolic", as if iconography has no place in Western art tradition, although it is widely known that it was by no means the art of the East only. The examination of the *Mirrors* shows that a huge change in the understanding of art took place in the late Middle Ages. Artistic anagogy here, in contrast to iconography which is the art of divine presence, shows that there is a distinction between what thought or art can conceive and describe, and what really exists outside representation (God). Anagogy implies the existence of God, and it can create meanings taking images from the earthly world only. Even when biblical or supernatural characters are portrayed, their features are as naturalistic as in the representation of any human being, perhaps with the exception of the representation of mythological monsters like gargoyles and griffins. The shift from the representation of the unseen and the metaphysical dimensions of the icon to the representation of life on earth signifies a replacement of the ancient opposition between Good and Evil by the opposition between Heaven and Earth. These four constitute a *Quarternio* that describes the entire Cosmos.

Conclusion

The two previous sections have dealt with art in the medieval East and West, respectively. A general comparison between the two would be impossible here, because the historical, ethnographical and sociological differences in the development of East and West are too many to allow us to perform such a task. On the other hand, Eastern art has been often interpreted and criticized from a Western point of view, because the history and philosophy of art as we know it has been based on the scientific spirit of the Renaissance and the Enlightenment. For the purposes of this study, however, we have adopted a religious perspective which has been consistent with the concept of art as it emerged from the metaphysics of the Jews and the art of the Greeks, and as it evolved into the

kind of sacred art that has been best represented by iconography. Contemporary art, or rather a strand of sacred art that has survived, mostly within religious music, will also be discussed later. In the following chapters we shall discuss some of the problems of post-medieval Western art from a religious perspective.

The metaphor of the mirror and its psychological extensions has been used extensively for the interpretation of Eastern and Western art here, providing a common level of reference for both cultures, a yardstick as it were, to measure the position of each kind of art *vis-à-vis* the inherited dichotomy between the Jewish and the Greek mode of art. In Byzantium and Russia we saw that the main representative of religious art was the icon as a mirror of the soul and a window to the metaphysical realm. Even when the East faced the Renaissance paradigm shift, in the so-called Renaissance of the Paleologians but also in the numerous iconographic crises of Renaissance Russia, it tried to maintain the link between religious art on the one hand, and metaphysical inspiration and mystical theology on the other. It is noteworthy that Renaissance in the East coincided with the rise of hesychasm. Despite the various changes in the iconographic style of the time, or maybe because of them, the function of the icon as an aid to prayer and contemplation was maintained and strengthened.

Moreover, it is important to note that iconography of this period did not attempt to employ the kind of visual illusion that became popular and almost synonymous with Renaissance art in the West and its emancipation from sacred models. There are great differences between the art of Cimabue or Giotto and Byzantine art from the Renaissance of the Paleologians. One has to keep in mind that, in spite of any "humanist" tendencies that can be detected in late Byzantium, the theological concerns of the fourteenth century (the hesychastic controversy) focused on the relation of humankind and God, and culminated in the doctrine of deification. Leonid Ouspensky argues that Eastern Renaissance gave more weight to hesychasm and the search for the "wisdom within" rather than to humanism and the "external wisdom", in an entire comparative chapter ("Hesychasm and Humanism: The Paleologan Renaissance") of his *Theology of the Icon*.[157] Furthermore, in this context, hesychasm and introspective theology proved to be the element that more than others illustrated the artistic and theological character of Russia in the sixteenth century. The next chapter in Ouspensky's *Theology of the Icon* ("Hesychasm and the Flowering of Russian Art"[158]) examines the debt of Renaissance Russian iconography to hesychasm. Perhaps exaggerating a bit, Ouspensky claims that all the leading iconographers of that time were hesychasts themselves, or somehow associated with the hesychast movement.[159] Even if his claim is not historically accurate, it definitely reflects the im-

portance of the issue of unity between the spiritual and the material. Iconography in East and West alike reflected this by representing the humanity of Christ as an indication of the potential proximity of man and God and, in that sense, the more "naturalist" an icon was, the heavier the metaphysical message it contained. At the same time, no concession was to be made to the representation of Christ's divinity. This premise was not developed in the same way in the East and the West, though. The human nature of Christ became a central theme of Western Renaissance painting, but the Renaissance and the late Byzantine concepts of the representation of Christ's humanity were diametrically opposed. Despite the technical developments of the Paleologian Renaissance, the metaphysical character of iconography and the practice of addressing God through the icon were still essential to what icons were about. The iconographers of the late Byzantine period were able to maintain a conceptual balance between a convincing representation of the visible and of the imaginary – reminiscent of the Greek popular and demotic literature, where horses and birds speak, the dead come back to visit the living, and the hero of the tale often has to find his way back from the underworld. A moderate naturalism as well as belief in the supernatural, nurtured by the hesychastic tradition, can be observed:

> The last Byzantines – in contrast to the Italians – made room for the natural, but without developing a naturalism; made use of depth without imprisoning it in the laws of perspective; and explored the human without isolating it from the divine.[160]

The *Mirrors* of Vincent of Beauvais, on the other hand, show a quite different treatment of the mirror theme. The Western mirror is opaque, compared to the mirror of the icon. The semiotic point of convergence for the iconic figures is the "Eye of God", which corresponds psychologically to a real presence of the divine, to the psychological *Other*, whereas there is no counterpart for the "Eye of God" or any other kind of divine presence in the Western painting. It is true that the art of the large medieval Cathedrals illustrates an anagogic understanding of the world, because everything it represents receives its meaning only through reference to God, but this kind of reference seems weak compared to the presence of God implied by icons. Along with theistic epistemic anagogy, which seems to fulfil a rational need (because the connection to God is used to *make meaning* out of the world), through an observation of a more psychological nature we can detect a growing chasm between Heaven and Earth. The images described in the *Mirrors* of Vincent of Beauvais show an increasing physical resemblance to the objects they represent: anagogy may still be the dominant epistemic order, but the shift towards analogy and the gradual shift from a theistic universe to an anthropocentric one are already evident.

This view is corroborated by Mircea Eliade's observation that Romanesque art combined images from "two opposing universes",[161] good and evil. Hideous, deformed monsters and demonic beings that provoked the reaction of St Bernard who wondered "What do these ridiculous monsters signify in our cloisters, these horrible beauties and these beautiful horrors?"[162] were brought to the same syntagmatic level as images of Christ, the saints and the Virgin. What we can see here is the weakening of a dividing line that separated good and evil in Heaven and Earth alike, and its replacement by another dividing line, separating the beings of the visible world from the beings of the invisible world. The acknowledgement of the latter separation reflects a society that, although it was not atheistic, was seeing a greater distance between the material and the metaphysical world, and was thus becoming increasingly secular. Subsequently, within this framework it would be meaningless for religious art to maintain its significance as a sign of the presence of God and the unity of the physical and the metaphysical. Art, originating in the material realm, could only become more secular.

From a religious perspective, this secularization of the work of art can be interpreted as a loss of the essentially spiritual nature and function of art. Our discussion of the icon showed that the thematic of art is only one of the many factors that contribute in its religious work. The psychological understanding of religious symbols may, ultimately, play a more important role in the work of religious art. An important difference between Medieval and Renaissance aesthetics, as far as the relationship of art and religion is concerned, is that whereas art in Byzantium seems to be engendered and motivated by religion and by a personal connection of the self with the divine, Renaissance art can sometimes be described as only superficially religious, even when its thematic is religious. Renaissance saw the withdrawal of spirituality in favour of the independence of the artwork, and this affected profoundly the structure and the essence of art proper. Secular art was, more or less, at the fringes of the artistic vanguard in the Middle Ages, but the roles of religious and secular art were reversed in the Renaissance and it is the religious element that passes to the fringes of an art which was from then on led by secular concerns.

It is interesting to note that the work of art in the East, or perhaps in the common tradition of East and West, had a direct relationship to the doctrines and the ideas surrounding the issues of the image of God within humankind. The West, following a line that extends at least as back as Augustine and the importance he gave to the *anima rationalis*, developed scholasticism more or less at the same time the East was elevating hesychasm and the possibility of deification within one's natural life at the level of doctrine. Accordingly, the work of art in the West developed rules that corresponded to or were inspired by science and rationalism.

On the other hand, the fascination of the East with the icon and the iconographic and iconoclastic issues that were often revived in Byzantium but also in Russia, that is, the exceptional importance the East gave to non-verbal symbols, may be connected with its theological strife for unity of the rational with the emotional part of man.

From a certain historical point on, the split between East and West reflects an opposition between the sacred and the profane, at least in art. Development of art in terms of building on the accepted conventions and the expectations of the audience, the continuous creation and transcendence of artistic and conceptual schemata, a key concept in Ernst Gombrich's view of art history, reflects the philosophical framework of Western science.

On the other hand, the sacred art of the East was, and still is, informed and engendered by religion. A development of art in such terms would accept and encourage any changes that would allow art to perform its religious role better. Such development can be said to be reflected in the new style of icons, and also in the development of the iconostasis, discussed by Ouspensky.[163] The secular orientation of the West would be seen from an Eastern perspective as a sterile path that separated the intellect from the heart, something that would inevitably produce the problems that brought about the discourse on the death of (secular) art. As we saw in the discussion of hesychastic ideas, in the journey towards deification one must enter into one's "absolute centre" and unite the intellect with the heart.[164] This practice contradicts the psychological repression that resulted from the Western line of thought that would tend to identify as "not good", therefore somehow evil, the part of humankind that does not fall under the divine image that was identified with the *anima rationalis*. Ultimately, something that could be indicative of the relationship between the concept of art as it was developed in the West after the Middle Ages, and the modern fragmentation of the self, is that in the modern age we see a profound change of our understanding of the self at more or less the same time the conditions for the death of (Western) art appeared. Virtually every school of psychology, from Freud and Jung to Carl Rogers and popular psychology, recognize the need for a reunification of the self and a kind of acknowledgement of the non-rational part of the psyche. If we accept that this has become a general, genuine psychological and cultural trend of our society, we may suspect that it is not unconnected with the crisis of the art that was based on the separation of the intellect from the heart.

2 Anti-Leonardo

Historical Definition of the Function of the Religious Work of Art

In several places in this study it has been mentioned that the medieval artists did not feel they had to make their name known to the public that enjoyed their art. Not without a degree of humour, it is known among art students that the name of the most prolific composer as late as the fourteenth century is "Anonymous". The role of the artist at the time was no different from the role of a craftsman, in the sense that the occasional artistic innovations, such as the much discussed "new style of icons" of the late Byzantine period, were not so much an affair of artistic creativity and originality, but rather an issue of what needed to be expressed at a particular historical point. It was not up to the artist to define what needed to be expressed or represented, but it was up to the people and the institutions concerned with the function of art instead, namely the Church and the (religious) intellectuals. Most of the art produced in the Middle Ages was commissioned by the Church, which accordingly set the rules for it. The role of the artist, technically speaking, was to follow the guidelines set out by the Church and carry out the work assigned to him. Ultimately, what was important was the functionality of art, regardless of its artistic merit as we would understand it today.[1] This is an important issue, which has been touched upon in several other places in this study, and it deserves a short discussion.

The definition of the function of art, religious art in particular, became an issue in the Renaissance, both in the West and in the East. As Michael Baxandall observes, discussing the art of the early Renaissance Italy, the term "'religious pictures' refers to more than just a certain range of subject matter; it means that the pictures existed to meet institutional ends, to help with specific intellectual and spiritual activities".[2] In fact, the function of the "religious pictures" could be defined only by the Church, which is responsible for these intellectual and spiritual activities. In that sense there was no academic or artistic challenge to the function of the religious work of art independent from its religious role, as far as the Church was concerned. Baxandall cites a few texts that are quite illuminating as to the role of religious art. First, from what was a standard dictionary of the early Renaissance, John of Genoa's *Catholicon*, written in the end of the thirteenth century:

Know that there were three reasons for the institution of images in churches. *First*, for the instruction of simple people, because they are instructed by them as if by books. *Second*, so that the mystery of the incarnation and the examples of the Saints may be the more active in our memory through being presented daily to our eyes. *Third*, to excite feelings of devotion, these being aroused more effectively by things seen than by things heard.[3]

Moreover, demonstrating that the view of the Church was quite consistent well into the spirit of the Italian Quattrocento, Baxandall adds the following text, from a sermon published in 1492, written by the Dominican Fra Michele da Carcano:

Images of the Virgin and the Saints were introduced for three reasons. *First*, on account of the ignorance of the simple people, so that those who are not able to read the scriptures can yet learn by seeing the sacraments of our salvation and faith in pictures… *Second*, images were introduced on account of our emotional sluggishness; so that men who are not aroused to devotion when they hear about the histories of the Saints may at least be moved when they see them, as if actually present, in pictures. For our feelings are aroused by things seen more than by things heard. *Third*, they were introduced on account of our unreliable memories… Images were introduced because many people cannot retain in their memories what they hear, but they do remember if they see images.[4]

From both these texts we can see that the function of the religious images was to instruct, to stir the religious emotions of the people, and to inspire feelings of devotion. Baxandall observes that these demands leave space for, although they do not depend on, aesthetic goals, as far as the aesthetic did not present a problem for the religious function of the image. In fact, Baxandall implies that one of the ways to explain the stylistic transformation of the style of religious images from traditional icons to Renaissance paintings was that images in their new, Renaissance style were more "lucid, vividly memorable, and emotionally moving" for the religious public.[5]

In the East, on the other hand, Leonid Ouspensky describes a more difficult situation, but perhaps even more illuminating as to the issue of the role of religious images. For a number of reasons, seventeenth-century Russia was in an iconographic crisis. For one thing, an increasing demand for icons led to a substantial increase in the number of iconographers, many of whom did not have the necessary technical knowledge.[6] Texts of the time show that there was an overall attempt to address the problem of cheaply made icons, but it seems that nobody was able to tackle the problem without stumbling on the question of whether the artistic merit of icons is irrelevant to their religious function or not. Unfortunately, as Ouspensky notes, these texts are not descriptive or technical enough, and we cannot really understand the aesthetic problem of the time.[7] One of the texts of the time, a letter written by the iconographer

Joseph Vladimirov, criticizes bad icon painting fiercely, but with no real indication as to what the particular iconographic problems were:

> Where else can we see such indecencies as can be recognized here and now? The lowering and profanation of the venerable, sound art of the icons have been caused by ignoramuses for the following reason: everywhere in the villages and hamlets, wholesale merchants bring icons by the basketful. They are painted in a most ridiculous manner. Some of them do not even resemble human images; their aspect is like that of savages.[8]

It is possible that one of the factors that created the artistic problem was an increasing Western influence, evident in the taste and the art of the upper classes, whereas the simple people still followed the Byzantine iconographic style. The latter was in decline as it was not supported by the secular state, which was gradually limiting the independence of the Church. This hypothesis could perhaps explain Vladimirov's attack on certain icons as "ridiculous", with figures that "do not even resemble human images", looking like "savages". It is also noteworthy that among the documents of the time there are some that oppose what they see as a new trend in iconography, without saying anything about the quality of the icons directly.[9] Among those is the *Life* of Archpriest Avvakum, who died as a martyr of the Old Believers, the sect that opposed the changes of the Patriarch Nikon, arguing that it reflected dangerous Western influences. Avvakum's writings are more explicit about the kind of art they oppose – he wrote against images of Christ made obviously in the Western style, with "a puffy face, red lips, curly hair, fat hands and muscles", looking "like a German, pot-bellied and corpulent". It is debatable whether could be contestable whether we should deduce a general idea about the opponents and supporters of "bad icons" from his writings. Western influence was almost certainly an important issue, but we do not know if it can be identified with the issue of the artistic quality of icons. Nevertheless, it is possible to imagine such an opposition between a people-rooted traditionalism and the upper classes that were adopting Western artistic techniques and standards, dismissing traditional iconography. An additional reason I find this hypothesis possible is that, as Ouspensky points out, we do not know of any such "unsuitable icons" today, although it is hard to imagine that they have all disappeared since there was no attempt to destroy them, and, as it is obvious from the texts of the time, they were made in great numbers.[10]

We have to accept, however, that the identification of the Byzantine tradition with the art of the poor is not important for the issue of the definition of the function of the icon. Furthermore, although it would explain some aspects of this seventeenth-century minor mystery, we do not have any proof that this was the case. What we are interested in is

the evident difference of taste between an artistically educated portion of the Russian people, and another portion which seemed to be content with "bad icons". Another writer, G. N. Dmitriev, offers a helpful hypothesis along those lines:

> [Opponents of bad icons fought the production] of cheap icons used by the people, the simple folk. It goes without saying that the authors of these documents viewed the painting of icons as poor, as not corresponding to what they required of art. However, we are in fact dealing here with two different arts existing side by side: that of the leading classes and that created by the people, or, at any rate, spread among the people and accepted by them. The struggle against that art was but a manifestation of the class struggle. It was not only the pretext, but the reason behind the first Russian 'treatises' on art history – treatises that justify and praise the 'superior' art of the leading classes as their struggle against the art used by the common people. To a greater or lesser degree, the authors of the 'treatises' (not only Simon Ushakov, but also the others) were advocates of the new style of painting that was established at this time.[11]

Whatever the reasons for this iconographic split, as Ouspensky observes, "by its very nature, the art of the Church sacred art, did not and could not have a class character... it obeyed only one criterion; and in it the doctrinal aspect was not differentiated from the aesthetic. The aesthetic appreciation of a work, as we have stated, coincided with its theological appreciation."[12]

The "new trend" in Russian iconography, expressed in a quite extreme way by Vladimirov, would welcome a split between art and theology, which is what happened later. Most writers of the time, however, even among the ones who were supporting the "new trend" and were writing against the "bad icons", such as Symeon, Bishop of Polotsk, accepted that even badly made, artistically unworthy icons could fulfil their theological function.[13] The seventeenth century was a turbulent time for Russia, especially for the Church. The discussion on icons and their significance continued, and we shall review some more of it later, but this part of the debate we examined touched exactly on the relationship of art and theology *vis-à-vis* the function of the work of art. Despite numerous other differences, we can see a consensus on this issue, with few exceptions, with voices that range between the moderate modernist Symeon of Polotsk, and Paul of Aleppo, who offered the perspective of the simple people, for whom the aesthetic content of an icon was irrelevant to its religious function: "As all Muscovites are known for their great affection and love of icons, they consider neither the beauty of the image nor the art of painting. For them, all icons, beautiful or not, are the same."[14]

The identification of the function of the religious work of art with theology and the submission of art to theology, as well as the overwhelming ratio of religious versus secular works, were some of the things the

Renaissance changed radically, however, and the artist has been enjoying a rather distinct social status since then. The artist as creator, intellectual, and cultural forerunner has dominated the history of culture since the Renaissance. One may go as far as to say that traditional art history since then consists exclusively of the history of the evolution of artistic forms and the history of the artists that instigated it. Indeed, most contemporary art histories organize their content based on the individual artists who expressed their personal views and subsequently influenced the way people perceived art. Accordingly, what we would call the sociological perception of art, or the relationship of the majority of the people with art, withdrew in favour of the pioneering artists and the work of art as a distinct entity, until recently, when the social environment of art emerged as a powerful factor in our understanding of art.

The figure of the artist is quite central in the present study. In many ways it circumscribes the distinct, and eventually marginalized, position of art in relation to life, because it is largely connected with the idea of the gifted human being who perceives the world for the rest of the people and, through his art, teaches them how to perceive it. This concept is problematic on many levels, not the least of which is the question of the special vantage point of the artist, or his claim to an original and personal creation. The status of the artist as creator has been recently challenged to the point that some writers have proclaimed the "death of the author", which can easily be extended to include the "death of the artist".

The concept of the death of the artist is of signal importance in the examination of art. It is made particularly interesting by the fact that in this, as in so many other issues, postmodernist thought approaches the legacy of the Renaissance with a critical eye, and finds unexpectedly common ground with the thought and practices of the Middle Ages. It is essential, then, to examine the portrait of the artist as a Renaissance man, which has remained influential to date, as well as some of the issues connected with the artist. This chapter is titled "Anti-Leonardo", because I chose to focus the critical review of the Renaissance using mainly, somewhat arbitrarily, the *persona* of Leonardo da Vinci, although references to other artists are made as well, for two reasons: First, because he is considered to be the Renaissance man *par excellence*, the genius who was at the same time an artist and a scientist. Second, because of Sigmund Freud's study on da Vinci, which I have used here. This little-known study poses some challenging questions and sheds some light on Leonardo's personality, and thus made it significantly easier for me to approach the psychological aspect of the Renaissance artist. We have to recognize that Freud's approach in general, and his work in *Leonardo* in particular, have been criticized severely. Perhaps one of the greatest faults of Freud's study was that a great part of his study was based on a

mistranslated word that appears in the writings of Leonardo da Vinci, where Leonardo recalls being visited in his cradle by a *"nibio"*: *nibio*, a word that means "kite", had been wrongly translated as *"Geier"*, vulture in English, in the German translation of Merezhkovsky that Freud used.[15] Unfortunately, Freud built quite a lot on this dream, and was, of course, misled, through no fault of his own. Moreover, Freud's methodology, approach and philosophy have been under attack, mostly correctly so, in the last few decades. Although in Freud's discovery of the unconscious and his decisive contribution to thought we find one of the first breaks with the epistemic paradigm that denied its own subjectivity and sought an "objective" view of the world, his West-centred values still express that paradigm very much. At any rate, as an old professor of mine, the late Richard Courtney, used to say, Freud has to be read not as a scientist – his thought is too inconsistent and his methods too inductive for that – but he should be read as a poet instead, in a manner of speaking; the reader should keep in mind that Freud projects a lot of himself in his work. I can see here the appeal of studying the work of a contemporary poet of the mind on the mind of the Renaissance man.

Breaks with the Past

The Renaissance artists introduced some radical (for the age), perceptual breaks with the past, which deserve a close examination. Some of those breaks, which reflect fundamental concepts of our culture, include our perception of:
- God
- The body
- Image and recognition.

God

The traditional religious directive on the representation of God, stated explicitly and unequivocally in the Ten Commandments, forbids any representations of him. Accordingly, representations of God the Father in medieval iconography are extremely rare. This kind of specific prohibition was, as mentioned elsewhere, challenged and settled as an issue in sixteenth- and seventeenth-century Russia, as far as the Eastern concept of the icon is concerned. The conventional depiction of the Holy Trinity follows the description of the visit of God to Abraham, in the form of three angels. Andrei Rublev's famous icon of the Holy Trinity is the most well-known example of an icon of this type. The sixteenth century saw a dispute over the correspondence of each of the three angels to a person

of the Holy Trinity in Russia. It was a quite widespread practice in the later Byzantine period and in Russian iconography to identify the central angel as Jesus Christ, at least according to Ouspensky's view. Perhaps the earliest piece of evidence for the identification of the middle angel with Christ can be found in an icon of a tenth-century Greek Bible, where the halo of the central angel is cruciferous.[16] Sometimes the inscription "IC XC" was also inscribed above or next to the central angel. As a reaction to the heresy of the Russian Judaizers in the fifteenth century, sometimes, although rather rarely, each of the three angels appeared with cruciferous halos and with the inscription "IC XC" above them, in an effort to emphasize the equal honour of the three persons.[17] The implication of the identification of the central angel as Christ was that the other two were representing the other two hypostases of the Trinity, the Father and the Holy Spirit. This was amplified further by the juxtaposition of the angels with symbols that denoted their respective identity: The house of Abraham, as a symbol of the Church, was depicted above the first angel, identifying him as the Father, the oak of Mamre – tree of life and wood of the cross – above the central angel, identifying him as Christ, and a mountain, a symbol of spiritual ascent, above the third angel, identifying him as the Holy Spirit.[18]

We have to mention here that the previous interpretation, supported by Ouspensky, is by no means the only one. Paul Evdokimov reads Rublev's icon in a very different way, based on an older icon of the Holy Trinity, owned by St Stephan of Perm, which was said to identify by inscription the three angels, from left to right, as the Son, the Father, and the Holy Spirit.[19] Evdokimov developed a quite interesting interpretation of Rublev's icon under this light, reading the symbolic language of the posture and the gestures of the angels, as well as the colours and the lines of the icon, in a way that reveals most of the Orthodox theology on the Holy Trinity.

It is not important at the moment to decide which of the two interpretations is correct. The issue we are interested in is whether all three persons of the Holy Trinity can be portrayed separately or symbolically, and this problem arises with both views. The identification of the angels as the three separate hypostases of the Holy Trinity was dealt with in the so-called "Hundred-Chapters Council" (*Stoglav*) in 1551 in Moscow, which concerned itself extensively with issues of iconography. The first question of the 41st chapter reads:

> On icons of the Holy Trinity, some represent a cross in the nimbus of only the middle figure, others on all three. On ancient and on Greek icons, the words 'Holy Trinity' are written at the top, but there is no cross in the nimbus of any of the three. At present, 'IX XC' and the 'Holy Trinity' are written next to the central figure. Consult the divine canons and tell us which practice one should follow. The Reply: painters

must paint icons according to the ancient models, as the Greeks painted them, as Andrei Rublev and other renowned painters made them. The inscription should be: 'the Holy Trinity.' Painters are in no way to use their imagination.[20]

For some reason the issue was not put to rest after the *Stoglav*. Although the *Stoglav* included a ruling[21] which made a distinction between representations of Christ in the flesh (which were acceptable) and in his divinity (which were not acceptable), perhaps because the language of the text was unclear, as some scholars posit,[22] images of God the Father, which should have been as unacceptable as representations of Christ in his divinity, kept appearing in the following years. Pictorial syntheses known as the *New Testament Trinity* or the *Paternity* from as early as the fifteenth century, depicted God the Father as the "Ancient of Days" and the "Lord Sabaoth". It has been suggested[23] that the restriction on the representation of Christ "in his divinity" was aimed exactly at such images. At any rate, after a tumultuous period in matters of iconography, the Great Council of Moscow in 1666–67 finally ruled unequivocally on the depiction of God the Father:

> Let all vanity of pretended wisdom cease, which has allowed everyone habitually to paint the Lord Sabaoth in various representations according to his own fantasy, without an authentic reference… We decree that from now on the image of the Lord Sabaoth will no longer be painted according to senseless and unsuitable imaginings, for no one has ever seen the Lord Sabaoth (that is, God the Father) in the flesh. Only Christ was seen in the flesh, and in this way he is portrayed, that is, in the flesh, and not according to his divinity. Likewise, the most holy Mother of God and the other saints of God…

> To paint on icons the Lord Sabaoth (that is, the Father) with a white beard, holding the only-begotten Son in his lap with a dove between them is altogether absurd and improper, for no one has ever seen the Father in his divinity. Indeed, the Father has no flesh, and it is not in the flesh that the Son was born of the Father before all ages. And if the Prophet David says 'from the womb, before the morning star I have begotten you' [Psalm 109/110:3], such generation is certainly not corporeal, but unutterable and unimaginable. For Christ himself says in the Holy Gospel 'No one knows the Father except the Son'… This is why the Lord Sabaoth, who is the Godhead, and the engendering before all ages of the only-begotten Son of the Father must only be perceived through our mind. By no means is it proper to paint such images: it is impossible… Besides, Sabaoth is not the name of the Father only, but of the Holy Trinity. According to Dionysios the Areopagite, Sabaoth is translated from the Hebrew as 'Lord of Hosts.' And the Lord of Hosts is the Trinity. And if the Prophet Daniel says that he has seen the Ancient of Days sitting on the throne of judgement, that is not taken to mean the Father, but the Son at his Second Coming, who will judge all the nations with his fearsome judgement.[24]

The representation of God the Father as an old man was commonplace in the West by the time of the Great Council of Moscow, but it had

never really spread roots in the East. As part of a particular pictorial type of the West, which also included the crucified Christ on the lap of the Father and the Holy Spirit as a dove, it can be dated back to the end of the eleventh or the beginning of the twelfth century. Ouspensky reads its character as initially mostly liturgical, intending to show that the Eucharistic sacrifice, in analogy to the sacrifice of Christ, is offered to God the Father as a means of reconciliation between God and humankind. The Eucharist then is symbolically offered to the Father through the crucifixion and the Holy Spirit.[25] On the other hand, it was quite frequent in the East, whenever the presence or the voice of the Father had to be directly suggested, as in images of the Epiphany, to see the hand of the Father depicted at the top of an icon, usually holding a scroll. Only the eye of God was consistently represented above the Royal Doors of the iconostasis, something that was also seen in the decoration of the synagogue. The representation of the Father was criticized as a Western practice, not consistent with Holy Tradition.

The iconographic issues the Russian Orthodox Church dealt with in the sixteenth and seventeenth centuries are, in a sense, an extension of the iconoclastic wars of Byzantium. The iconoclastic wars raised the issue of representation in general, and, simply put, whether man-made images could be used for religious purposes. The Russian Councils dealt with the other extreme and put a limit on what could be represented. It is interesting to note that in both periods iconography was a major issue in the East, iconoclasm and the Russian Councils; the West remained uninterested. Religion through art never had the same meaning in the East and the West, at least inasmuch we are able to detect religious and cultural differences between them. The iconoclastic character of the Reformation was, perhaps, no more than the logical conclusion of the secular character Western art had from much earlier. It should then not be surprising that the renewed interest in religious art in our days comes again mainly from the East, with Orthodox composers such as Arvo Pärt, Giya Kancheli and John Tavener.

What are we to make of this observation? The medieval artist did not use his material as a means of personal expression, where his imagination could assume the pivotal role in the originality of the work. The work of art was, instead, an opportunity for the artist to participate in the work of the Church and help express its teachings and its ideas in a didactic and/or liturgical fashion. The concept of representation, therefore, was not necessarily interpreted as reproduction of physical likeness, at least not in the way of the mechanically objective reproduction of physical likeness we think of at present, but it had to do with adherence to and proper expression of the particular religious meaning the icon was meant to convey. God the Father was not a Being one ought to think of in an

anthropomorphic way, and this rule is evident even in its exceptions. The few icons that include the figure of the "Ancient of Days" are either made in a way that attempts to demonstrate the triadic nature of the one God, something we see in representations of Christ as a child seated on the knees of the Father, with the Holy Spirit in the form of a dove painted on the chest of the young Christ, where the alignment of the three persons is the main signified, or in pictorial syntheses that correspond to a psychological *quaternio* including the Theotokos and sometimes John the Baptist. The representation of the Father is secondary in those cases; Byzantine icons depicting the Father on his own are extremely rare.

The prohibition of the representation of the Father cannot be explained on the basis of rational theological thought alone. As it became evident in the iconoclastic crisis, the restrictions of the Jewish legacy did not necessarily need to be observed in the practices of the Christian era, because a new meaning could be found in the new dispensation. The taboo on representations of God was somehow lifted by the icons of Christ, but the figure of the Father, God in himself, remained elusive because it was not only theologically but also psychologically sound to avoid representing the Creator in the form of a person. The *kenosis* of God in the person of Christ would be meaningless if the Father were to be thought of in an anthropomorphic fashion in the first place. God is formless because he is beyond being and form; he is conventionally known as "the Father" because of his creative nature and because of his fatherly relation to Christ, but theologically speaking he cannot be thought of as possessing any characteristics that make him appear more like a father than a mother. Sigmund Freud, however, has produced a plausible hypothesis as to the cultural roots of the conventional gender of God and his "fatherhood" in his works *Totem and Taboo* and *Moses and Monotheism*, showing that it is based on a quite complex primordial psychological background. Some attempts of the fourth century to distinguish between the person of the Father and the formless Ουσία behind it were severely criticized by St Basil the Great as a form of Sabellianism. A paradox concerning the nature of God is that he has been consistently delineated as formless and personal at the same time. This indicates a great divide between pagan philosophers like Plotinus and Christians like Origen: their philosophy could be similar in many ways, but the great chasm between them is brought to light by their different concepts of a personal or impersonal Supreme Being. The psychological background of the elusive nature of God can perhaps be traced to Yahveh who identified himself as "I am who I am"[26] to Moses, because he could not be compared with or explained through anything else. In the book of Genesis, on the other hand, there is not much to suggest that God is not anthropomorphic; rather the opposite can be claimed more easily. The importance of the concept of God as an

entity formless yet personal, which survived well into the Christian era, was reflected in the relationship of the believer, and vis-à-vis iconography in the relationship of the believer, the artist and the viewer, with a transpersonal God.

Nevertheless, during the late Middle Ages, in anticipation of the Renaissance revolution, the forbidding avaton was broken in the West and images of the Supreme Being were painted (perhaps most prominent among them being Michelangelo's The Creation), for the first time in Judeo-Christian tradition after the time of strict adherence to Mosaic Law. However, the tradition that held the icons and the images responsible for their spiritual meaning was not discarded immediately. The images did hold their spiritual meaning, only now this meaning was subtly changing. Not only did it become possible to actually see the Father in the flesh, as a venerable human being and not through the strictly metaphorical apparitions of the past (as a burning bush, as three angels, etc.), but the features of the Son became increasingly human as well. The proportions of the work of art ceased to represent the moral dynamics and the spiritual and metaphysical quest of the represented and the viewer, and became a mirror of the existing world instead. The door that used to connect this world to the other was closed and the orientation shifted towards another world, material or psychological, instead.[27] Art did not have a functionally religious role anymore, at least in the sense of the connection with the supernatural. The centre of the universe was moving to the earth, in a psychological sense. The meaning of the images and the symbols was changing subtly, and this was bound to affect the way this meaning was expressed and signified.

The body

With the metaphysical dimension lost, the self had to be withdrawn to the domain of immediate experience. The self became identified with the body, and painting did more justice to the representation of the body than ever before, but at the expense of the attempt to depict the spirit, or rather the transcendental understanding of the world and the self as something which includes the invisible. Even the halos in the icons became solid and three-dimensional: if they were to remain part of the painting repertoire, they had to be materialized and to conform to the rules of proper perspective, like flat hats worn by saints and angels, as can be observed in paintings by Giotto, Verrocchio, Rosselli and other painters. As the self became solidified in the body, it became the object rather than the subject of perceiving. The body gained new attention as something to be studied and understood better. On an external level that would mean the withdrawal of what we could describe as the iconographic gaze in favour of the medical or mechanical gaze. The former

would look at the body and see its spiritual content, hoping that the way of the saint would be imitated and deification accomplished, whereas the latter would look at the body and see a wondrous machine that should be studied so that the ways of nature and God be understood. It is tempting to detect an underlying dualism in the case of the body as an object, reflecting perhaps the contrast of the medieval theologian and the Renaissance philosopher. The former would attempt to ascend *through* the created order in his body, realizing the unity of the cosmos and allowing divine grace to bless even lowly matter, whereas the latter would attempt to circumvent the created order and aim at the highest spiritual principles, understanding as it were the mind of God.

Once the self was identified with the body, the way numinous truths were expressed was affected. The body became a *topos* to be displayed and celebrated, and the Incarnation of God in Christ assumed an outstanding significance. The difference on this issue between East and West, or between early Middle Ages and Renaissance, is widely known. In the East the Divine Passion, which includes the Crucifixion and the Resurrection, is thought of as the most important feast, because it is through the sacrifice of Christ on the Cross that humanity was saved. In the West, on the other hand, the Incarnation is more important, as the moment God became human in the flesh. The Patriarch Photios wrote in the ninth century that "wondrous was the manger at Bethlehem which received my Lord...as he had just emerged from a virgin's womb... Yet a far greater miracle does the tomb exhibit. In the latter is accomplished the end and the purpose of God's advent."[28] Conversely, John O'Malley in a study of the papal sermons of the fifteenth and sixteenth centuries wrote that the Renaissance preachers emphasized the Incarnation, holding that "all the subsequent events of Christ's life are articulations of what was already inchoately accomplished in the initial moment of man's restoration, which was the incarnation in the Virgin's womb".[29] One cannot really find a doctrinal difference between the two views. It is rather a difference of emphasis, and I believe it has to be attributed to the different psychological rather than theological background of the two views. Of course we must keep in mind that there are quite a few historical reasons that played a role in this difference between the two Churches, although this does not diminish the psychological significance of the (difference between the) two feasts.

The human body, especially the body of Christ, has been seen as a hierarchical system from at least as early as the third century. In Origen, for instance, we find the convergence of the Platonic idea of the World Soul and the idea of the personal God, in a way that suggests that the higher spheres of existence correspond with the upper body parts of the imaginary body of God. In Περί Αρχών he accepts that the universe is

something like "an immense, monstrous animal, held together by the power and the reason of God as by one soul".[30] And then he portrays somewhat graphically the relationship of the universe and God, quoting scripture extracts where God is said to have "heaven for his throne and the earth for the footstool of his feet".[31] Later writers identify Christ's head with his divinity and his feet with his humanity, in an almost polarized manner. Eusebius wrote that "the nature of Christ is twofold; it is like the head of the body in that he is recognized as God, and comparable to the feet in that for our salvation he put on manhood as frail as our own".[32] Maximus the Confessor wrote: "Whoever says that the words of theology 'stand at the head' because of the deity of Christ, while the words of the dispensation 'stand at the feet' because of the Incarnation, and whoever calls the head of Christ his divinity and the feet his humanity, he does not stray from the truth."[33] St Symeon the New Theologian in the eleventh century taught that the body of Christ corresponds with the body of the Church, and the members of the body of Christ correspond with the saints who fulfil the respective role of the body of the Church. The head of the Church corresponds with Christ himself, but the hands, shoulders and the other members correspond with the saints. The thighs, for instance, correspond with the ones who "carry in themselves the fecundity of the concepts adequate to God of the mystical theology, and engender the Spirit of Wisdom upon the earth, i.e., the fruit of the Spirit and his seed in the hearts of men, through the word of their teaching".[34] Finally, Bernard of Clairvaux deduced rationally the polarity between head and feet, arguing that "if it seemed right to St Paul to describe Christ's head in terms of his divinity,[35] it should not seem unreasonable to us to ascribe the feet to his humanity".[36]

The stress to the body of Christ and the body of the Church existed for quite some time then, but it used to symbolize a kind of unity rather than an opposition. In writings like those of St Symeon, for instance, emphasis is given to how every member of the Church can contribute in their own way, while the total is as harmonious as the body that consists of many different parts. Bernard, on the other hand, lived in a time of dissent, when faith and reason seemed to be almost irreconcilable. It is only in the late Middle Ages that we see the body itself being used as a statement of the humanity of Christ, and for this reason it is the naked body that receives the honour. Accordingly, the baby Jesus appears increasingly less dressed in the late Middle Ages, and very often completely naked in the Renaissance. Émile Mâle wrote on the gradual undressing of Jesus:

> In the twelfth century, the Son of God, seated on the lap of his mother, is robed in the long tunic and the philosopher's pallium; in the thirteenth, he wears a child's dress; in the fourteenth, he would be entirely naked did not his mother wrap his lower body in a fold of her mantle. This nudity of Christ is, as it were, the mark of his

humanity; he now resembles the children of humankind. He resembles them further in his whims, his lovable infant capers, whether caressing his mother's chin, or at play with a bird. He resembles them, finally, in his subjection to nature: the Son of God feels hungry, and the artists show the Virgin giving him suck.[37]

One wonders, though, whether the Virgin conceals or unveils the lower body of Christ. What may appear as a motherly gesture of protectiveness, expresses at the same time the presentation of the body of Christ to the world and the manifestation of his human nature. From the early Crucifixes where Christ was dressed in a long tunic, to the naked Christ of the Renaissance, the tendency was to present God-made-man with increasingly human characteristics and behaviour. The trend to depict the nakedness of Christ went so far that many paintings between the fourteenth and the seventeenth centuries present, quite centrally, the unveiling, presentation, touching or protecting of the genitalia of the baby Jesus. Such an emphasis can be also observed in paintings of the dead Christ. Andrea del Sarto, for instance, painted the naked Christ touching his genitals as a child (the Tallard Madonna, 1515) and as a (dead) man, after the Crucifixion (Pietà, 1520).

One of the most famous images to present manipulation of Christ's genitalia is Hans Baldung Grien's woodcut *Holy Family* (1511). The divine infant is held by Mary and shown to her mother, St Anne, who touches Christ's genitalia with her left hand. The traditional explanation for this shocking gesture is given by Carl Koch, who attributed it to an underlying folk superstition. Koch wrote that Baldung displays "insight into arcane popular customs believed to possess magical powers. Thus, under pretext of representing the pious companionship of the Holy Family, he dares make the miracle-working spell pronounced over a child the subject of a woodcut composition".[38]

One could posit that the point Koch is trying to make attempts to explain away the gesture as a folk symbolism that has little to do with the identity of the represented persons. This is a little difficult to accept, however, because this image would have been rather unacceptable as an image of ordinary peasants under the circumstances. Such images were said to draw their inspiration from ordinary settings, reflecting the life of ordinary people. Philippe Ariès actually cited Baldung's woodcut to argue that playing with the private parts of a baby was once a "widespread tradition".[39]

The problem with interpretations such as Koch's, who saw the woodcut as a popular portrayal of an ordinary family, is that they seem to ignore that Renaissance art is not renowned for the representation of realistic situations. Religious images, especially, held very often an allegorical meaning, and at any rate treated the divine child as the incarnate God, doing things no other babies do, such as handing the keys of the kingdom

to Peter, examining a book, placing a ring on St Catherine's finger, etc. It seems more likely that the intention of innumerable such images was to stress the human side of Christ, or rather the *humanation* of God, his descent into manhood. In this picture, St Anne as the grandmother of Christ is the one who guarantees his human lineage and holds the tangible truth. In Renaissance images we can detect a shift of focus. Medieval paintings often, as a reaction to Jews, Monophysites, Muslims and iconoclasts, aimed to demonstrate the simultaneous presence of the human and the divine natures of Christ, but for the Renaissance West, where the main opponents of ecclesiastical doctrine were the dualist Cathari, some of which maintained that the body of Christ was only an illusion,[40] the issue was not so much the divinity of Christ, but the declaration of his humanity. Christ's humanity is a constant theme in Renaissance pictures of the Nativity, Adoration of the Magi, and the Holy Family.

Leo Steinberg has grouped many of the representations discussed above in a very influential book,[41] exploring the sexuality of Christ as a sign of his humanation. As Caroline Walker Bynum has noted, however,[42] Steinberg's approach perhaps relies too much on modern views on nudity and sexuality. Without denying the value of Steinberg's work, Bynum argues that when representational art was demonstrating a fascination with the genitalia of Christ – which, she agrees, is a sign of humanation, yet not necessarily of (male) sexuality – another group of texts and representational works depicted the body of Christ with feminine characteristics (Christ lactating or giving birth); the body of Christ was often identified with the Church, as we saw in the writings of St Symeon the New Theologian. Bynum may disagree with some of Steinberg's arguments, but she agrees with, and actually strengthens, his interpretation of the nudity of Christ as a stress on his humanation, albeit in a way that transcends (male and female) sexuality.[43]

The problem with the stress on the human nature of Christ, especially in a medium so much indebted to the mirror and its psychological significance, was that his humanity, and by implication humanity as a property or condition, became glorified to such an extent that it gradually took personal characteristics and dimensions. Not unlike the soul that descended into matter in order to govern it as described by Plotinus,[44] or as we would say in a Christian framework, in order to save it, and then focused on the particular and lost the way back to the divine, the Renaissance artists celebrated the Incarnation and the body, but this led to the gradual secularization of the numinous image. Demythologization of the deity led to the profanation of sacred art, and now most viewers stop at the level of the prominent visible, not seeking to make the connection with the invisible and with the mysteries of faith.

It has been known that Renaissance painters were using live models for the depiction of religious images. This indicates a conceptual break with iconographic tradition, because the identity of the depicted person becomes problematic. According to St Theodore the Studite, an icon partakes of the holiness of the depicted saint because it shares his or her ὑπόστασις (identity). Apart from the theological arguments in favour or against the use of models, painting in the iconographic tradition, according to certain guidelines that ascribed particular characteristics to particular saints, somehow implied a unity of the visible and invisible realm. Even without direct experience, it was possible for anyone to know what Jesus or a saint looked like. The point was that they were recognized when they were seen in visions or in the afterlife, based on the stereotype of their appearance and the signs that described their earthly vocation (military saints or doctors) or ecclesiastical position (monks or bishops). The use of models, although allowing for far greater illusionist realism (the realism of appearances), posited that there can be no direct connection between Heaven and Earth, and at best the Earth could try to look like Heaven as convincingly as possible. The true identity of a painted person was subsequently of no great importance, because what mattered was only his or her conventional name. If a painter painted Venus and then decided to name her Virgin Mary, the painting *became* Virgin Mary.

The effects of the humanization of Christ and the realistic illusionism of the figures had their counterpart in the psychological realm. These changes correspond to a profound change in the relationship of the self with religious art, which reflect the difference in meaning of φαντασία or imagination between the early Middle Ages and the Renaissance. Imagination, for Fathers like John Damascene, is what enables the viewer (and the artist) to make the connection between the visible image and its invisible counterpart. It is directed outwards, to something completely independent of the viewer and as real as the tangible visible world. Later we find that the meaning of the word has changed to mean contemplation of the personal, perhaps fictional, certainly not necessarily corresponding to any outside truth. Girolamo Savonarola in the fifteenth century was writing that "every painter, one might say, really paints himself. Insofar as he is a painter, he paints according to his own idea".[45] The Renaissance artist, as we will see, plunged into his self and his unconscious to draw inspiration.

What can we say is the difference between the one kind of imagination and the other? At the one end we can find a concept of imagination as a way of revelation, something Plotinus was very much aware of when he used imagination to grasp a purely intellectual, divine image:

> Let us, then, grasp with our mind (διάνοια) this cosmos, each member of it remaining what it is, distinct and apart, yet all forming as far as possible, a complete unity,

so that whatever comes into focus, say the outer orb of the heavens, shall bring immediately with it the image (φαντασία), on the one plane, of the sun of the other planets, with earth and sea and all living things, as if exhibited upon a transparent globe.

Let there be, then, in your soul the gleaming image (φαντασία) of a sphere, a picture holding all the things in the universe whether in motion or at rest, or rather, some at rest and others in motion. Keep this sphere before you, and from it imagine another, a sphere stripped of magnitude and of spatial differences; cast out spatial conceptions and the image (φάντασμα) of matter within you; do not simply substitute an image reduced in size, but call on God, the maker of the sphere whose image you now hold, and pray him to enter.[46]

At the other end, we find Sartre's quite blunt definition of imagination as "the ability to think of what is not",[47] although, interestingly enough, he identified imagination with human freedom. At any rate, our age does not tend to respect the invisible, and the usual measure for the value of imagination is the visualization towards a more or less practical goal, something that brings Sartre impressively close to Anthony Robbins.

Imagination has been defined and evaluated in many different ways since Plato, for whom φαντασία refers to knowledge that is "tentative (Philebus), sometimes fake (Republic), and in any case second rate, inferior (Timaeus)".[48] It is Plotinus, however, whose writings on imagination provided a template for its understanding in the Christian era. Plotinus discusses the imagination in Ennead IV 3, 23–32. For Plotinus, imagination is based on memory and, like memory, it belongs to the higher as well as to the lower level of the soul. It can, therefore, perform two distinct imaginative faculties, one serving either level of memory.[49]

In Ennead III 6, 4, 19–21, Plotinus distinguishes between "imagination in the primary sense (πρώτη φαντασία), which we call opinion (δόξα)", and a lower imagination, ανεπίκριτος, which involves no judgement or synthesis, and apparently just absorbs images. The first faculty is what synthesizes the data of sensory perception and produces an opinion. John Dillon, in his essay "Plotinus and the Transcendental Imagination",[50] compares the two imaginations of Plotinus to two levels of imagination defined by Immanuel Kant in the Critique of Pure Reason. Kant describes two imaginations, the "productive" or transcendental, and the "reproductive" or empirical. Commenting on the transcendental imagination, Kant wrote:

What is first given to us is appearance. When combined with consciousness it is called perception... Now, since every appearance contains a manifold, and since different perceptions therefore occur in the mind separately and singly, a combination of them, such as they cannot have in sense itself, is demanded. There must therefore exist in us an active faculty for the synthesis of the manifold. To this faculty I give the title imagination.[51]

Dillon writes that Kant's transcendental imagination seems to be very similar to Plotinus's πρώτη φαντασία, yet he identifies a great difference between them. For Plotinus, imagination is also the recipient, the "mirror", of the operations of the intellect,[52] in a way that is reminiscent of Maximus's λόγοι, as discussed in *A Religious View of the History of the Arts*: φαντασία for Plotinus is a mirror for intellectual activity, which is operative only when the surface of the soul is smooth and harmonious. On the other hand:

> when this is broken because the harmony of the body is upset, thought and intellect operate without an image, and the intellectual activity takes place without imagination. So one might come to this sort of conclusion, that intellectual activity takes place with the accompaniment of imagination, though it is not identical with imagination.[53]

Although on the psychological level imagination as conceived by Plotinus and as conceived by Kant is very similar, the difference is its ability to possibly understand something of the divine. As we saw above, Plotinus thinks that imagination is a worthy tool that can be used to construct mental images that can grasp the Idea of God. For Kant, on the other hand, as he argued in the *Critique of the Pure Reason*, the idea of God, as well as the ideas of freedom and immortality, are beyond human understanding. Therefore, somewhat simplistically put, Kant's transcendental imagination cannot contribute to our knowledge of God. Notwithstanding several other differences among Plotinus, Kant and Sartre, one of their main differences is that Plotinus's πρώτη φαντασία is very much connected with the contemplation of God; perhaps it can provide our closest possible understanding of the divine, save for a direct union with it, whereas Kant's transcendental imagination is not theistic at all, but has a psychological orientation instead. In a sense, the age expressed in Sartre's aphorism was bound to follow, since imagination can no longer reveal anything beyond the senses. What we see in the change of imagination is reflected on the focus in the human aspect of Christ instead of the divine, the tangible instead of the spiritual, the visible instead of the invisible, both in art and in metaphysics.

Sigmund Freud has illustrated in his relatively little-known work *Leonardo* that Leonardo da Vinci projected himself and his childhood memories with his mother and the second wife of his father, in the image of Christ to be found in his *St Anne with Mary and Christ*. We would never go as far as to assume that he could ever suspect this himself, yet even the unconscious basis for such an occurrence would be guarded against by a medieval iconographer, as much as possible. One's psychological assumptions were quite important, and as it has been stated before, the medieval artist was focusing, consciously and unconsciously, on the very real world

of the invisible: it was mostly the invisible world the icons sought to represent. When the theological, philosophical and psychological connection with the numinous was broken, the invisible was replaced by the (personal and) psychological, perhaps the closest possible kin to the numinous. The work of art was becoming, from then on, an increasingly personal affair, and the artist assumed the role of the *Creator* of a mini-universe, corresponding to the mini-universe of his personal subconscious, whereas in the past the artist was a humble servant of the divine will and, as Jung could have put it, was more overtly influenced by collective archetypal images. It is only recently that, in postmodernity and the New Age, we have tried to re-establish our position in the universe and we have conceived of a holistic, harmonious coexistence with it, accepting that we are not truly the masters of our world, but mere guests on this planet.

Leonardo's penetrating gaze goes beyond the surface of the human body. However, at the same time, it seems that he distanced himself extremely on a personal level from it, as the records he has left indicate that his sexual activity was non-existent, and, as the following statement of his illustrates, he was evidently frigid: "The act of procreation and everything connected with it is so disgusting that mankind would soon die out if it were not an old-established custom and if there were not pretty faces and sensuous natures."[54] It seems it was impossible for him to feel any attraction for what only appeared as a dissectable object, and the admiration and study he devoted to it through his work is the admiration and the fascination for the work of art and the God-made engine. Still, his subjectivity could not be placed on the same plane as the object he observed: does not the mechanistic paradigm of medical science start here? The objectification of the body has an additional effect, which has changed only on the outside since then. The work of art assumed gradually an autonomous existence, without necessarily referring to a signified outside the system of signification. An image in the Middle Ages was thought of as a depiction of an existing object. Even allegorical syntheses, such as the paintings of Hieronymus Bosch in the late fifteenth–early sixteenth century, allude to a reality that justifies the orgiastic fantasy of the artist. Bosch's paintings however, can be thought of as a border between the metaphysical and the psychological.

The self was at the same time identified and distanced from the body, as we already see in the case of Leonardo da Vinci. A few centuries after the foundation of internal anatomy and its pictorial study, we find the effect of this act described from the reverse angle as the psychological problem of "the Body without Organs",[55] the "I" that denies its own subjectivity. In their monumental work *Anti-Oedipus: Capitalism and Schizophrenia*, Gilles Deleuze and Félix Guattari attempt a synthesis of political

and psychological economy, and identify the tension between the concept of the body as a *locus* of the organs that desire in a quite mechanical way, and the self which identifies itself as a body without organs, a materialist self but without the need to exist in the material world. The body without organs is *repulsed* by the desiring machines that lurk in it, and attempts the intelligible or imaginary separation of its organs. This image, so fundamental for the understanding of the contemporary concept of the self and its ontology (or, more accurately, its pathology), is closely connected with the perception of the self in terms of solid flesh, which we can identify, perhaps for the first time, in Renaissance painting.

In the case of Leonardo da Vinci's sketches of the body, it is rather "the Organs without Body" we see, something that expresses subjectivity being denied to the Other, and the Other's subsequent objectification. The gaze of the artist/scientist penetrates beyond the surface, but in doing so it separates and defines the surface and the interior in material terms. What lay beneath the surface for the medieval iconographer was divinity itself: to go beyond the icon as a symbol would be to penetrate into the unknowable, into what could only be revealed in mystic symbols and metaphors. It is no surprise that the defenders of icons accepted that symbols and icons became redundant within the divine θεολογία, the kind of theology that examines the existence of God in himself, while they saw the need to maintain the language of symbols and icons in the divine οικονομία, the kind of theology that examines the relation of God with the world.[56] For Leonardo, on the other hand, the interior of an image adheres to an analogy with the depicted body and its organs, which in turn reveal themselves in the beautiful complexity of their hydraulic and muscular systems. This way of looking seems to transform humans into machines, and does not differ much from the similarly "objectifying" gaze of de Sade, who portrayed men and women as totally *Others*, with a functionality for pleasure, machines that could be used in a variety of ways in order to produce pleasure for the somehow transcendental, unsubjective self.

The psychological dynamics that correspond to the Renaissance painting are quite different from the dynamics of iconography. As we have seen elsewhere in this study, the viewer of sacred images at some point pulled back from them, and became conscious of the act of gazing, embracing the role and identity of the spectator, which was initially reserved, as far as the theological interpretation goes, for the eye of God alone. The effect of the icon was at the same time experiential and conscious/rational. We can later detect a break into two different directions: while art maintained its psychological power, its discourse shifted to the rational, consisting of objectified rules of what art should be and how it was to be appreciated. This coincides with the emergence of the artist/genius, the

artist who comprehends the art of the past and, first of all, advances into the future.

The experiential dimension of iconography with its effect on artists, laymen and theologians alike, was suppressed after the humanistic revolution. According to Jung's frequently cited psychological rule, a suppressed part of the self will sooner or later express itself on a large scale. Thus, eventually the taste of common people became dissociated from the *avant-garde*, but this is further explored in another chapter of this study. What is more relevant to the present examination is the experiential demand that art inherited from iconography, and what happened to it once it had to be translated into the level of the solid, material body.

We usually think of the reification of the human body as an act of pornography, a demotion of the self to the level of *thing*, a voyeuristic act of looking without being looked at. We also think of a fetish as an object that replaces and, in a way, obstructs a genuine pleasure. Pornography and fetishism are usually associated with sex, but their origins can be traced well beyond it. After all, it is not the association with sex that makes pornography offensive, but what it does to sex. It would be equally offensive if pornography were connected to any other form of pleasure, food for instance, and in fact one can easily extrapolate the exploitation of the self from the sphere of sex to the sphere of consumerism. Advertisements have dominated the media world of the twentieth century in a way of promised gratification and symbolic pleasures reminiscent of sex, as the early school of French semioticians who followed Roland Barthes in the 1950s and 60s, and analysed advertisements, films, dress codes etc., amply demonstrated. Nevertheless, pornography of the body has to be recognized as the conceptual archetype of the mechanistic/objectifying paradigm wherever it is expressed, because of the (relative or absolute) identification of the body and the self, especially in the period we examine.

The history of pornography as we know it today starts in the late Middle Ages. One could claim that its precedent can be found in ancient Greece and Rome, but the naked body and the representation of sexual scenes, rather frequent in ancient ceramics, was a quite different thing for the Greeks. The Greek gods were made "in the image and likeness" of humans, instead of the other way round. The gods themselves, Zeus most of all, often indulged themselves in human passions. The concept of right and wrong was, therefore, fundamentally different in ancient society. The idea of sin does not appear anywhere in the ancient world with the metaphysical meaning it has in the Judeo-Christian tradition. The only comparable concept is that of *hybris*, which meant disrespect to the gods and their paradigm; it had the meaning of excess, offence to nature, and not so much transgression of the God-given law of morality. Because

of the liberal ethics of the ancient world, there is no evidence to suggest that its erotic statues and representations had the effect of pornography, as we understand it today. It would be more fruitful and consistent with psychological information to look for the beginning of pornography at the end of the decline of iconography and the emergence of the materialist depiction. We can, for instance, note some examples of early pornography in two different cases in the paintings of Leonardo da Vinci: his aforementioned sketches of the body with their objectification effect, and all the paintings he made with the famous enigmatic smile of the Mona Lisa.

The portrait of Mona Lisa del Giocondo has drawn a great amount of attention from critics and audiences that line up before it in the Louvre. Its prominent and most famous feature is the smile on the face of the depicted woman, something that makes her appear mysterious, inviting and seductive, yet cruel and distant at the same time. Sigmund Freud used a quite descriptive source in his study of the Gioconda and the effect she has on viewers:

> What especially casts a spell on the spectator is the demoniac magic of this smile. Hundreds of poets and authors have written about this woman who now appears to smile on us so seductively, and now to stare coldly and without soul into space; and no one has solved the riddle of her smile, no one has read the meaning of her thoughts. Everything, even the landscape, is mysteriously dreamlike, and seems to be trembling in a kind of sultry sensuality.[57]

This is a characterization that foreshadows Freud's view on the painting. Not surprisingly, the scientist who coined the term "Oedipal complex" argues that the representation of Mona Lisa can be read on a deeper level as the representation of Leonardo's mother. This possibility of a subtext may have indeed had a certain place in Leonardo's life and work; however, its significance for us here lies in the painting's refusal to reveal its secrets – the woman on the canvas wants to remain a two-dimensional image, one with whom the viewer will never be able to relate in any other possible way. The painting becomes a mirror of the passion of the viewer, as it was a mirror of the passion of Leonardo himself. However, and this is one of the reasons I locate the beginning of contemporary pornography in the Renaissance paradigm shift, it is not a painting that could have been created by a woman, nor can it be enjoyed by a woman in the same way as by a man. It exploits, in a way, the sexual mystery of the surface and its appeal, and at the same time it signifies the lack of true contact between the passionate narcissistic viewer and the woman on the canvas. The passion of the painting is the passion of *absence*, whereas the passion of the medieval icon was the passion of *presence*. The icon reminds us that God is present, among us, and he gazes upon us from behind the surface of the icon, from where his eye was

painted before the colours were placed. It was this very discourse of presence that made the icon itself a holy artifact that participates in the honour and the glory of the depicted saint or of Christ.[58]

It is interesting to note here that the icon and the pornographic image are both functional representations, rather than symbolic ones. The viewer has a direct and personal relationship with them, and the meaning of their function lies in this affective relationship. They have no substance whatsoever outside of the response they try to elicit. Pornography has no meaning without the libidinal instinct that supports it, and the icon does not convey any meaning to someone who has no understanding of the sacred and of the religious feeling. In fact, the idea that an icon or any other religious object can be viewed as a cultural artifact only, without the reverence its creation presupposed, would be offensive to most believers, perhaps even blasphemous. The Seventh Ecumenical Council of Nicea in 787 declared that religious images are objects of veneration, and this view has not changed very much since then in the East or in the Catholic Church. The icon is succeeded by the pornographic image as an object of direct personal relationship that eludes and transcends the artistic evaluation. Yet, they co-exist today, representing the two opposite poles of an imagery that can only be described as meta-art.

It can be fruitful to examine pornography and the icon simultaneously. They share the nature of a trajectory, a discourse of desire in the first case, a soteriological one in the second. Yet, the similarity of their nature tempts us to discover an ontological connection between them, somehow decreasing the gap that places them at the opposite ends of a Freudian trinity. Desire and its mechanics can be, exactly like the faith in a divine plan, all-inclusive and all-encompassing in their intended holism. They both have an end destination on the individual and on the social plane, and they can both be extended to metaphysics. The main common characteristic is the promised salvation at the end of the trajectory. We may be fast to point out that pornography, and the psychological states (neuroses) that are related to it, often appear to be a static condition, as the pornographer substitutes reality with an artificial fantasy. However, my hypothesis is that this halt is due to the plane of lesser desire the pornographer is caught on, and attempts to escape from, acting out the fantasy over and over. Moreover, the equivalent of the sexual neuroses could be found in the area of religion as well. I feel strongly that the immeasurable crimes committed in the name of the institutionalized religions throughout their history should not be blamed on the needs and the insight that inspired them, but on the occasional lack of metaphysical faith and the pleasure it can provide. It should be possible to describe religious neuroses using the terminology of libidinal neuroses (religious fetish, religious sadomasochism, and so on).

Both pornography and iconography owe their existence to the accept-ance of an "as if" alternative reality, yet they aim to reverse it through their respective trajectories. Religion and desire both retain the memory of a blissful care, a womb and a mother or Paradise; they both register the attempt to return to it, as the aim of the neurotic, according to the Freud-ian psychology, is the attempted identification with the mother, which at a certain point he realizes cannot happen. Still, it is possible to view neuroses of this nature as stages in an interrupted development, at least to the extent that every psychological stage and trial, like the enigma of the Sphinx, leads to a broader knowledge. The resolution of each stage leads to a different level of awareness with its own challenges,[59] yet the final stage, or rather the desired destination, is usually not clearly visible to the one that undergoes the trajectory.

However, both the pornographic and the iconographic praxis are part of a therapeutic process, an internal healing that intends to compensate for the creation of the "as if" reality, by providing paths to the deeper parts of the psyche, the id and the superego, according to the Freudian classification, and bring as much as possible to the light of the conscious mind. Still, it is a very good question whether the structure of the psyche preceded the alternative reality, which filled in the two opposing voids it found (the superego and the id), or whether there is something in the nature of the triadic separation of the psyche that connects it ontologically to the alternative reality that haunts the human race since its birth in this particular way. In other words, was it the compartmentalized structure of the psyche that resulted in the two worlds of imagination, or was the creation of the multiple structure and imagination simultaneous, both being symptoms of the same step humanity took at a certain point in history?

We may not be in a position to answer this question conclusively, yet a major characteristic of the present age is the resolution of the opposites. Jung offers psychological data affirming that this stage was to be expected and is part of a greater trajectory of the human race, which reflects on our traditions and our religions. This religious wallowing is relevant to art and its investigation, because art, in a way, exists as a play of the opposites. First, art is a tool that allowed us to exist in the fantastic ("as if") reality, because it manufactured a world analogous to the real one, with the modifications that would appeal to us according to our moral, mental and psychological frames of reference. However, art has always been the guide out of the labyrinth of the simulations, as well; it is the connection between the projected and the perceived, the expression of the artist as well as the pleasure of the audience, fantasy and realization at the same time.

Interestingly, one of the ideals and the fixations of the Age of Reason (especially the Enlightenment) has been the development of the psyche in a way that would circumvent the ego (evident in the myths of the "wild child": reason was becoming conscious of, and at the same time was trying to deny, its negative face). The age was witnessing the emergence of a new aspect of the psyche, and in a maturing process, it was becoming conscious of its negative potential. The Renaissance was, undoubtedly, the age of the ego and the age of individuality. However, technology, the breakthrough in communications and transportations, and the discovery of the subconscious mind in our century, have allowed individuality and the ego to flourish and extend considerably; it is now possible to observe how the individual is becoming increasingly responsible for the world, and how it is imperative to become more independent in a changing economy. The vocational institutions of the present are not sufficient and the fast adjustments to new technological environments in the workplace, as well as the fact that most of us must now be prepared to change our vocation quite frequently, have become some of the biggest contemporary social problems, but are also indicative of a change in the social role of the individual. One's identity used to be largely defined by one's vocation; however, the present turmoil promotes an as wide as possible view of society and its needs, and this reflects a change in the identity of the New Age person. The extension of this evolution in the condition of individuality inevitably reaches the spiritual domain. The ideals of contemporary society include racial and religious tolerance (it is characteristic that the Pope spoke recently of other faiths and asked that they be respected). Difference is becoming less and less controversial, because everyone's culture, religion and worldview is, eventually (even if ideally) accepted within a postmodern world. However, the moral conventions of a society cannot be multiple, but they have to allow for the coexistence of everyone's freedom, and at the same time demand everyone's commitment. Ultimately, this process is going to place certain demands and expectations on the human psyche.[60]

The psychodynamics of the New Age person suggest that he has, finally, come in terms with his ego by adopting and nurturing it, and that the collective has to be re-negotiated on new terms, not within the community, the family or the factory, but within the psyche itself. The ego becomes the receiver and the transmitter that connects us to the internalized collective conscious. The desired goal of the ego is to compromise the memory of the primal Paradise (the Age of Innocence, and the womb), with the knowledge it has acquired after the Fall (birth and the subsequent socialization/rationalization). This is reflected equally on iconography and on pornography, and describes, I believe, their profound connection. I can see them as two parallel discourses of ego

transcendence, which, although so different in nature, are nevertheless driven by the same psychic desire.

It is important here to finally recognize the functionality of art that is neither pornographic nor iconographic, but personal/psychological. It can provide a safety valve, a balance mechanism, and a meditative technique for the artist and the viewer alike. An old music teacher of mine[61] used to say that art proves we are handicapped, because we need it as a walking cane. We are not strong enough to face the world without it, which, according to the religious tradition, we only do it now "through a glass, darkly". We can see the religious dimension of this problem in the fact that the Bible and the biblical apocrypha present a complete account of the trajectory of art within human civilization, something that supports on a psychological/archetypal plane the previous statements, from the Fall of the angels who taught the arts and sciences to humans, to the end of the arts announced in the book of Revelation, as discussed earlier.

Image and recognition

As it has been discussed previously, icons were made in a way that defied natural perspective, as well as "natural" colours, shapes, angles, sizes and ages of the depicted persons, etc. Although, as we have seen, no formal painting guidelines from the Middle Ages survive, one should not assume that the reason for the unnatural depictions was the limited technical ability of the artists, or that the technical language of the time was primitive. After all, the bases of iconography and its super-real, distorted reality were laid by the direct descendents of the people who invented the plastic arts, the study of proportion and perspective, and all the classical rules of duplicating reality "precisely and correctly". The shift to iconography was a conscious moral choice, and it had to do a lot more with the mission and the function of art, rather than with its artistic appreciation and critical acclaim. Relevant to this point, the issue of inverted perspective has been discussed elsewhere in this study from a semiotic perspective. It is also noteworthy that inverted perspective, as well as the rest of the non-realist devices of iconography, did not prevail, as it were, as a result of a series of technical and/or religious semantic decisions on the conscious level, but came about gradually, through the constant effort of iconography to express the spiritual, the supernatural and the super-rational.

One should keep in mind that, according to the artistic expectations of the Byzantines, iconography was producing quite convincing life-like portraits. Henry Maguire devotes a lengthy chapter[62] on this issue, in his book *The Icons of their Bodies*, arguing that icons were convincingly life-like to those who looked at them at the time. Maguire cites several cases of icons whose similarity to the depicted persons had been proven by the

recognition of those persons (St Nikon Metanoeite, St Irene of Chrysovalanton, and the Virgin in the vision of St Stephen the Younger) after their images. The most famous example is the recognition of Saints Peter and Paul by the Emperor Constantine the Great, who had seen them in his dream, in the icons shown to him by pope Sylvester. Yet, it is understandable that the modern observer can be somewhat apprehensive to accept the characterization of icons as life-like portraits, compared with images of contemporary naturalism.

Portrait types even older than the icons, such as the Hellenistic funeral portraits found at Fayoum, employed a technique much closer to the naturalist approach than iconography. It is doubtful, however, whether the external likeness of a person can always be considered a convincing representation of this person, especially if we are not familiar with the person in real life. A photograph of someone we know can be considered a satisfactory reminder of his or her personality, but we cannot expect someone who is not familiar with the depicted person to have the same response. The question is what can an image tell us in order for us to have an understanding of who that person is, what were his or her thoughts, and, ultimately, why it is important to look at his or her picture. Every age sets its own conventions about what is expected in an image and how *life* is to be captured in it, depending largely on the relationship of the viewer with the image, the viewer's expectations. The convincing representation for the Byzantines had to do with the successful entry of the icon into the discourse of hagiography. It is perhaps not a coincidence that the word used then to describe iconography (and still used by iconographers) is hagiography. The saint was successfully depicted if certain signs associated with him or her, such as the liturgical vestments of the bishops, medicine boxes of doctors as St Panteleimon, etc., were clearly depicted as well. Maguire describes this as an issue of definition.[63] A saint was accurately portrayed when he or she could be identified not by virtue of an illusionist technique that presented a person in a way comparable to natural vision, but when he or she could be recognized for *the* person they were. The icon was attempting to capture the identity instead of the surface. We can find an example of how important this was, in the account of the impression of a Byzantine cleric of the fifteenth century, Gregory Melissenos, when he entered a Western church granted to the Greeks during the Council of Ferrara (1438):

> When I enter a Latin church, I do not revere any of the [images of] saints that are there, because I do not recognize any of them. At the most, I may recognize Christ, but I do not revere him either, since I do not know in what terms he is inscribed. So I make my own [sign of the] cross and revere it. I revere this sign that I have made myself, and not anything that I see there.[64]

Post-medieval Art and Thought

It is only in the Renaissance that we came across the concept of the artist as a different, charismatic person the name of whom has to be known and to be passed on to the next generations. The artist, just as the scientist and the thinker, became the prophet of the new era, if not its saint. It is generally agreed that by the term humanism we mean a cultural shift that emphasized the personal worth of the individual and the central importance of human values, as opposed to religious belief. It can be seen as a shift of focus from Heaven to Earth, and the replacement of the theocentric universe by an anthropocentric one. The notion of the charismatic person that transcends the limits of his age, something like a predecessor of Nietzsche's *Übermensch* who replaces the dead God, can be found here. It can perhaps be observed for the first time in the philosophy of the "renegade Dominican" as Balthasar,[65] called Giordano Bruno, one of the best-known writers of the Italian Renaissance.

Bruno's much studied cosmology can be also described as the dream of a Jungian psychologist: the cosmos, according to Bruno, consists of two "unfathomable" trinities, a trinity of Darkness (chaos, abyss and night), and a trinity of Light (pater-pleroma, primus intellectus-nous, light-spirit).[66] As was the case with some dualist views, as well as with Jung, Bruno does not speak of a final conquest or absorption of darkness by light (or the reverse), but of a balance between them. The two trinities are "unfathomable" because they correspond to the "intoxicating experience of the bottomless height, depth and glory of Being".[67] The universe depends on the union of the opposites. Moreover, Bruno sees the spiritual strife of man as an attempt to be in union with the cosmos, to comprehend or possess the *coincidentia oppositorum*, even if, as Balthasar says, "it tears him apart".[68] A theme from pagan mythology Bruno used to illustrate the power of this danger was the myth of Actaeon and Diana. It is interesting that Artemis/Diana has a special significance for Bruno, being the shadow of her brother Apollo, who, being identified with the sun, cannot be seen directly. Although Jung had an extensive knowledge of medieval sources, I am not aware of any writings of his on Bruno, but, having based a great part of his psychology on the psychological concepts of the shadow and the *coincidentia oppositorum*, it is certain that he would find statements such as this very interesting from a psychological point of view:

> For no-one can see the sun itself, the universal Apollo and the absolute light in its highest and most withdrawn form, but one can see his shadow, his Diana, the world, the universe, nature, which is in things, the Light which is reflected in the darkness of matter, that which shines in the darkness.[69]

In Bruno's philosophy the ascendance of the soul and the union with the cosmos has little or nothing in common with the neo-Platonic concepts of return to a (Father) God. Eliade sees in Bruno a revival of Egyptian magic Hermeticism[70] with a simultaneous shift from an anthropocentric and geocentric universe to a heliocentric one. On the other hand, whatever the cultural roots of Bruno's beliefs, they demonstrate a change of the *locus* of spiritual activity from Heaven to Earth, since man cannot rely on divine intervention, and even if it were to happen, it could be catastrophic, as in the myth of Actaeon who was devoured by his own dogs after Diana transformed him into a stag. Balthasar, therefore, observes that in Bruno's philosophy prayer does not have a place; it is up to the individual – the hero – to attempt cosmic union. Bruno's philosophy was quite influential, and it can be reasonably said that humanism is very much indebted to his ideas. As Balthasar wrote:

> Bruno becomes secretly father of the modern religion of the cosmos; Spinoza and Leibniz are decisively indebted to him; on him Schelling will build further, and when Herder and Goethe say 'Spinoza', they really mean Bruno.[71]

Bruno is symptomatic of the emancipation of human spirit from religion, which is almost synonymous with the secularization of the world and the secularization of art. His ideas express the Renaissance spirit and they became the basis on which later writers and artists based theirs, but perhaps we should push this investigation a little further, from a sociological point of view, and examine the humanistic turn from another perspective. It would be useful at this point to sketch a brief account of the development of perception from the Middle Ages to date. To this end, we shall follow mainly the thought of Michel Foucault in his signal work *The Order of Things*.

Perception and art in the Middle Ages was ordered by the epistemic rules of anagogy.[72] According to anagogy, every kind of knowledge depends on God, but the difference between the infinite God and the finite world means that, since there is no possibility of immanent knowing, anagogy bridges the gap and translates the immutable being into the transient becoming: every kind of becoming is created by and can be known only by reference to the transcendental being. The world was, as it were, a set of signs emanating from God, and intellect had to be firmly grounded in faith. Anagogy, therefore, was "the set of epistemic rules which ordered the intellectual knowledge of becoming in terms of faith in God's absolute being. Knowing the immanent from the standpoint of the transcendent, the medieval intellect delighted in the play of signs as figure, metaphor, analogy, symbol, and vision."[73]

The open structure of the medieval universe corresponded with an emphasis on oral culture, or, more precisely, the mentality of oral culture

applied also to writing and painting. Oral culture is open to constant interpretation; in a sense it depends on (anagogic) interpretation for its meaning. The icon could only be understood through reference to the divine. The meaning of what is to be communicated was beyond the words or the images, and in this sense truth and the meaning of art could only be expressed from within subjectivity.

The "epistemic order of the Renaissance", to use Foucault's expression, replaced the rules of anagogy with the rules of resemblance or similitude. In the epistemic order of the Renaissance "to search for a meaning is to bring to light a resemblance. To search for the law governing signs is to discover things that are alike... The nature of things, their coexistence, the way in which they are linked together and communicate is nothing other than their resemblance."[74] Replacing the medieval anagogic subordination of the transient becoming to the absolute being, the Renaissance proposed a "converging, centripetal world of order".[75]

Foucault tells us that the model of Renaissance understanding was based on an analogy between the macrocosm and the microcosm, with the human being located at the centre of the universe (an idea that can be traced to Plato's *Timaeus*, which passed to the West through John Scotus Eriugena's elaboration on the writings of Dionysios the Areopagite and Maximus the Confessor). Analogy, however, as it was developed in the Renaissance, implied a kind of separation between the microcosm and the macrocosm, or Earth and Heaven, as opposed to the Dionysian concept of hierarchy, a concept that "connotes inclusion and union"[76] throughout the entire Cosmos. In the discussion of the *Mirrors* of Vincent of Beauvais earlier, we saw how the separation of the two realms was evident since the late Middle Ages.

The four essential kinds of the Renaissance similitude were *convenientia*, "a resemblance connected with space in the form of a graduated scale of proximity",[77] *aemulatio*, "a sort of 'convenience' that has been freed from the law of place and is able to function without motion from a distance",[78] *analogy*, in which "convenientia and aemulatio are superimposed",[79] and *sympathy*, which "excites the things of the world to movement and can draw even the most distant of them together".[80]

The hierarchical, centripetal Renaissance universe corresponded with a separation of the subject and the object of observation. Since the late Middle Ages, written word was gaining importance over the spoken word. Michael Clanchy presents a series of cases from the eleventh to the thirteenth century which demonstrate the increasing significance of writing, especially in matters of law.[81] Perhaps the most revealing example is the Magna Carta, "the great precedent for putting legislation into writing".[82] It is particularly interesting that by 1300 significant emphasis had been put to seeing the document instead of it just being read to the people.

Clanchy mentions the case of the Archbishop Pecham of Reading, who had ordered a copy of the Magna Carta to be posted in every cathedral and collegiate church, "so that it can be read by the eyes of everyone entering".[83] Seeing was gradually replacing hearing and, despite the persistence of an underlying popular oral culture, the advent of typography tipped the scales decisively. This meant that the body of knowledge or the work of art became an object to be gazed upon. A dynamic distance can be observed between the reader and the text, as well as between the viewer and the picture. The icon became incomprehensible according to the rules of resemblance, because that which it represented could not be seen by the eye, or because the divine Other behind it was lost in the hierarchical, anthropocentric universe of the Renaissance. The immediate reference to the divine was also lost, as we saw in the discussion of the philosophy of Giordano Bruno, and this meant that the perceptual rules of resemblance presented the same emancipation from theistic reality as Bruno's philosophy did.

The order of similitude was replaced, in the seventeenth and eighteenth centuries, by an order of representation in a dynamic space: "The circular world of converging signs is replaced by an infinite progression."[84] Modern science as we know it emerges here, and it is no coincidence that what Foucault calls the "Classical time and thought" corresponds to what is generally known as the "classical", golden age for the arts. Reason, comparison and measurement replaced the Renaissance hierarchy of similitude. Similarly, the semiotics of the universe was based on forms, magnitudes, quantities and relations of objects, everything that could be measured and calculated. The work of art had become a text with many variables that had to be connected with each other as the parts of a machine, something that can be observed especially in music. The classical period saw the rapid flowering of the sonata form and the first maturity of the symphony, the solo concerto, the solo piano sonata, the string quartet, and other forms of chamber music. During this time the orchestra was expanded, in both the number and the variety of instruments.

In the epistemic order after the industrial revolution, time gained a more central position. "The logic of identity and difference was enhanced by one of analogy and succession."[85] The new epistemic order was based on development-in-time, transformation, and evolving structure. Art, accordingly, attempted to incorporate the element of time, and it is no surprise that this era ends with cubism (one of the basic principles of which is representation-in-time) and cinema, the "moving pictures". Cinema critics have pointed out that a kind of non-photographic moving picture could have been invented as early as in antiquity. André Bazin argued that the invention of the moving pictures in the nineteenth century instead of, say, the sixteenth, cannot be explained on grounds of

scientific, economic or industrial evolution, but it has to be seen as part of a wider artistic trend towards "total cinema", a complete representation of life, and it is only in the nineteenth century that this trend reached the maturity, as it were, to combine image and movement.[86]

The last of the epistemic orders corresponds with a revolutionary change in the twentieth century, and is still the epistemic basis of the contemporary world. The culture of typography was replaced by electronic culture, in which sound, image and word converge. This change brought about many difficulties in the old order. The modernist claim that analytical reason can develop connections with the objective concepts of time and space does not reflect the relativity of the new epistemic order. However, although Kant in the eighteenth century had already posited a similar restriction of reason in relation to absolute time and space, the postmodern order addresses this restriction more radically. Knowledge is reduced to something very reminiscent of the observations and interpretations of a mathematical chaotic system; it recognizes the inherent tendency of constructing units, independent from time and space, towards larger systems. Those units, moreover, are identified only by their difference from each other and, therefore, their relative ability to form a system, with no reference to a central, absolute point. Postmodern art has shown comparable tendencies. The problem of differentiation between subject and object, as well as the question of the possibility of objective knowledge, have returned, and the structure and the conventions of art acknowledge the new reality.

As expressed repeatedly by several writers like Ernst Gombrich,[87] artistic expectation translates itself into perceptual expectation. Art, and especially representational art, should not be taken only as an expression of our present view of the world, but it should be considered one of the factors that create our *Weltanschauung* and what we think the world looks like. Gombrich proposed that, in a way indebted to the scientific method, artistic conventions reflect the perceptual expectations of the people who accept them. As new developments from within art challenge the artistic conventions of the past, perceptual limitations themselves are challenged, and lead in turn to a new series of artistic conventions and perceptual limitations or *schemata*. Gombrich has illustrated that the naturalist perspective brought about a new series of problems to visual representation. Representation in post-medieval art is not independent from the expectations or from the visual education of the artist or the audience. Every artist or school of painting teaches us how to look, and in doing so establishes a different framework of implicit representational conventions. Even if the desired goal is the faithful depiction of what one sees, it is hard to accept that in *seeing* one does not follow exclusively what previous generations of artists and representational conventions have taught. This

mechanism is dynamic, however, because the difference between "the image of the retina and the image of the mind",[88] the inconsistencies of every framework, are pointed out by the next generation of representational artists, who modify it in order to answer some of those inconsistencies. Yet, the framework remains, even modified, and it is not possible to ignore the pictorial tradition that dictates the way artists observe the world.

One of the examples Gombrich cites to support this view is Dürer's woodcut of a rhinoceros (1515).[89] Dürer had never seen a rhinoceros, and he had to rely on other people's descriptions. His representation, therefore, looks grotesquely unreal, a "dragon with its armoured body". Yet, this strange creature has been the basis for many subsequent sketches of a rhinoceros, even for sketches made by people who had seen one themselves, such as Heath, who drew a rhinoceros for Bruce's *Travels to the Source of the Nile* (1789). Maybe Heath himself was not aware of the influence, but his drawing looks more like Dürer's woodcut and less like an actual rhinoceros. Gombrich seems to argue that had photography not been invented, offering a different kind of representational convention, we would never be able to have the *Essential Copy* of a rhinoceros.

This kind of perceptual/artistic development is comparable to Karl Popper's principle of the "priority of the scientific hypothesis over the recording of sense data".[90] Popper's influence is evident throughout *Art and Illusion*, as Gombrich himself recognized.[91] The work of the scientist, as described by Popper in *Objective Knowledge*, is a "continuous cycle of experimental testing".[92] A problem is followed by a trial solution, a hypothesis that can possibly explain it. An experimental situation can be devised, by which some aspects of the problem are explained, but new problems may be revealed from it. Art, according to Gombrich, proceeds in exactly the same way towards the Essential Copy. Norman Bryson has argued, however, that there is a weak link in the formula "Problem", leading to "Trial solution", leading to "Experiment", leading to "New problem";[93] different trial solutions, intuitive even for science and a lot more so for art, can lead to different problems, or to different lines of scientific or artistic development altogether. As there can be no single trial solution, there can be many approximations to the Essential Copy, not better or worse from each other. Ultimately, however, we cannot know if the Essential Copy is actually approached: the only thing the scientific method can prove is that the trial solution was wrong, and we are not in a position to really know whether the new situation we start with is closer to the target. Bryson described this process as cyclical instead of linear, meaning exactly that there is no objective way of knowing whether the change consists of a progress or not:

> Between Cimabue and Giotto there is certainly change, but our decision to call it advance rather than to categorize Cimabue and Giotto as two equally invalid 'false

starts' will depend on their degree of approximation to the Essential Copy: the latter is essential to the doctrine of progress, even when Giotto's advance beyond Cimabue is alleged to consist in the elimination of Cimabue's errors. And as long as the Essential Copy remains a necessary component in the theorization of painting, analysis of the image will continue to preclude the dimension of history.[94]

The thought of Gombrich and Popper expresses the scientist and the artist who have placed their faith in the process of development itself, even if the Essential Copy appears infinitely inaccessible. In that, they would conform to the epistemic rules of the modern age as defined by Foucault, while Bryson's criticism seems genuinely postmodern.

On the other hand, our approach to representation and the Essential Copy has been profoundly affected by the invention of photography. Technology provided the means to attain an "objective" depiction, without the direct intervention of man, but this also meant that the concept of the "original" work of art was lost; it does not make sense to speak of an "authentic" or "original" photographic copy, since all of them are equally "authentic" or "original". Walter Benjamin discussed the loss of the "aura" of the work of art in the age of mechanical reproduction, in a very influential essay.[95] In a way that anticipated the discourse on the withdrawal or death of art, he noted that "the instant the criterion of authenticity ceases to be applicable to artistic production, the total function of art is reversed".[96] According to Benjamin, the work of art has now transcended the Renaissance "cult of beauty" which has been influential for three centuries, and entered the world of politics – a reintegration of the separated realm of art into life.

The initial reaction of traditional art to the dangers brought about by photography was the movement of *l'art pour l'art*, understood by Benjamin as "a theology of art".[97] This movement towards "pure" art, the first instance of which is located by Benjamin in the poetry of Mallarmé, believed in an art above social necessity, and it therefore denied any social function to art, and resisted any categorization of subject matter.[98] Social necessity, however, proved to be stronger than "pure" art, especially in our days. In the world of politics, which for Benjamin was the next arena of the work of art, both possible approaches, socialism and capitalism, attempted to define art according to the very social function "pure" art reacted to – be it *via* social realism or commercial art. The integration of art into general social practice can be observed here. Photography and cinema, by all means creations of humanism and the scientific revolution, established the framework within which art withdraws as a separate practice, in other words the death of art.

3 The "Death of Art" in Postmodern Philosophy

The problem of the "death" or withdrawal of the author has been approached in postmodern criticism so much that it would not be inaccurate to say that it is one of the issues that identifies postmodern thought as such. The Western sense of culture is so much indebted to the concept of the Author-Creator that it is impossible to criticize modern culture without stumbling on it. Yet, even postmodern thought, with its often iconoclastic zeal, has not paid equal attention to the conceptual framework of authorship, with few exceptions. Let us then take the discourse on the death of the author a step further here, and connect it with the discussion of the death of art, or rather, let us use the discourse on the death of the author as an entry point for the examination of the death of art. Truly, the ramifications of such an induction are much more far-reaching than the examination of art, and one could develop similarly the concepts of "death of writing" or "death of science", or even "death of thought". Of course, the expression "death" has to be taken with a grain of salt. Death, in this sense, is what precedes a regeneration, a renaissance, on different grounds than the ones that made necessary and, finally, gave birth to the "dead" concept or practice. The figure of the author in Western culture is connected to two things pertinent to the present analysis, which will be examined at some length. One is the meaning of the concept of the author and his authority in Western culture, and the other is the identity of the author as the initiator of art. The recognition of an author as a respected or renowned thinker entails some kind of intellectual or artistic authority that somehow precedes, or at least accompanies, his writing.

The concept of the author is almost as old as written language, or rather written thought. Even "texts" whose origin precedes writing have been occasionally handed to us under the name of an author (such as Homer's epics) who validates them, if not as an original writer, at least as an editor. When the phonetic alphabet was put into wide practice by the Greeks, thought passed from the ear to the eye: A text that could codify the thoughts of its writer in a way that allows itself to be examined, analysed, dissected and criticized in an "objective" way (as an "object") would not dissolve into oral collective tradition. Certain systems of thought committed to writing by certain authors deserved a grouping that was not possible earlier, but at the same time brought about the concept of an

author as an initiator of a (world)view that could be expressed on many levels and developed into many fields. This is how we came to recognize Plato and Platonism, Aristotle, the Stoics and the Skeptics, and other schools of thought. Similarly, this is how tragedy and poetry became influential after their writers were long gone. Unfortunately, we cannot claim the same for all kinds of art. The visual arts were fortunate enough to maintain a continuity, from the statues and paintings of antiquity to the icons and paintings of the Middle Ages, the statues of Renaissance, and contemporary painting, even though not much remains of ancient Greek painting. Almost nothing remains from the musical tradition of antiquity on the other hand, and it is only much later, when a system of music notation, practical enough to be read and studied by people who could not necessarily be given direct instructions by the composer of a musical piece, was invented, that we can talk about the composer as the author of music. The situation is even more dismal in dance; standard choreography systems were only recently developed, and they are not very accessible to lovers of the art without formal dance training.

It has to be said, however, that inspiration and the "gift of art" usually came from the outside in antiquity and the Middle Ages. The *Iliad* and the *Odyssey*, for instance, begin with an invocation to the muse. The poet invokes the muse to sing the wrath of Achilles (Μῆνιν ἀοιδε, θεά, Ἀχιλλῆος), and it is the muse who sings the adventures of Odysseus to and through the poet (Ἄνδρα μοι ἔνεπε, μούσα, πολύτροπον), not the other way round. It is only relatively recently, in the Romantic era, that the authorship was unequivocally identified with the artist.[1] We cannot be sure, therefore, that the concept of the author always had the same meaning it does today. As such a concept, it is more an invention of criticism rather than an artistic idea.

Nevertheless, as far as our civilization is concerned, the examination of a body of work in a critical sense, more or less as we understand it today, can be traced, according to Michel Foucault,[2] to hagiography and the authentication of the writings of saints and Fathers of the Church, perhaps because florilegia (collections of writings) before the Christian era were too eclectic to be compared to contemporary criticism.

Foucault discusses the problems encountered by St Jerome, a forerunner of literary criticism in that respect, and his critical methods. St Jerome addresses the concept of the author in terms that set its tone for the following centuries. In *De Viris Illustribus* he argues that texts which appear under a single name do not necessarily belong to one author; homonymy does not necessarily prove that several works can be attributed to a single author, since many writers may have shared the same name and since one might have composed a work under another writer's name or persona. A famous example that can be used to demonstrate Foucault's

(and St Jerome's) argument can be found in the writings under the name of Dionysios the Areopagite, an Athenian saint of the first century AD, who according to tradition was converted by St Paul, and became the first bishop of Athens. It is now generally agreed that these writings were written some time around the sixth century, probably by a Syrian monk who had assumed not just the name, but the entire *persona* of St Dionysios. The assumption of the persona of the real St Dionysios can explain why no references to events after the first century can be found in the writings of (pseudo) Dionysios. A kind of literary investigation has to be carried out, therefore. Foucault observes that four criteria are employed by St Jerome in order to ascertain the authenticity of the works of an individual: (1) works of lesser quality should not be considered as works of an author whose writing is considered to be of higher quality, and thus a kind of standard level of quality is accepted; (2) works that contradict the main body of writing in doctrinal matters should also not be considered being written by the same author. This implies that the beliefs of an author are supposed to be, or expected to be, consistent throughout his lifetime; (3) works written in a different style, using words or expressions not found in the recognized corpus, should also be rejected. Stylistic uniformity and consistency is a criterion. Finally, (4) works that mention events or persons subsequent to the death of the author have to be rejected. The author has a particular place in time; he is a definite historical figure.

What we see here is a method that has not radically changed throughout the centuries that followed. The needs of modern literature and medieval hagiography may be different, but the concept of the author as a source to examine critically and then use as an authority for an argument has survived. At this point we should keep in mind that the idea of authorship in the early Christian years took its value from the acceptance of something that was beyond words and language: the truth was received or attained by holy men and women who would then commit it to writing, but this process was compromising, because divine truth is beyond the realm of words, beyond the realm of the ordinary. St Paul and St John the Theologian are two of the earliest Christian writers who described their transcendental experiences or visions, but their writing alone cannot easily guarantee that these were the visions of saints and not of schizophrenics. Any ancient or modern doctor would raise an eyebrow if someone were to say that he found himself in the third heaven and did not know whether he were with or without his body, or that he had a vision of monsters with ten horns coming out of the sea. The text itself was therefore not enough to guarantee the truth of its meaning. That also means that the meaning of a phrase depended greatly on who said it and what we may infer about its context. A simple statement like "Christ is the Son of God" attains a completely different meaning, depending on

whether it is attributed to Arius or to Athanasius. In that sense the personhood of an author maintained a primacy over the text that appears under his name, although once the authentication, translation and exegesis of the works of an author had been accomplished, there was no need to remember that the "author-function" corresponded to an actual person, and the text itself was as revered a source as the saint himself. Of course, it can be argued that the text is *more* revered and valid than the author himself, because it has assumed a *legal* function, whereas *personal* truth tends to be elusive and subjective. The text, more than anything else, has been used to found institutionalized religion. Extreme as it may be, the example of the confrontation between Christ and the Grand Inquisitor in Dostoyevsky's *The Brothers Karamazov* makes exactly this point.

This attitude was inherited by modern literary research. An anonymous piece of writing was an enigma whose solution had to be sought. Every effort had to be made to identify its author and the date, place and circumstances of its writing. A text had to belong to an author, and this belonging eventually attained the status of legal property toward the end of the eighteenth century and the beginning of the nineteenth. Foucault argues that this occurred in order to harness somehow the transgressive nature of writing. Discourse in our culture was not a thing, a product or a possession, but "an action situated in a bipolar field of sacred and profane, lawful and unlawful, religious and blasphemous".[3] In other words, free discourse can present a danger to a rigid social structure, and the course of action in this case would be to identify the initiators of such discourse and hold them responsible for it, whether this meant that the text and the author were to be recognized as a (social) authority, or as subversive agents. Undoubtedly, the sociological nature of Foucault's approach is quite evident, because this observation supposes a social structure that attempts to contain the elements that may possibly harm it, in this case by appropriating or discarding them. The contrast between social structures and the individual is a recurrent theme in Foucault's writing (central in works like *The Birth of the Prison* and the *History of Sexuality*, for instance), which could be questionable as a basis for such research, because it is almost exclusively interested not in the concepts as such, but in the way they reflect and provide the framework for the development of modern society. That means that although Foucault's view seems justified within post-antiquity Western society, it may not necessarily be impervious to criticism in a different social setting.

Yet, Foucault recognizes that even within our civilization there is a kind of discourse that does not need an author. Stories and folk tales were accepted without any question about their author, their real or presumed age being a kind of guarantee for their authenticity. Still, such secondary discourse never rivalled the status of "authored" texts, even in the

Middle Ages. Texts under the name of Pliny or Hippocrates, argues Foucault, "were not merely formulas for an argument based on authority; they marked a proven discourse".[4] It is only much later, in the seventeenth and eighteenth centuries, that scientific texts emerged on the basis of their value alone, which initiated a different system of authentication and verification, although literary texts were still only acceptable under the name of an author.

From the point of view of criticism, however, the author is more or less a projection of psychological nature: although we may actually have very little information about the true identity, or the true opinions and feelings of a writer, the construction of an author, a persona behind the text, makes the handling of the text immensely easier. It is possible for a text to be completely misread under a falsely constructed persona of its author, maybe not so easily in scientific writing, but certainly in non-verbal discourse, the other end of the spectrum. Such an example is Dmitri Shostakovich, who although was the semi-official representative of Soviet music for many decades, reveals a completely different person in his memoirs, published under the title *Testimony*, one who deeply resents the communist system and fears for his personal safety on an almost daily basis. Whether this affects the value of his music is an open question for criticism; Shostakovitch did not betray his musical ethics, but he tried to conceal them as much as possible in the ambiguity of his music, at least ambiguity with respect to the specific identifiable political ideas he had to juggle. Moreover, even with artists like Sergei Eisenstein who aligned themselves completely with the communist regime, one may discover different layers of meaning that rise above political discourse. The master of montage helped create a new language in cinema, and his films, like D. W. Griffith's racist *The Birth of a Nation*, cannot be judged on the basis of the (presumed) ideas of the author alone, but have to be taken as a multiple and complex text that may tell us more about itself than its author would. Another example from cinema is Fritz Lang, whose *Metropolis* was admired by Hitler, presumably for all the wrong reasons. Thea von Harbou, however, who was the original script writer of *Metropolis*, Lang's co-author at the time, never hid her Nazi sympathies, and when Lang emigrated for America in order to avoid working in Hitler's propaganda industry, she stayed back and worked happily under the Nazi regime. *Metropolis*, nevertheless, was thought by both Lang and von Harbou to express their respective views, and it would be therefore inaccurate to identify the text with the one or the other author.

The author-function is not necessarily so much an invention for the convenience of the reader as an invention for the convenience of the critic: the author explains the presence of certain elements in a text, as well as their transformations, distortions and various modifications. The

personal biography of the author, as well as the social conditions he lived and wrote in, in addition to any views he was known to have, even our psychological analysis of the personality of the author from what the texts allow us to use, all these constitute a persona which criticism may take material from in order to interpret, connect and explain away the peculiarities of a body of work. In a kind of textual fetishism, the author's eccentricities or personal faults may assume a central role in the reading of a text. It is, therefore, often said that "Baudelaire's work is the failure of Baudelaire the man, Van Gogh's his madness, Tchaikovsky's his vice".[5] Still, inasmuch as the presence of a personality behind the work is assumed, one of the most important functions of the author on that level is the resolution of any apparent contradictions in his work, as if the presence of a single mind, responsible for the work, assures the reader or the critic that whatever incompatible elements can be found in a text must somehow be resolved on a higher level of reference. The function of the author here is to guarantee a kind of unity in the little universe that is the work, and therefore make it possible for the closedness of the text to be maintained. The "closed" or "open" text in that sense has been a critical issue for almost forty years now, at least since Umberto Eco's seminal *The Open Work*. The question about the "closedness" or "openness" of a work is really a question about the internal (assumed) unity of a work so that the closed work exists in a self-contained space, whereas the open work first acknowledges the paradox of this practice, and then involves the reader not in an illusion of the unattainable completeness, but in a presentation of the process of writing itself, which, if we follow Lyotard's call for the postmodern as that which constantly evolves and breaks the rules that set it as a paradox of the future,[6] always attempts to evade textualization and become part of what is outside the text. All this alludes to a theological problem the historical beginning of which was discussed in Chapter 2: a closed text aspires to be a little independent universe and the author poses as its Creator. The work of art was not as distinct and independent before the Renaissance, when art in the Christian world assumed a more functional position, connected to a practical or liturgical role. In that sense, and since the analysis of the present forces upon us such a review of the past, the present condition has to include that theological insight: the signs of the times show that postmodernism may result in the biggest religious event since the Reformation.

Still, there is something more to be said from the reader's perspective. The above questions are valid from the critic's point of view, or rather it should be noted that they are associated with the kind of semiotic criticism that focuses on the text itself. Rather than exploiting the old contrast between semiotics and phenomenology, however, we should be

interested in the analysis of the text, but also in the observation of the artistic process as a whole, and especially in its interaction with the reader.

First of all, it is no longer accurate, or rather acceptable, to think of the author as the initiator of a discourse that flows exclusively out of his creative self. According to contemporary criticism, scientific writing as well as literature, music as well as the visual arts, are all indebted to previous writers who created a tradition in their respective field. Any piece of writing consists of a plethora of ideas that occur in previous writings, which blend and clash. Any text is "a tissue of quotations drawn from the innumerable centers of culture",[7] and the author is reduced to a compiler, an ingenious editor perhaps, who will assist the reader in his discovery of the material, or will, at best, propose a certain reading of older texts. To connect this thought with the previous point about the open text and the Author-Creator, it is no longer acceptable to assume that the text contains a single "theological" meaning, as Roland Barthes put it,[8] the message of the Author-God, but a much more complex and multidimensional field of ideas.

This corresponds with evidence provided by the kind of psychoanalysis (especially Jungian psychoanalysis, which accepts that the psyche consists of many "splinter" psyches with a great degree of independence from each other) that demythologizes the concept of the self as a rational being with a solid identity. The self is not a static being, but is defined by innumerable actions and choices on conscious and unconscious levels that may not be consistent with each other. Put in simpler terms, a normal individual consists of many partial personalities or personas, behaving or rather "being" somewhat different with one's colleagues, family, friends, but this division extends largely to the unconscious. What Jungian psychology calls complexes (a characteristic of the normal psyche in Jungian psychology – splinter psyches – unless one or two of them "take over"), but similar concepts in other schools of psychology as well, are largely a product of ancient archetypes or social factors, or other kinds of external influences. On this basis we cannot speak of a single total expression of the self into writing or art, because, leaving aside the problem of what can and what cannot be expressed, such a total personal expression is not feasible, at least not to the degree that one could say that the personality of the author as a single initiator of *linear* discourse is reflected in the text.

The convention of the author-function, however, suited the practice of criticism extremely well. The removal of the author renders the aim to decipher a text futile. The presence of an author implies the closeness of a text, and corresponds to the presence of a final signified, which can ultimately explain, or rather explain away, a text. Of course, in that sense removal of the author has been seen by postmodern criticism as the

removal of the critic and criticism. As noted above, art and writing can function extremely well, and this has happened in the past, with no need for the professional author or the professional critic.

Still, there is a kind of unity in any text, but it can be perceived and explained when we look for its centre at the other end of the artistic process: The reader (or viewer, or listener) is the focus of the multiple diverse quotations from different cultures and times that make up a text; it is he who provides a hypostasis for the text. The reader, however, and this is a great difference between the Author approach and the Reader approach, is impersonal, without biography, history or psychology. Postmodern criticism, accordingly, distances itself from the anthropomorphism of classic criticism, and defends the rights of the reader, so to speak.

This point will be brought up again later, but at this stage I would like to discuss a special kind of author, not just the initiator of discourse in general, but the initiator of artistic discourse: the artist. The artist, or author of art, is the figure that assumes responsibility and provides conceptual unity for the work of art, and should be considered conceptually identical to the author as far as the discourse on the death of the author is concerned, but most postmodern thinkers have generally developed their discourse using language borrowed mainly from literary or scientific critical tradition. The artist, nevertheless, is often seen as the creative, as opposed to just intellectual, genius whose insight marks great art. Art history, as it is still taught in schools throughout the world, owes its structure to the romantic ideas about art and the artist, and is almost synonymous with the history of the author as artist.

One problem contemporary criticism had to deal with, with respect to the concept of the artist, is the possibility of a single individual responsible for the work of art. Contemporary art, perhaps with the exception of painting, is created, technically speaking, by many artists who collaborate towards the creation of a single work of art, each from a different perspective and a different role (composer, performer, director, editor, writer, etc.) and to such a degree that an artistic result is shaped by the input offered by all of them. The best examples for this view can be found in cinema, which has developed into an artistic industry where it is inconceivable for an artist to have sufficient technical knowledge or control over the entire process of filmmaking. A cinema student may discover a certain stylistic consistency in the films directed by John Ford, for instance, but another kind of stylistic consistency may be also found in the films photographed by Gregg Toland. The name John Grisham, on the other hand, is usually enough to attract a certain kind of audience and to prepare it for the kind of film it is going to see. The same overlapping can also be observed in music, or wherever art has evolved to a greater

structural complexity, from the moment of the first inspiration to the moment art reaches the audience. John Tavener has composed, having in mind the particular sonority and the technical capabilities of the London Sinfonietta or the Tallis Scholars, for instance, while the Kronos quartet has commissioned a work by Phillip Glass, and in this sense, a work of art may owe its existence, artistically speaking, both to the composer and to the performer. It is hard to say who is the author-artist in these cases, but it is probably not easy to claim anymore that a work of art can be attributed to the creative force of a single individual. The artists have formed a cast or guild of their own, as it were, which includes a structure of marketing and opinion polling, and can be said to be collectively responsible for contemporary art, generally speaking. Moreover, classical and popular art alike have long ago abandoned the maxim *"Ars gratia artis"* (although this phrase is still the motto of MGM), and, quite consistently with the general observations on the discourse on the death of the author, have turned their interest towards the audience. Art is not, for the most part, supported by rich sponsors, as in the time of Haydn and Wagner. Instead, it is either supported directly by its wide audience, as in the case of commercial, popular art, or, at least partly, by government grants, which also reflect the interest of the audience, albeit in a different way. The feedback of the audience, directly or through arts councils, defines the course of contemporary art more than any creative artist could. Hollywood, for instance, has never been as powerful as it is today, and the marketing of companies such as ECM or *Nonesuch* obtains support for works that would otherwise be lost within commercial competition, by targeting a particular audience and building a trust-taste relationship with it. Although the stocks of the art market, so to speak, are still identified and measured by names of artists, it is more accurate to say that Arvo Pärt, for instance, was created by ECM as an author-function – although definitely not as a composer – than to say that ECM is a company that became successful because of artists like Arvo Pärt. The case of ECM is especially characteristic, because its director, Manfred Eicher, does not normally accept project submissions, but does actively and personally seek and promote artists that fit the artistic profile of the company. Ultimately, the artistic choices and the taste of Manfred Eicher are more influential than the choices and the taste of a single composer.

The concept of the author has been approached from various angles in contemporary criticism. Insofar as literary criticism is concerned (although this argument can easily be generalized to include music and the visual arts, any kind of artistic discourse), the physical person of the author and the cultural structure conventionally identified as the initiator of a body of work can, and may, be completely unrelated. The author exists by virtue of the text, or rather he exists in the text. As Michel Foucault put it, "in

our culture the name of an author is a variable that accompanies only certain texts to the exclusion of others. The function of an author is to characterize the existence, circulation and operation of certain discourses within society."[9] What Foucault has called the "author-function" is, then, no more than a social convention, and we could easily do without it. Elimination of the concept of the author does not necessarily mean a compromised creativity.

What we have seen so far is not necessarily a set of rules that attempts to reconstruct the past, claiming that the way we have been looking at the past until now is completely wrong, although subject to criticism and revaluation, especially in the light of the postmodern condition. The death of the author is a contemporary phenomenon that can be observed in modernity and postmodernity. This means that it cannot be easily separated from the particular conditions that defined postmodernity: the recent revolution of information, communications and transportation gradually brought about a profound change in the way art and the art market works. The technology of mechanical reproduction has given the audience the power to enjoy and own the art of its choice. The "aura" of the original work has been long lost, as observed by Walter Benjamin, and that means that for all purposes of artistic enjoyment everyone has more or less equal access to art, whether this means a good (photographic) copy of Leonardo's *Gioconda*, or Sting's latest CD. The media, television especially, on the other hand, provide an open line of communication with the outside world, that even if it cannot be described as art, includes and uses art constantly. Art, then, appears to be transforming into an environmental event, so to speak, changing from the focused attention event it used to be. "Television is a cool medium", Marshall McLuhan used to say,[10] meaning that it leaves much space to be filled in by the viewer, who assumes for this reason a relaxed, distanced position in relation to television, as he cannot be expected to give it his undivided attention, and provide the information gaps cutting off the outside world. What happens instead is that television withdraws as a source of information and visual and aural stimuli into the background. This observation can be generalized for other media, as well. McLuhan often wrote that we live in a "cool" age, where most stimuli around us give us a modicum of information and we provide the rest. McLuhan's observations on the hot and the cool extend many centuries back, and he describes many cases where a "hot" age succeeded a "cool" age and vice-versa, depending on the dominant medium of the culture and the time. Still, it is difficult to see how the present course of the information age of the interactive user and environmental art could be reversed. For all we know, and for all we can observe and predict, art gradually recedes into life, reminding us of Hegel's prediction. The first step, the death of the author as the external initiator

of artistic discourse, has already been accomplished. The next step is the wholesale withdrawal and death of art.

Although the death of art sounds like a very novel postmodern idea, maybe the logical step after the discourse on the death of the author, it has roots in much older writings. Two contemporary writers who have commented on the death of art, Umberto Eco and Gianni Vattimo, trace the concept to Hegelian dialectics and Hegel's prophecy of the death of art through a "general aestheticization of existence".[11] Neither writer, however, understands Hegel's prophesy too literally, i.e., corresponding to an "historical end of art",[12] but rather as the "death of a certain form of art, part of a historical development in which the advent of a new idea of 'art' must appear as the negation of what the same term meant for the preceding culture", as put by Eco.[13] Vattimo, on the other hand, seems to take this idea a step further, reading Hegel in an intentionally "perverse" way according to Adorno, and arguing that, for all intents and purposes the "universalization of the domain of information could be interpreted as a perverted realization of the triumph of absolute spirit",[14] in which case the general aestheticization of existence corresponds to postmodern "environmental" art.

The methods of the two Italian writers differ significantly, and they use completely different methods in their philosophical investigations, but they both accept that the death of art corresponds to a transformation that takes place under the visible surface of the artistic procedure, not unlike the gradual death of the author. The significant difference between writings on the death of the author and writings on the death of art is that the first describe a phenomenon that transformed primarily art itself, whereas the second consider the effect of essentially the same transformation on the relationship of art with the contemporary world, its philosophy and, even, its metaphysics.

One of the characteristics of contemporary criticism is that it focuses more on the *how* rather than on the *what* vis-à-vis the work of art. Contemporary criticism and contemporary art seem to be more concerned with the development of a certain poetics, something that in a sense followed naturally after the "open work". Criticism is not simply interested in the evaluation of the work of art, but also in the identification and interpretation of its methods, the choices that constitute its poetic language and the structure these choices reflect. Eco sees a distinction between the part that is meant to be "understood" and the part that is meant to be "enjoyed", and sees nothing wrong with the reduction of the work of art to an intellectual "whodunit" where the pleasure derived from reading corresponds mainly to the pleasure of identifying the poetics and the poetic structure. The work itself can be there to communicate things that "the mere enunciation of its poetics could not have told us,

and this, in turn, helps us amplify and verify the enunciation of its poetics".[15] Eco identifies here an interaction between the two sides, and this is important, but he places thought hierarchically higher than feeling in his account. I do not see the reason for such a classification.

This view of the work of art poses a problem for the historiography of art. A history of art that consists of the description of the stages that explain how art accomplishes its task is completely different, as a conceptual structure, from the description of what the artwork is and how it evolves. Something is lost in the first case, although the interpretation of art, that is to say its demythologization, can have certain advantages when it is used with respect to one particular work of art; it is conceivable that a work of art is, at some point, totally interpreted, and all the questions about its function are answered. If this happens, however, if the significance of a work of art becomes finite, no more pleasure can be derived from it, and it ceases to "do" the work of art. Eco does not dismiss the pleasure one may take in demythologizing a work of art, and he compares it to the intellectual pleasure a medieval reader derived from a text, looking for allegorical interpretations.[16] To apply this measure to art in general, however, is catastrophic. The process of art would then be seen as a continuous mathematical transformation of the sublime, and the object of study would not be the sublime itself, but the fossils it has left behind, everything "pure" art had to jettison in order to maintain its sublimity. Art history in that sense is the science that attempts to study something alive by examining its excrement.

Of course, art history and criticism as we know it today is a child of the scientific revolution and rationalism, since it stems from the same *Weltanschauung* that sees progress as an achievement of linear nature, the same one that gave the power of artistic appraisal to the critic, the knowledgeable and specialized representative and interpreter of social codes. Art here is a phenomenon to be witnessed, described, analysed and classified, something that helps us draw a cultural profile of ourselves; however, it is not expected to be lived and unconditionally experienced. The nature of direct and immediate art eludes this circle; an artwork intended to communicate rather than to teach is perhaps seen only by the one(s) this communication is aimed at, just like a shyly written secret love letter, being a true artistic moment no one ever witnessed. A hypothetical discussion between the writer of such a note, describing his experience to a young pianist (for instance), might have resulted in the conscious choices this pianist later made in his life, and if his name were Achilles Claude Debussy, for instance, this is something that could have influenced the music of the entire twentieth century. Which is the original, the archetypal artistic moment here? I believe it would be the secret love letter.[17]

Art history is really trying to connect the evolution of the language of arts with the achievements of civilization, or with the conditions of life that provide inspiration and methods of a different kind to the artists of a certain age. However, apart from the scientific examination of the art tools and the discovery of the references to the past and the echoes in the contemporary environment, art history, practically speaking, cannot give a more complete account of the history of the content of art. Is there a change in how much people wanted to communicate with each other or with their god through art? Is there a shift towards any of those directions? Do people express more things now than in the past? Do they express less? What happened before art, and what is going to happen after it? Does art affect us more, less, or in a very different way? Do we need art more now, or do we need it less? Have the properties of art changed throughout the centuries? Is it becoming more therapeutic, or more metaphysical? It is hard to think of an art history that would address such questions.

The question of historiography of art is quite complex. It is not exactly possible for us to speak of a development of the arts in a sense similar to the development of the sciences, although the *science* of art criticism has repeatedly attempted to do so. The basic problem stems from the fact that the transformation of art does not have to take into account something like "objective artistic truth". Unlike the development of science, as described by Thomas Kuhn in *The Structure of Scientific Revolutions*,[18] art maintains a much looser continuity with its past. Scientific paradigms usually take much longer to change, and even when they do, the new paradigm appears in hindsight as a rational progression of the old one, as it is usually born out of some of the known inconsistencies of the old paradigm. Art, on the other hand, is not measured against an inert, objective reality; it does not have an uncontested base, so to speak, a stick by which to measure the degree of its progress or regression – the next step, therefore, can be much more unexpected. Moreover, artistic "paradigms" exist in the here and now, and their changes are usually abrupt, unlike scientific ones, where the Newtonian and the Einsteinian model can co-exist for some time. Eventually we can allow the old scientific paradigm to maintain its validity, as long it is confined to a limited part of the perceived world. As far as we can limit our observations to everyday life, most of the scientific experience and the observations we acquired during the Newtonian model have survived. Scientific progress is measured by the fact that, with few exceptions, the science of the past is not discarded, but is perfected, even when the addition of new findings urges the creation of a broader scientific framework.

We have to note that the above observations apply to the level of art as production and consumption. It is perfectly possible for a work of art to

maintain recognition through many centuries, and for audiences of the twentieth century to be captivated and enchanted by a work composed in the fifteenth century. This, however, is not just the exception to the rule, but it can also be seen as an anomaly of the art production system. Continuity with the past has traditionally taken different overtones in art. The paradigm of formal artistic conventions has often been seen as a domineering and repressive rule, challenged by the new generation of artists, who often offer a radically different way of making art. By contrast, scientific revolutions tend to appropriate the knowledge and the experience of the past, and expand it further, creating new limits for the scientific universe as they go along.

Still, we have to admit that there is some kind of conceptual continuity in the development of art. The paradox here is that the rules that define this development in art are obviously quite different from those that define the development of science. Nevertheless, art criticism *is* practised along scientific methods. If nothing else, Kuhn's writings point out that a relativism of the artistic kind, although at a much smaller scale, is evident in scientific revolutions, as well. New paradigms do not usually prevail by proof, but by persuasion. Or, as put by Max Planck and quoted by Kuhn: "a new scientific truth does not triumph by convincing its opponents and making them see the light, but rather because its opponents eventually die, and a new generation grows up that is familiar with it".[19]

It would be foolish to argue that the traditional concept of art history does not offer anything. However, the analysis, the evaluation and the understanding of the conceptually structural materials of art can help us conceive of a small part of the nature and the history of the artistic process. Some of the trends and the revolutions that art history describes may reveal cracks and contours of an aspect of our evolution and history we would be profoundly interested in knowing. Very often, the most revealing instances may prove to be not the most obvious, but the most enigmatic ones. Such an enigma is the question of the appearance of the medium and the art of photography when this happened, although as a technological task it could have been achieved, or at least attempted, centuries ago. We have to conclude that photography was not invented earlier because it would not have any meaning (or at least, not any meaning that would be *appropriate*) for someone living in the Middle Ages, for instance. It is only when "objective" technological capture of the similitude of an object and its mechanical reproduction became part of the art vocabulary, that photography could be conceived as a form of art. In this case, technology was employed when painting had reached a degree of abstraction which could not be bothered with superficial observation. Photography undertook the task of capturing physical likeness when it was abandoned by painting, but it soon developed an artistic language of

its own, based not so much on its technical, "naturalistic" capabilities, but on the way it could be used to produce literal or abstract meaning.

We are left, however, with the question of the historiography of art. If the study of the *how*, the mechanisms of art, can lead us nowhere, what could we say about *what* art is, and possibly how it evolves? To answer this question, especially after we have just dismissed the disembodied study of the materials of art, we would have to gain an understanding of the pleasure one derives from art. Eco's analysis distinguishes, as we have seen before, the art structure that can be investigated and understood, from the pleasure that can be derived by looking, reading or listening to a work of art. He dismisses "idealist aesthetics that broke down the entire *Divine Comedy* into 'structure' (tolerated as a nonartistic framework) and 'lyrical flashes' (the only enjoyable fragments)".[20] Finally, he dismisses romantic aesthetics that defined the appreciation of art as "an art of intuition, precisely in order to underline the fact that the proper understanding of a form involved a number of factors that could not be reduced to a mere intellectual understanding – factors which, together, constituted an organic reaction that could be analysed only *a posteriori*".[21]

I am afraid that art since 1962, when these lines were written, has followed if not a neo-romantic path, at least one that has largely depended on the "aesthetic emotion" Eco dismissed. The difference is that in romanticism or in intellectualism, one part of art (to recall the dichotomist analyses of the *Divine Comedy*) is opposed to the other, whereas art since minimalism has attempted, with some success, to bridge the gap and see the work of art as an organic whole, whose mechanics are not the restraints of its emotion, and its emotion not the restraint of its intellect.

Minimalism, which can be seen as a counterpart of nihilism in art, is a phenomenon that started at about the same time Eco was writing the *Open Work* – Terry Riley's *In C*, which is generally considered to be the first musical minimalist example, was composed in 1964. What followed after minimalism, however, proved that art relied heavily on exactly what Eco dismissed as "intuition" or "beyond intellectual understanding", albeit not returning to the romantic ideal of emotion. New Age art has proved to be a quite enigmatic step as far as conventional art historiography is concerned. The evolution of the forms cannot account for meta-minimalist art, where music has perhaps taken the lead, in contrast to the visual arts.

A gap can be observed here: this analysis started with the presentation of the discourse on the death of the author, a phenomenon that can be manifested to such a degree that we could dare say it has been accomplished totally. The death of the author means, on one level, the negation of criticism and the return to the reader, his rights and his perspective. It

means the transcendence of an intellectualism that makes art a business of a select group of artists, whereas commercialization of art brings about a kind of democratization of taste. On the other hand, early postmodern comments on the death of art employed similar language, and prophesied the decline of modern art, placing at the same time the recovery of the aesthetic value in an intellectual construction, a hybrid of art and criticism. It seems that the two concepts are not quite consistent, and although Eco's observations on modern art are brilliant, he did not foretell the future successfully. It is interesting to notice that contemporary art is based on an element that eludes Eco's early analysis completely, and is not only consistent with the death of the author, but it could be seen as one of its natural consequences: the return of metaphysics in art.

Gianni Vattimo, a leading interpreter of Heidegger, connects the notion of the death of art to the trajectory of metaphysics in modern culture.

> The death of art is a phrase that describes or, better still, constitutes the epoch of the end of metaphysics as prophesied by Hegel, as lived by Nietzsche and as registered by Heidegger. In this epoch thought stands in a position of *Verwindung* in regard to metaphysics. Metaphysics is not abandoned like an old, worn-out garment, for it still constitutes our 'humanity' in *geschicklich* terms; we yield to it, we heal ourselves from it, we are resigned to it as something that is destined to us.[22]

Vattimo's comments on the withdrawal of thought in favour of metaphysics indicate some kind of way out of the modernist dead end, the infertile opposition between thought and emotion. Eco was writing about the priming of emotion and the criticism that condemned structure, and the poetics of a work in favour of an "aesthetic emotion" that reflected the undisciplined, spontaneous, but ultimately extremely conservative, ideals of Romanticism. This kind of deconstructive postmodern criticism engaged the problem of identification of author and work by giving autonomy to the work, focusing on the poetics rather than on the "subjectivity" of emotion which was closely connected with the personality of the author. In other contemporary texts as well, like in *The Structure of Bad Taste*,[23] Eco expressed similar views that point towards the emancipation of the reader from the prefabricated emotions of the *Kitsch*, the response he is expected to have, so to speak, provided to him with the text. One should not commit, however, the mistake of taking this position too far and dismissing the subjectivity of the reader together with the subjectivity of the author. We should not forget that the primacy of thought in science and the celebration of individuality were some of the reasons that assisted the emergence of Romanticism. Vattimo, on the other hand, writes about a more advanced stage of the same phenomenon, where

not only emotion, but also thought, or the primacy of rationality, with-draws in favour of metaphysics.

Vattimo's comments strike one as quite consistent with and descriptive of the "New Age" condition. The return of metaphysics is a phenomenon that can be approached, predicted and described in philosophical terms, but it is also registered by pop culture on a large scale. It is interesting to observe that the death of art affects high and popular culture in a remarkably similar way. Perhaps we should discuss this point before we proceed with the return of metaphysics in art.

Eco's previous comments on the death of art belong to what is often described as the "deconstructive" phase of postmodernism, which consists of critiques of the absolute ideological systems of the past, what Jean Francois Lyotard called "the big narratives", but postmodernism also had a second phase, a "reconstructive" one, with writings and works of art that sought a kind of inspiration from the era before the Enlightenment, tracing the steps of culture and picking the thread before the much-criticized emergence of modernism. The withdrawal of the author and the withdrawal of art in general can be seen as a protest to the central position they claimed since at least romanticism, which is not something that can be explained in philosophical or sociological terms only, but also comparing the "perceptual fields" of modernity and postmodernity. Let us try to review a more technical, or rather perceptual, account of how this happened.

Christos Hatzis, a music professor at the University of Toronto, has developed, in a series of unpublished papers[24] on contemporary art, a theory of "invasionist" versus "non-invasionist" sound. His writings describe an analogy between the Zeitgeist and the qualities of sound, since the Renaissance. Eighteenth- and nineteenth-century music, both composition and performance in his analysis, is said to have been constructed on the principle of goal orientation. This meant that, from the relatively static early music to baroque and romantic music, there was a gradual increase of dynamic tension in music:

> At the height of the Romantic era dramatic tempo and dynamic (amplitude) transfor-mations and gestures of every kind became the lingua franca of musical communica-tion. The orchestra increased in size and volume, to celebrate the ideals of the industrial revolution. New, louder instruments were invented and older ones were outfitted with new appendages to cater to ears which were becoming used to the powerful intensity of industrial machinery.[25]

Further on, Hatzis contrasts the dynamism of the industrial era to the contemporary information age. Our age is characterized by a continuous competition of information providers for our attention: advertisements, elevator music, a super-multiplicity of television and radio channels, etc.,

create an information overload "similar to the environmental contamina-
tion caused by the industrial revolution".[26] To defend ourselves, there-
fore, from this information blitz, we have developed a complex set of
filters in order to (attempt to) block unwanted information. One could
also say that we are so saturated with information that our attention is no
longer easily attracted. Hatzis's observations are quite consistent, at this
point, with the thought of another Canadian, Marshall McLuhan, who
argued that the more information a medium provides (a "hot" medium),
the less participation from the audience it elicits. It is to be expected,
then, that in the age of "perfect" digital reproduction of sound, music
withdraws to the background of attention.

A great part of the success of contemporary music can be explained in
terms of the non-invasionist quality of its sound. We can make some
observations about the way sound and information pollution favours cer-
tain kinds of art over others, comparing the recent popularity of Mozart
over composers like Beethoven. Hatzis argues that this is so because
Mozart "'pushes' information less relentlessly",[27] his music being enjoy-
able as a sonic experience, as opposed to Beethoven, whose music is the
"rigorous sonic implementation of structure",[28] a view reminiscent of
McLuhan's famous maxim: "the medium is the message". Music, in Hatzis's
analysis, is absorbed by the listener at the level of *sound* rather than at
the level of *structure*. This is reflected in the way radio, as the medium
most appropriate for classical music, tends to avoid linear, "conceptual"
programmes, single-composer or single-work presentations, in favour of
the variety show, which reflects a non-linear approach, based on the
difference of the successive items, where the connection can be found
only if the music is seen as just sonic experience and pleasure, instead of
a conceptual structure with linear development. The same observation
may be made for contemporary music, although this kind of approach
was first adopted by the early twentieth-century French music school.
Ravel and Debussy focused on the quality of the sound more than their
contemporaries, and Igor Stravinsky later developed the music of arrange-
ment and sonority to its limits, although their approach was not without
precedents. Musical impressionism, however, was limited to the concert
hall, and was destined at the time to be excluded from the Hegelian
convergence between art and life. Contemporary music, on the other
hand, is primarily the music of recording and broadcasting, probably be-
cause the recording industry has developed to such a degree that digital
reproductions of studio recordings provide a much better sound than the
unregulated sound of the concert hall, even if we do not count factors
such as price, multiple auditions, mediocre performances, audience noise,
dubbing and studio effects difficult or impossible to reproduce at a live
setting.

Evaluation of music on the "pure" level of sound favours the convergence of the classical and the popular. At this point I will have to disagree with Hatzis's view that music is being narrowed to two distinct choices, "the first leading up a narrow path to spirituality, whereas the other choice is increasingly MTV",[29] or rather I will have to disagree that these paths actually constitute different choices. Semiotically speaking, MTV music and post-minimalist classical music share many characteristics. Both use minimalist language without being minimalist. Both place the utmost importance on the quality of the sound rather than on the melodic and harmonic lines as such. Finally, both allude to a conceptual centre located outside music itself, beyond art; dance and socialization in the former case, spirituality in the latter. Furthermore, I think that the concepts of "non-invasiveness" and "environmentalism" apply to classical and popular culture in a way that ultimately forces them to converge conceptually, with their only defining differentiation being the kind of event or state they are part of. Vivaldi and hip hop music do not necessarily represent different ideologies incompatible with each other, but may reflect a moment of relaxation and a moment of social interaction in the life of the same person. The fact that certain people may prefer consistently the one over the other may not reflect so much a difference of views on appreciation of art, but a difference of lifestyle.

It has to be noted, however, that the split between spiritual art and MTV culture Hatzis warns against, can be seen through a different prism, corresponding to the centuries-old opposition of art according to the Greek and the Jewish model, art that attempts to make a connection with or to ignore metaphysical reality. Still, although I can sympathize with such an interpretation, which could trace the present cultural split to an opposition whose roots can be found in the founding forces of our civilization, I would have to reluctantly dismiss it as too extreme, at least as far as contemporary art is concerned. The reason is that I can see a quite rigorous return of metaphysics, more inclusive or total than any other time since the Middle Ages, while at the same time MTV culture does not seem to be threatened at all. Pop culture can be extremely flexible, and it may cultivate surprising links to spirituality. The new-found interest of Madonna Ciccone in Kabbalah and mysticism may or may not be interpreted as an isolated example of a pop idol who, after years of casual use or commercial exploitation of religious motifs and symbols (who can forget the young girl who used to make stage appearances wearing big crosses, singing "Like a Virgin"?), discovered that those things carry a much deeper meaning; structurally speaking, pop culture, the best example being hippie music, can easily include an element of ritual and communion. But, to be fair, art and spirituality at young ages is usually not so much an affair of metaphysical nature, as of a certain psychology of growing and

maturing. Although academic, scientific thought cannot say that religious practices are not given to humanity by God, it can certainly detect certain elements that reflect collective memories of growing and maturing that apply not only to the individual, but to the entire culture. Freud's *Totem and Taboo* is a significant study that, in spite of its materialist assumptions, examines such a cultural psychological trajectory, connecting spirituality with the rule of the father, his replacement by brother hordes who, after they kill him and consume his body, fight for years before they re-establish the memory of the father as a religious taboo, a social convention that will help them maintain civilization. As much as ontology of the individual reflects the ontology of civilization and vice-versa, the psychological stages the human being has to go through in order to achieve an integrated self and then pursue higher interests belong to a religious Becoming, from a psychological point of view. Rebellion against authority and a strong connection to one's peers (perhaps a memory of the brother hordes) would be necessary stages, at least according to a model much indebted to Freud's ideas, towards the acquisition of religiosity, as these would be necessary steps one would have to take in order to attain a kind of psychological "distance" from the taboo, and rediscover its meaning on another level. Having this in mind, we may easily concede that so-called spiritual art represents the *avant-garde* of contemporary art, and MTV art its rear-guard, but I will insist that they express the same tendency; they both move towards the same goal. Seen from another perspective, it is very likely that the people who tuned into John Tavener in the 1990s are the same ones who, as youngsters, followed the Beatles in their religious explorations.

At any rate, as far as the death of art is concerned, both spiritual and popular art express it in different ways. This should not be surprising; Vattimo describes the withdrawal of art in three different ways: as utopia, as Kitsch, and as silence.[30]

1. Death of art as utopia, is connected, in Vattimo's account, to the avant-garde movements at the beginning of the twentieth century, which, aiming towards a Hegelian integration of art and existence, and having acquired the technological means, attempted to transcend through their art the traditional institutionalized limits that had kept art segregated:

> This explosion becomes, for instance, a negation of the places which had tradition-ally been assigned to aesthetic experience, such as the concert hall, the theatre, the gallery, the museum, and the book. A series of developments occur – earth-works, body art, street theatre, and so on – which appear somewhat more limited in regard to the revolutionary metaphysical ambitions of the earlier avant-garde movements, but also more concretely within reach for contemporary artistic experience.[31]

We may observe here that this kind of "death" does not mean a reduction of artistic experience as such. People like the Dadaists, and certain surrealists, realized that the distinction between high and popular culture was a bourgeois invention, and changed the way they were doing art. A "downward" move can be seen even earlier, in the paintings of Toulouse-Lautrec, for instance. At any rate, this trend is identified by Vattimo as a kind of death of art, because a certain kind of art was indeed put aside by such practices. Overall, however, the opening of the artistic event beyond its traditional confines, although it was a first step towards the withdrawal of art into the background of the information age, resulted in a (at least short-term) regeneration rather than a decline of art.

2. The much-discussed *Kitsch* is often seen as a degeneration of art, a "manipulative mass culture".[32] According to several critical analyses (such as Greenberg's famous aphorism: "Avant-garde imitates the processes of art, whereas Kitsch imitates its effects"[33]), one of the major defining characteristics of the Kitsch is the *katachresis* of overexposed symbols, i.e. the use of images heavily charged with cultural and artistic memories, which can thus be exploited in a more marketable form.

The Kitsch is also, in Vattimo's perspective, a realization of the aesthetization of existence, albeit at a low and weak level, but I often feel I have to defend it somehow, or rather to distinguish between bad taste as such, and the cultural conditions that allow its expression. It is rather naïve to argue that a work of art is "manipulative" just because it is bad, or because it acknowledges the emotional response of the audience. The art market, the commercial system of artistic use-values, is completely amoral, and there is no reason whatsoever for bad art to be promoted over good art, since good art can be equally accessible and cheap. I would tend to see views as condescending as Vattimo's, as the result of a surprise brought about by the democratization of taste, and the legalization of (= tolerance to) bad taste. It may be bad, but even (or especially) the question of good and bad taste as an objective value has to be put on the table. The aesthetic aspect of a work of art can be secondary or irrelevant, if art is to be seen as a functional process. Such was the case of medieval sacred art: it was not important whether an icon was aesthetically pleasing.

An icon, even an ugly icon, could still perform its function as a sacred image. Taste is not such a significant issue for sacred art, because an icon, for instance, is not a work of art that intends to please the spectators; it is a sign of a divine presence. Sacred art does not express anyone's personal view. The Kitsch is similar to sacred art in that they both ignore the question of taste, albeit for entirely different reasons. They both fulfil a need that has little to do with art and the appreciation of the work of art, but is

more of emotional and psychological nature, rather than of aesthetic and cultural.

3. Silence, the most visible kind of death of art, can be observed from two different aspects. Vattimo takes it as a reaction of authentic art against Kitsch and culture manipulation. In that sense, art has often "taken refuge in programmatically aporetic positions which deny any possibility of immediate enjoyment of the work (its 'gastronomic' aspect, as it were), refuse to communicate anything at all, and opt for silence instead".[34]

I find this rationale highly problematic, and I am not sure that it can account for all or most of the ways art is "decaying" into silence. Fellini's *8½*, for example, ends with the theme of the silence of the artist; this in fact can be seen as one of the central issues of the film, but silence here is not at all presented as a protest to the devaluation of art, but rather as a result of the realization of the artist that the work of art cannot fulfil its promise and express the personal vision of the artist. The filmmaker within the film, and in the last scene also the critic who advises him, agree that the film cannot be completed, because there is nothing it can say, it has no substantial *raison d'être*. Fellini, however, did complete his own film, but the difference is that his film was opened up in a self-reflexive manner, bringing the viewers behind the scenes, and showing them that the story line of a narrative film can be, at best, a canvas for an unaccountable number of influences that shape the final product. In the end, art cannot measure up to life, but *8½* was not such a narrative film, but a commentary on filmmaking, authorship and the withdrawal of the work of art. Fellini is doing this in a quite "non-intellectualist" way, showing very often that it is exactly the "gastronomical" qualities of reality, to use Vattimo's expression, which cannot be translated into artistic material. In that sense, I would not directly disagree with Vattimo's observation, but I would definitely disagree with his "denial" of gastronomical enjoyment.

Interestingly enough, Bergman's *Persona* picks up the thread exactly where *8½* left it: The central character is an artist who refuses to speak, and is put under the care of a nurse who does the talking for both of them. The personalities and, finally, the identities of the two women clash, and instead of communication (an impossible task, something that corresponds directly to the inability of the artist to communicate with the audience), the film ends with the question of subjectivity. Silence here means the abdication of the author in favour of the reader, an interpretation opposed to Vattimo's reading of Adorno. Silence, as in Cage's *4'33"*, indicates a shift of focus as it is described above, but the death of art altogether, whether we take it as utopia, Kitsch or silence, seems to be happening in many places at the same time. This is hard to dismiss as coincidence, and looking for an explanation on the level of the symptom

seems futile. Maybe we should go deeper into the philosophical dimension of art for an explanation.

Vattimo argues that the information age in a way corresponds to the triumph of the absolute spirit in the Hegelian sense, and there are indeed many similarities between the two conditions. The triumph of technology and the possibilities it has opened up can be seen as the fulfilment of the metaphysics that led us to this point, the metaphysical assumptions, or axioms, of the late Middle Ages and the Renaissance. These axioms became the basis for the consequently mathematically predictable evolution of art and society. The paradigm shift, discussed briefly in Chapter 2, visualized the information age. I tend to see the fulfilment of materialist metaphysics as a neurosis that has finally completed its course and is being cured. The course of this cultural neurosis seems to be similar to fetishism: The fetish is more attractive than what it conceals, because it signifies the pleasure or passion of *absence*, drawing its power from *what is not*, whereas *presence* (of fulfilment) tends to bring about a dispassionate, balanced state. We should remember at this stage that the icon signified exactly the *presence* of the divine among humans, and its importance was based on this very presence. Nevertheless, when every piece of clothing is finally removed, the fetishistic magic disappears. Similarly, having eventually reached the end of materialist metaphysics we discover it is not quite what we expected. What is the position of the work of art in all this?

Vattimo claims that what we experience at the deathbed of art is describable in the terms of Heidegger's notion of the work of art as an "exhibition" (*Aufstellung*) of the world and a "production" (*Herstellung*) of the earth.[35] As "exhibition" it is defined by the historical and social conventions that distinguish "art" from "non-art", in the same manner a painting is exhibited in a museum or a gallery. It also refers to the idea that the truth of a historical epoch is reflected in the work of art more than in any other product of culture, something Vattimo traces to the philosophy of Dilthey.[36] This idea is particularly important, not so much for the celebration of the work of art, but for the "truth" it brings forth, which is also described as the "constitution of the fundamental outlines of a given historical existence, that is, what is called (in depreciatory terms) the aesthetic function as an organization of consensus".[37] In other words, the work of art expresses the social consciousness of a people, not in a legal sense, not even in the way of the social or religious conventions as repeatedly described by Freudian psychoanalysis, but in a sense of participation, or an identification of the self with the community. The work of art in its capacity as "exhibition" of the world proposes, criticizes or develops a certain social or philosophical framework in which it finds meaning. This framework reflects directly the truth at a particular point in the

history of a culture. Moreover, the "setting-into-work of truth" does not belong only to the individual work of art as an "exhibition", but to the entire function of art, even (or especially) art in the commercial era, although in a quite different way. The work of art as "setting-into-work of truth" marks the participation of the individual in the group, but even when it collapses into its use-value and withdraws into the background, the function of art as the locus of the meeting of the individual and the social remain, and is further intensified. How is this compromised with the theory of the death of art? We have accepted that "death" may actually mean a radical transformation, and what the withdrawal of the work of art amounts to is the end of the work of art as something to be exhibited.

This has been manifested in two different ways. First, on the level of "environmental", non-invasionist art and the transformation of the work of art into something that attempts not to attract attention directly, dispensing with the barrier between art and non-art, and withdrawing into the art of the supermarket and the advertisement. There is certainly something less than an exhibition of art here.

Second, intellectual art has repeatedly and consciously attempted to transcend this barrier, from at least the time of Bertold Brecht. The theoretical counterpart of such a tendency is better expressed by Andrew Louth and his description of the separation of art and life in the nineteenth century:

> Beauty, instead of being something we might find in life, and something that has to do with life, is relegated to the fringes of life: and consequently is only of concern to those who have the leisure to spend much time at the fringes. (The very self-consciousness of the efforts of Rushkin and others to prevent this, only bears out the truth of such an analysis.) We find art for art's sake: art as the potentiality for pure aesthetic experiences, and the cultivation of an aesthetic consciousness by those who have the time and the inclination to indulge. Such a marginalization of the aesthetic is simply an attempt to live with this dissociation of sensibility, an attempt to regard it as normal.[38]

There has been talk of meta-art, meta-literature, meta-theatre and meta-painting, and so on.[39] I understand the importance of all this as an attempt to lead the readers or viewers to unlearn that they have to be shown a spectacle to which they have no input. The reader should learn to transcend the "exhibition" and re-compose the work, or participate in (the responsibility of) its composition. This attitude can be found as early as Brecht's theory of the epic theatre of alienation, where "the viewer must not abandon himself passively and emotionally to the illusion of the stage, but must be urged to think and to participate".[40]

It is even more interesting, however, to consider the other aspect of the work of art according to Heidegger, as "production" or "setting forth"

of the earth. The word *Herstellung*, although usually translated as "production", literally means "setting forth". Heidegger's translators often use both translations. What is associated with the idea of the work of art as a setting forth of the earth is its "thingness", its materiality (not to be understood physically), and the fact that this materiality suggests a continuous return of the work to itself, reflected in the writings of Eco discussed above, where he pointed to the usefulness of the work of art as something poetics always returns to, in order to develop further and explain something more. The "thingness" of the work of art consists in what is addressed to a pre-logical, sensate understanding. This is what Heidegger means when he says that "the setting forth of the earth happens in such a way that the work sets itself back into it".[41] The "earth" includes all that, which civilization or the intellect, the "world", cannot describe and explain:

> Colour shines and wants only to shine. When we analyze it in rational terms by measuring its wavelengths, it is gone. It shows itself only when it remains undisclosed and unexplained. Earth thus shatters every attempt to penetrate it.[42]

Nevertheless, the earth, the unexplainable, provides not only the raw material for art, but also the basis of what seems to be a psychological rather than intellectual or cultural connection with it. The work of art as setting forth of the earth seems to correspond to raw experience, a certain feeling one may have in front of a work of art when one realizes how deeply this work can penetrate into regions of the mind deeper than language and cultural understanding. Raw experience, on the other hand, would be useless without the structure, the rational choices and the decision of what to exhibit or "set up" (*Aufstellen*), and how to do it. The unity of *Herstellung* and *Aufstellung* is essential, because the raw, unexplainable experience will have no effect if it is not somehow linked to cultural understanding and the conscious mind, maintaining its secretive or elusive qualities at the same time.

Heidegger describes an opposition between the world and the earth, with art standing between them. The work of art is the gift of the earth to the world, so to speak, and codifies the elusive essence of truth. Truth as αλήθεια – Heidegger reads this as "unconcealment" – is manifested in the rift between the world and the earth, the place the work of art exists by virtue of its language, its materials, which are – as referrals – connected to the earth and "unconcealed" by the world, which advances into what it is being given by the earth. The relationship between the earth and the world is a dynamic one, however. The work of art functions as such in a time-specific capacity. The work of art is not eternal as an expression of αλήθεια, because according to Heidegger's model, the rift between the earth and the world changes (the world advances into the

earth), and the "setting-into-work of truth" moves and is constantly rede-
fined, so that what "setting-into-work of truth" means in an epoch may
become a mere cultural memory for another. Vattimo, in fact, finds here
the explanation for the decline and death of art. He thinks of the work of
art in this context as the "one kind of artifact which registers aging as a
positive event that actively contributes to determine new possibilities of
meaning".[43] Still, Vattimo's approach leaves some questions unanswered,
because although his connection of Heidegger's writings on art to the
withdrawal of the work of art, in the sense pointed out by Benjamin, is
interesting, he does not explain as effectively how the entire practice of
art withdraws, and how this is different from the withdrawal of the work
of art. Vattimo's interpretation of the death of art as a consequence of the
end of (post-Renaissance) metaphysics and the identification of this end
as the final victory of the world over the earth, with the advent of the
information age, should result in a complete halt of artistic activity. The
transformation of the art as a separate practice into the art of the back-
ground shows that this is far from the truth, although a certain kind of art,
in fact art as we have known since after the Middle Ages, is dying indeed.
On the other hand, we witness an emergence of a completely different
artistic phenomenon, brought forth by the audience rather than the artists
or critics (the music of Gorecki, for instance, eluded the first critics who
approached it, until there was a better understanding of the art of *new
simplicity*). Vattimo's view cannot account for this, and the reason is that
his observations are limited by the Heideggerian model.

Heidegger observed that the Greek word τέχνη, which can be trans-
lated as art or craft, denotes a mode of knowing, something with a uni-
fied sense of art and craft. In fact, the concepts of art and craft are de-
rived from τέχνη, sharing two parts of the whole:

> What looks like craft in the creation of a work is determined and pervaded by the
> essence of creation, and indeed remains contained within that creating. What then,
> if not craft, is to guide our thinking about the essence of creation? What else than a
> view of what is to be created – the work? Although it becomes actual only as the
> creative act is performed, and thus depends for its actuality upon this act, the
> essence of creation is determined by the essence of the work. The work's becoming
> a work is a way in which truth becomes and happens. It all rests in the essence of
> truth.[44]

I think this differentiation between art and craft can be further dis-
cussed, since the unity between the two is dynamic. We have repeatedly
seen an opposition between two directions in art (Greek and Jewish,
inward and representational, etc.), and it is possible to argue that neither
direction exists entirely void of its opposite; for all we know this may be
the same opposition marking its presence on different levels. Here we
have the chance to observe such a dynamic opposition on the level of the

artwork itself. Is a painting art or is it craft? Is it primarily a gift of the earth, or an unconcealment of the world?

The artistic creation faces problems, challenges and pleasures on two different levels, or rather fields of freedom, which occupy almost the same space. Their difference is defined by the broadness of the art that is created within the degrees of freedom of each field, its intent, its level of reference (personal, social, metaphysical), and its target audience. I cannot say that the two fields are mutually exclusive, or that we can always tell them apart. However, they indicate different sets of reasons and motives that drive the artist to create; moreover, the difference between the two fields, in my analysis, is mainly a difference of *vision*. In the case of craft, the vision extends to the cultural and social traditions that describe and explain art and life, whereas in the case of art proper, the vision extends to the deepest parts of the psyche of the artist: craft includes all the technical, material, social and other details that make the work of art interesting primarily to the other artists as well as the connoisseurs, the people who can evaluate and respect the artistic language of the creator, the innovations and changes the particular work presents, in general its contribution to the history of the artistic tradition and media that brought it about. Usually the social value, or even the social role, of the work of art is known or suspected; sometimes the work of art exists *by virtue* of the social or philosophical ideals it expresses. Such would be the art of the Soviet socialist realism, which reflects a conscious focus on social and political issues, as well as a revolutionary technique. Some other times, the ideals that permeate the work of art have to do with the history of art itself, and the work of art exists in order to articulate a turn of style or thematic content. Such would be the work of the first surrealist poets.

The other field is more difficult to define and describe. *Art proper* is not concerned with the creation of a work that will be received and appreciated by artists or critics, or at least it is not concerned with them more than with anyone else. The most apparent need that underlies and sustains it is the need of communication (which is conscious, direct and personal), as well as the need to offer. It is not important whether the work of art is known, recognized or appreciated by the community of the experts, nor is this, on the other hand, a fate it tries to avoid. Success and recognition are just *irrelevant* to *art proper*. For all this description implies, a work of art could be a game, a personal letter, even a plate of food. However, I would separate this concept from the concept of craft, which could be seen as more technical and perhaps more intellectual or informed, even more conscious than *art proper*, because the latter is the driving force and the paradox, and carries the artistic properties that ignore social and cultural recognition. This is the kind of art the artist

creates for the sake of his own soul, so to speak. I have already extended this examination into the realm of the deeply and uniquely personal, which is also the domain of the metaphysical. The artist, whether a nobleman or a rogue, a saint or a murderer, opens up and offers his deepest self, his whole self if possible, to his art, because his reference level and his criterion speaks to him only from within.

The term *craft* can be used to describe art from a left-brain perspective, and includes everything we can ever *know about* art, in terms of verbal information. If we were ever to recreate the practice of art using the information we have recorded, excluding, however, any experiential testimonies and the works of art themselves, we would end up with *craft*. *Art proper* includes, except for everything we can externally see about the process, a direct and unique, for each artist, connection to the personal and the collective unconscious. The artist struggles with the unspoken; in that sense the artistic experience is a mystical experience, a channel, rather than an opposition, between nature and culture.

The artist cannot limit himself to the extents of his craft. His art, as opposed to his craft, including the deliberations, quests, questions and dilemmas associated with it, must take place on a deeper-than-practice level within him. His artistic identity is problematic, and it has been problematic since the Renaissance, from the moment Velazquez added his face as a distant reflection on the mirror of *Las Meninas*.[45] Still, Velazquez was articulating, perhaps not consciously, a new vision and a new visual field for the artist and the layperson alike. The question is not the same for the contemporary artist who finds himself in the midst of a socially and politically charged selection of schools of thought and artistic traditions. Velazquez acknowledged his physical presence on the canvas, but the problem we face now is the *ego* of the artist; the contemporary challenge is to make the ego invisible and to see past it.

The artist cannot be an art critic or a social analyst at *the same time* as he is an artist, because he has accepted that the rational world, the domain of the critic and the academic is inadequate for his needs. In some ways, art is the denial of rational culture; it punctures its cohesion and it challenges its validity as a closed system, because the very existence of art proves the inadequacy (or lack of cold rationalism) of the system. Criticism as a form of rational evaluation and approval cannot be justified within the artistic process, and the artwork cannot be judged by any scientific criteria of art, as far as they arise out of a system of comparison and classification of artistic forms of the past (that, as such, can be seen as the "shells" – empty or not – of artistic communication) and not the inner need they express(ed). Criticism and intellectual games in the area of the arts can be, for the artist, a pretext for further research and creation; his function is beyond the critical process, because its end is not known and

cannot be assumed to be known. In that sense, the artistic process is a *mystery* that connects this world and the other one.

The work of art is autonomous, something we have known since Benjamin and the *Work of Art in the Age of Mechanical Reproduction*, and does not necessarily reflect the conscious intent of its creator. In fact, the very word "creator" may be inappropriate after the emergence of the work as a distinct object, since its effect depends largely on the receptor (viewer, listener, etc.) as well. Artistic communication occurs in two vital instances of the artistic process, and in both of them the work of art functions as the displacement of, or, at best, as the conduit of the real communication: the author is the first to communicate with an imaginary artistic interlocutor, using the work of art to mould a message, then the receptor communicates with an imaginary aesthetic interlocutor, attempting to decipher the message. In both cases, the author, as much as the receptor, incorporate their personal choices with the content of the message. Having this in mind, it would be inaccurate to state that the author communicates with the audience only through the work of art. The work of art has an identity of its own and the laws that define it are, very often, beyond the intentions and the expectations of the author. We can examine the artistic process as a structure the ontological centre of which exists outside art itself. In fact, the entire process and phenomenon of art denotes a presence and a structure that extends well beyond the immediate reach and domain of the artist. Classical music, for instance, extends from the concert halls to the entertainment parlours, the coffee shops and the commercial advertisements.

I believe that Heidegger's comments on the opposition between the world and the earth deserve a closer examination. From a psychological point of view, those concepts seem to correspond to oppositions like conscious/unconscious, ego/shadow, or even left/right brain. Heidegger's essay could easily be read in those terms, but there is still more to it. The world and the Earth have a metaphysical dimension which was not pursued further here. It is interesting to note, however, that *die Erde*, the earth as a concept, appears for the first time in Heidegger's *The Origin of the Work of Art* (1936).[46] It is found later as one of the "four" of the "four fold" – earth and sky, mortals and divinities – in his essays on the *Geviert*.

Moreover, death of art in Heidegger's terms would imply a closing of the rift between world and earth, an intrusion of the "other" into "this". What is the "other"? It may have a psychological dimension, as we have seen elsewhere (the Lacanian *Other*), but the "exhibition" aspect of the work of art denotes a strong collective social character, a social "truth" more extensive than its psychological counterparts. I think it is more fruitful here to connect the Heideggerian opposition to Mircea Eliade's opposition between the sacred and the profane.

There are certainly many differences between the two sets. The sacred and the profane in Eliade's writings appear as almost binary opposites, whereas the *Welt* and the *Erde* in Heidegger's thought are part of a more complicated cosmology. Still, it is fair to disregard this difference for the moment, because both oppositions delineate the ontological relationship of art and the cosmos in similar ways, with art being born in the rift between the opposites. Furthermore, the sacred and the profane are not immediately linked to concepts of space, like the earth and the world, but are initially seen as two distinct modes of being, in general. Their first application, however, is an identification of space. In the first chapter of *The Sacred and the Profane*, Eliade speaks of sacred and profane space, but this differs from Heidegger's notions of the earth and the world in that sacred space is described as non-homogeneous, constructed around a hierophany or theophany, an expression of absolute reality, opposed to the non-reality of the vast surrounding expanse: "The manifestation of the sacred ontologically founds the world. In the homogeneous and infinite expanse, in which no point of reference is possible and hence no *orientation* can be established, the hierophany reveals an absolute fixed point, a center."[47] The profane experience, on the other hand, "maintains the homogeneity and hence the relativity of space. No *true* orientation is now possible, for the fixed point no longer enjoys a unique ontological status."[48]

In Heidegger's description of the Greek temple, the earth corresponds to the φύσις that surrounds it.[49] Earth here is "that whence the arising brings back and shelters everything that arises as such".[50] So far, there is no difference between Heidegger's earth and Eliade's profane space. Both are homogeneous, undifferentiated, and provide the material on which the world, or the sacred, organized space exists. Yet, Eliade accepts in several writings that modern man has made it possible to exist in a predominantly profane space. As mentioned above, the sacred and the profane are primarily modes of being rather than spatial concepts, and it is thus possible for both of them to exist in the Heideggerian world. This analogy between the two pairs of concepts so far can be said to be valid for the religious person, who cannot exist outside sacred space. Moreover, one could argue that if the sacred denotes what is consistent with the metaphysics of an epoch, the modern world is not at all profane, but rather organized according to the sacred of materialist, post-Renaissance metaphysics. There seems to be a problem, therefore, superimposing the sacred/profane on the world/earth in a spatial way. How should the two sets be connected, then?

Eliade's concept of the sacred is based on the presence of hierophany or theophany, a manifestation of the divine, something with no counterpart in Heidegger's model. Hierophany marks the connection of the world

to yet another space, the numinous, which exists outside the grasp of humanity. Nevertheless, it provides the *sign*, the centre of orientation for the sacred space. The construction of the sacred space is achieved through the efforts of humanity, but only inasmuch as "he reproduces the work of the gods".[51] The meaning of the entire sacred space is derived from the central axis provided by the gods, and in that sense αλήθεια is identified with it, or if we accept a model more consistent with Platonic tradition, the *image* of αλήθεια exists there, true αλήθεια being confined in the divine realm. For Heidegger, however, the unconcealment of the truth takes place in the bringing forth of the (concealing) earth and the clearing of the world. That suggests that the truth as a materiality, as a thing, is essentially part of the earth, but can only be experienced and witnessed at the clearing of the world. This unconcealment can be found only at the centre of Eliade's sacred space. From this, it seems that as far as the essence of the truth is concerned, the divine, as it is meant here, is included in the Heideggerian concept of the earth.

It has to be admitted, however, that Heidegger's writing is not very concerned with theistic metaphysics, something that can lead to a certain amount of confusion. Heidegger's description of the Greek temple illustrates the position of "God", at least in the particular text we have been examining:

> The building encloses the figure of the god and in this concealment lets it stand out into the holy precinct through the open portico. By means of the temple, the god is present in the temple. This presence of the god is in itself the extension and delimitation of the precinct as a holy precinct.[52]

It is obvious that Heidegger speaks of the statue of god, and his references to "the god" are therefore limited to the cultural rather than to the metaphysical aspect of religion. The presence of the statue of the god in the temple is what designates the temple as a sacred space, but this has little to do with the real presence of God as a metaphysical entity. As we saw above, the metaphysical content of religion, although not culturally "sacred", seems to exist in the earth surrounding the temple, rather than inside the building. With this in mind, we would have to revise our earlier observation, and conclude that, although from a cultural point of view, Heidegger's concept of the earth corresponds to Eliade's concept of the profane, from a metaphysical point of view it corresponds to, or rather it includes, the numinous, that which for Eliade is even beyond the sacred, which is the space of humanity.

This seems a quite functional comparison, despite the difficulties of superimposing the one opposition on the other, as discussed above. The main difference in the two approaches is a question of direction: Does the truth come from above or from below?

Why is the comparison between Heidegger's and Eliade's models useful in the examination of the death of art? First, we have to see where art fits in the scheme of oppositions. We saw above that art in the Heideggerian model is to be found or discovered in the rift between the earth and the world, whereas in Eliade's model it must be located between the numinous and the sacred, but man's actions are restricted within sacred space. This, with some Platonic overtones, is superbly expressed by Fr Pavel Florensky:

> In creating a work of art, the psyche or soul of the artist ascends from the earthly realm into the heavenly; there, free of all images, the soul is fed in contemplation by the essences of the highest realm, knowing the permanent noumena of things; then, satiated with this knowing, it descends again to the earthly realm. And precisely at the boundary between the two worlds, the soul's spiritual knowledge assumes the shapes of symbolic imagery: and it is these images that make permanent the work of art. Art is thus materialized dream, separated from the ordinary consciousness of waking life.[53]

Human art mirrors, or rather repeats, the truth given by the gods, transforming profane into sacred space. Here, art as αλήθεια does not assume the function of unconcealment, but the function of revelation. It is by virtue of the truth of the *noumena* that art sets the truth forth.

We can accept a certain correspondence, however, between Eliade's and Heidegger's rifts, in that both writers seem to treat art as a "setting-into-work of truth" due to its capacity to stand between two realms, and express a kind of knowledge that is acquired by existing in both of them simultaneously. Art, for Eliade (or Florensky) and Heidegger alike, is a *coincidentia oppositorum*.

Such an observation would suggest that the death of art is a process that *tends to* (in a mathematical sense) the eventual coincidence of the opposed realms we have noted (*this* and the *other*). If this convergence cannot be ascertained at present, after the death of the author and the triumph of the information age (therefore the "victory" of the world over the earth), this probably suggests that there is more to the existing metaphysics than the post-Renaissance materialist metaphysics which Vattimo continuously refers to.

Of course, to treat Heidegger with justice, we have to accept that the victory of the world over the earth and the triumph of the spirit of the information age have to be taken with a grain of salt. The earth (in both the philosophical and the geological meaning) could at any moment reverse the situation and produce conditions that could end civilization as we know it within a few years. But at least we can agree that the "possibility" or at least the "illusion" of such a victory is an accomplished fact. In this view, however, Heidegger's earth can assume unexpected, infinite

powers, which accounts for the identification of the earth with Eliade's concept of the sacred.

Vattimo discusses the signs that point to the decline and death of art, such as distracted perception and mass culture, through his position that modern metaphysics are coming to an end or a fulfilment in a (perverted) sense, where thought has reached a position that demands a *Verwindung* of metaphysics. That would suggest that, (a) the concealing earth is un-concealed and withdraws giving way to the world, and (b) the work of art has no further function to perform, and art becomes obsolete without the opposition between the earth and the world. From another point of view, Eliade echoes Vattimo's concerns when he writes that modern man has achieved an almost total desacralization of the world, and has moved his social organization well into profane space. This also eliminates the opposition between the profane and the sacred; numinous truth becomes obsolete, and its reflection on the action of man, art, also becomes obsolete. Yet, Eliade notes that "the *completely* profane world, the wholly desacralized cosmos, is a recent discovery in the history of the human spirit".[54] We cannot, therefore, draw conclusions about it that would completely nullify the sacred, because in effect we cannot suppose that such a world exists in reality. Moreover, Eliade does not see the present profane condition as a final one, but foresees the return of spirituality, albeit in a different way, perhaps similar to pagan pantheism.[55]

Eliade's writings on art confirm, as it were, the extrapolation I attempted by superimposing his notion of the sacred and the profane on the Heideggerian concepts of the earth and the world: "Even in archaic and 'folk' cultures, lacking any philosophical system and vocabulary, the function of sacred art was the same: it translated religious experience and a metaphysical conception of the world and of human existence into a concrete, representational form."[56]

Sacred art is, according to such statements, what makes religious experience comprehensible. In some ways, as we have seen earlier, its validity as a religious statement equaled the validity of intellectual tradition. Art, furthermore, has coupled the meaning of "setting-into-work of truth" with a "pleasurable integration of the senses with the intellect".[57]

As mentioned above, Eliade accepted the desacralization of modern society, something that can be reflected on its art: "For more than a century the West has not been creating a 'religious art' in the traditional sense of the term, that is to say, an art reflecting 'classic' religious conceptions."[58]

Yet, in the same way, Eliade insists that a society cannot become completely profane; art cannot lose its sacred quality completely. The sacred is disguised in a "non conventional and mysterious manner".[59] Eliade's text reads further below:

> This is not to say that the 'sacred' has completely disappeared in modern art. But it has become *unrecognizable*; it is camouflaged in forms, purposes and meanings which are apparently 'profane'. The sacred is no longer *obvious*, as it was for example in the art of the Middle Ages. One does not recognize it *immediately* and easily, because it is no longer expressed in a conventional religious language.[60]

Observing one of the transformations of the sacred in art, it is interesting to note in this context that the art of modern society has transcended the representation of the surface, a product of the Renaissance and the celebration of (Christ's) materiality, and attempts to represent the formless: "The two specific characteristics of modern art, namely the destruction of traditional forms and the fascination for the formless, for the elementary modes of matter, are susceptible to religious interpretation."[61] Resonating with the thoughts of the religious scholar, the views of René Magritte on painting remind us very strongly of the epoch of the icon and its theory: "Things do not have resemblances, they do or do not have similitudes. Only thought resembles. It resembles by being what it sees, hears or knows; it becomes what the world offers it... It is evident that a painted image – intangible by its very nature – hides nothing, while the tangibly visible object hides another visible thing – if we trust our experience."[62] This is consistent with the decline of art described by Vattimo, based on the thingness of the work of art in Heidegger's writings. The thingness declines as the opposition of the earth and the world is being overcome, and this certainly means the death of a certain kind of art. Nevertheless, it also means a new direction and a new role for the work of art, since its hitherto philosophical and metaphysical basis is challenged.

The death of art is a complex phenomenon. We have briefly examined some views on the death of the author. Contemporary art and criticism have abandoned (at least to a great degree) their fascination with the creator, and have focused on the reader instead. This automatically makes art a process that receives its input *vis-à-vis* its evolution, not so much from the people whose profession is connected with the production or evaluation of the work of art, but from the people who use it. The use-value of art is expressed by a gradual infusion of art into the other activities of existence, and the contextualization of an environment, or operational background, where the work of art as a distinct and unique entity continuously withdraws.

This can be juxtaposed to the understanding of the work as a revelation of truth: If the end of the opposition between the earth and the world is to be taken as the end of post-Renaissance materialist metaphysics, the work of art that expressed it becomes obsolete. On the other hand, the very change of the language of art, and the loss of its separate realm, can be seen as an Hegelian convergence. With the work of art on

its deathbed, art in general can assume its non-material function and transform into a practice that attempts not to represent but to connect with, or lead to, the intangible. As such, art after the first (deconstructive) waves of postmodernism shares many characteristics with art before the Renaissance. Its goal is functional rather than representational, participatory rather than exemplary. If we extend a conceptual line that connects the art of the modern age and the art of the future, it would not be farfetched to say that its evolution shows that art dies as such, giving its place to a practice similar to spiritual pursuit. With the end of the "big narratives" and the death of the author, we can accept the end of the history of art.

This cannot signify the death of art *per se*, because, as argued above, having located the basis of the existence of art in the rift between "this" and the "other", we have to accept that art of some sort will always exist, as long as an opposition between "this" and the "other" still exists. Does that mean that the death of art is a process with no (visible) end? Having followed Vattimo in his account for the death of (a certain kind of) art, we saw that the same model can be applied to metaphysical concepts wider than the Heideggerian world and earth. The presence and regeneration of contemporary art, whether we speak of pop art or post-minimalist classic art, shows that the triumph of the information age has far from eliminated art, but it has certainly affected its orientation.

We should not forget that medieval metaphysics were put aside (or *under*), never completely conquered by rationality, and the end of materialist metaphysics should not be taken as the end of metaphysics altogether. Art, accordingly, redefines its values and its goals, adjusting itself to the (new) rift between the visible and the invisible. Beyond the history of the work of art there is yet more art to be made, but maybe it will look similar to what it looked like "before the era of art".[63] Is it replaced by a spiritual revival?

4 The Religious Artist Today: From the Postmodern to the Medieval

The historical relationship between art and religion in the past has been approached in previous chapters. In order to examine the relationship between art and religion at the present, however, we would have to extend our observations to the particular problems of contemporary art, focusing closely on the actions and choices of the artists of the sacred, the people whose work expresses this relationship overtly. As we saw earlier, we may observe a split between consciously spiritual art and popular art. The development of the latter may be consistent with the general ontological observations on the religious turn in the development of the arts, but from a scientific, academic perspective, this happens only passively, whereas the former kind of art follows a spiritual path, explicitly and systematically or, rather, works towards the re-sacralization of the profane. This chapter presents the views of some artists that can definitely be thought of as artists of the sacred. For reasons explained in the introduction, the examination of contemporary art here will be limited to music.

Let us attempt to define what the position of the contemporary religious artist can be. A few centuries ago things were quite simple, at least on the surface, because art was a lot more religious than secular, at least thematically speaking. The Church was the major art patron and supporter, and the content of art was therefore largely religious, yet the gradual secularization of the world between the Middle Ages and the Enlightenment can be reflected even in this kind of, at least ostensibly, religious art. Art became more stylized, more elaborate, and surrendered itself to a process of rationalization, corresponding with the social transformations of the times. Social changes, which signaled an increasingly objective scientific way of thinking, had their counterpart in the domain of art.

One has to pause here and wonder whether we can actually criticize this turn from a religious point of view. I have done something like that in many places in the present study. It has to be admitted, however, that we now have the luxury of knowing the results of the humanistic turn of the Renaissance, and we can therefore interpret and criticize it through contemporary experience and it is maybe too harsh to criticize the choices

that were made a few centuries ago, by people who might have never suspected the development of art and society. On the other hand, we have to recognize that religious art did not stop at the Middle Ages, even if its style and its understanding of the sacred underwent dramatic changes in the centuries that followed. Are we ready to dismiss, as unreasonably secularized and profaned, everything that followed medieval Church-centrism, or, to paraphrase Simone de Beauvoir, "should we burn Bach?"

This chapter focuses on the attitude of the religious artist from the Renaissance and late Middle Ages to date. The question is how it was possible to connect art and religion: what I would like to examine here is how the tradition of religion and spirituality affected the creative process in art.

In a sense, all the phases of art after the Renaissance were expressing the same inner condition and axiom, the emancipation of art from religion, and its adherence to rules that were dictated from within art, and not by religion. The concept of art as something that lies beyond and above morality and any other responsibility and answerability has survived now. This does not mean that there is no religious art after the Middle Ages. Art was still being put into the service of the Church, and many artists were profoundly religious. At the same time, however, we observe that the development and the evaluation of art cannot depend (only) on religious or even moral measures, as was the case with the medieval icon, which could perform its religious function and thus successfully fulfil its role as an icon, regardless of its artistic merit. The work of art gained an additional dimension, so to speak, and the Renaissance religious artist served initially two different purposes. The first corresponds to the purpose of art to instruct, to stir the religious emotions of the people, and to inspire feelings of devotion. The second was oriented towards a more abstract, "pure" aestheticism, that was oblivious to the spiritual content of the work of art. It has to be said, however, that these two directions were not necessarily mutually exclusive. It is much later, in Romanticism for instance, that we encounter the claim for the total independence of the work of art. Still, the paradigm change has to be located in the late Middle Ages/early Renaissance, and it has been dominant until fairly recently. We may observe many of the complexities of the paradigm that has dominated art since the Middle Ages in the music of Johann Sebastian Bach.

A great part of the music of Bach was written in order to be used by the Church. His music is still heard in religious services throughout the world, yet it can be appreciated by the religious and the non-religious in more or less the same way, as opposed to medieval iconography, for the appreciation of which a certain understanding of religiosity, if not religious belief itself, is required. Bach's musical genius is, by the standards of any

age, unique, perhaps unsurpassable. Yet, his music epitomizes an artistic paradigm that approaches its end in our days. The appeal of Bach's music is not to be found in his melodies, his arrangements or theoretical innovations (his "technical" poetics, so to speak); his musical language was rather revisionist, technically speaking. Other artists of lesser value, like Bellini and Verdi, have written melodic arias that can be recalled immediately, whereas it is difficult for most people to recall more than a short theme from any of Bach's oratorios – not that Bach has not written memorable melodies as well. His use of harmony, although exquisite, does not demonstrate any theoretical breakthroughs that were not present in the music of, say, Buxtehude. Bach's distinct character can be perhaps described by the mathematically ingenious way he erects structures, which he immediately destroys, only to build new ones with their materials. Many such examples may be found in his work, from the ever-rising canon and the permutations of the Royal Theme in the *Musical Offering*, to the alteration of bold and subtle modulations in the gigue of the *French Suite No. 5*. An analysis of Bach's music by David and Mendel in *The Bach Reader* expresses this abstract quality superbly:

> His form in general was based on relations between separate sections. These relations ranged from complete identity of passages on the one hand to the return of a single principle of elaboration or a mere thematic allusion on the other. The resulting patterns were often symmetrical, but by no means necessarily so. Sometimes the relations between the various sections make up a maze of interwoven threads that only detailed analysis can unravel. Usually, however, a few dominant features afford proper orientation at first sight or hearing, and while in the course of study one may discover unending subtleties, one is never at a loss to grasp the unity that holds together every single creation by Bach.[1]

Still, analyses like this express an attempt to capture something of the inexplicable. A semiotic analysis, on an initial level, cannot easily distinguish between a masterpiece and the work of an untalented yet industrious composer with some original ideas who writes what most musicians would dismiss as "paper music", music that may be technically impeccable, but otherwise not interesting.

Polyphony and counterpoint, an important element of Western music since the Renaissance, found their best expression in the music of Bach, reflecting the passage from a theocentric to an anthropocentric universe. The advent of polyphony signalled musically the end of the single voice, through which everyone was expressed. Originally the independence of the voices was rather aimless, as in the organa or Perotin. It was refined during early Renaissance and reached its highest point with Bach. In the baroque era, this independence of contrapuntal voices was pitted against a harmonic goal orientation. The voices had to make sense vertically (harmonically), thus confirming the common musical goal of all the

participating voices, but had at the same time to maintain enough horizontal (contrapuntal) independence, so that their individualism was not sacrificed to the common goal. This is where Bach excelled, having found the balance between individualism and unity.

What, on a second level, makes Bach exceptionally interesting is the way the act of creation itself is constantly manifested in his music. Bach's *opus* can be seen as a study in poetics, an exploration and exposition of art as a creative process. It would be difficult to say whether any other artist has ever done anything like that with such intensity. It would be fair to say that, as far as the artistic paradigm since the Middle Ages is concerned, everything can be expressed through Bach's poetics. An example of this debt can be demonstrated by the comments of Anton Webern on *The Art of the Fugue*:

> All these fugues are created from a single theme, which is constantly transformed. What does this all mean? An effort towards an all-embracing unity... So we see that this – our – kind of thought has been the ideal for composers of all periods... To develop everything from a single principal idea![2]

With Bach the work of art assumes such a complexity of virtually infinite variations, yet with a tight unity, that it becomes a separate world, a little universe that can be admired in amazement. Although it may still ostensibly have a religious function, serving something outside art, the work of art also attracts attention to itself, something that can be observed as early as Josquin Des Prés. Quite a lot has been already written on the trajectory of the work of art from the Middle Ages to date in the present study, which does not have to be repeated here. We have to add, though, that the religious artist since the late Middle Ages did not have to face any issues – as he does in our days – which could question his sense of artistic direction radically. The role of the work of art was quite straightforward. The work of art evolved into a separate kind of entity, which would reflect the artist's understanding of the world on its constituent materials, consciously and intentionally. Augustine's *City of God*, for instance, can be read as an impressive piece of religious fiction, but its difference from post-medieval art is that its words, its expressions and its structure are only secondary to its theological content, and this is how it was read. When such a work has to be translated into another language, it is clear to the translator that the measure of success is the theological thought it contains. To that end it is acceptable, although certainly not desirable, to sacrifice secondary elements of the text, such as its literary style or the strength of its metaphors, which would be of primary importance in a work of literature. It is theologically sound to publish such works with a long body of interpretative comments and even to edit critically the original, which is something one would not dare do in a

work of literature which is supposed to be self-evident and normally with no need for interpretative comments. It is much later, for example in Dante's *Divine Comedy*, that what was once considered to be allegorical theological thought that words merely tried to do justice to, was transformed into a structure of meaning which was derived from and was reflected on the words and the poetics, and would have no substance without them.

We have discussed the parallel evolution of art and society in several parts of this study. It would be redundant to repeat here an analysis of the development of (artistic) perception since the Middle Ages. The present chapter is concerned with the conditions of art seen from the level of the artist, and its historical gap between the Renaissance and the present has to be forgiven. It would be enough to say here that in the centuries that followed Bach and his art the world became more secular, and in many ways art took the place of religion. We can trace the celebration of this phenomenon at least as far back as Friedrich Nietzsche:

> Art and nothing but art! It is the great means of making life possible, the great seduction to life, the great stimulant of life. Art as the only superior counterforce to all will to denial of life, as that which is anti-Christian, anti-Buddhist, antinihilist par excellence.[3]

With the death of God the system of values that were recognized in his name came into doubt. Divine commands became nothing more than social and moral conventions, something created by the human beings themselves. Art, according to Nietzsche's writings, offers the only possible redemption to the man of knowledge, the man of action and the sufferer, "as the way to states in which suffering is willed, transfigured, deified, where suffering is a form of great delight".[4] Nietzsche's view is very similar, not surprisingly, to Freud's comments on art in his "atheist manifesto", *The Future of an Illusion*:

> As we discovered long since, art offers substitutive satisfactions for the oldest and still more deeply felt cultural renunciations, and for that reason it serves as nothing else does to reconcile a man to the sacrifices he has made on behalf of civilization.[5]

The work of art is replacing the work of religion, providing meaning, purpose, and values people can live by. In Nietzsche's work we see that the aesthetic assumes a central position, comparable to the position held by religion in the Middle Ages. In a section of his final, unfinished theoretical work, which was titled *The Will to Power as Art* (it was published in fragmentary form as *Der Wille zur Macht*), Nietzsche discussed the function of the *anticipation* of the aesthetic in relation to the development of civilization.[6] Nietzsche claimed that since one cannot believe in a linear development towards an ultimate point, the world can be seen as a work

of art that makes itself (*ein sich selbst gebärendes Kunstwerk*). The will to power makes itself known through the artist, and ultimately reveals itself as the very essence of the world, something that coincides with the death of God as a historical event. Art is, as we saw in Nietzsche's excerpt, that which anticipates and shapes the future. The will of God has been replaced by the will to power. The centrality of aesthetics is expressed in the art of modernism; one has to remember at this point that the modern *episteme* or condition is defined by Michel Foucault, among other things, by the identification of truth with the laws of history,[7] an anthropocentric concept *par excellence* which can be understood through Nietzsche's self-making world after the death of God. Despite Rothko's great spiritual dimension and his special position within religious art, his work also demonstrates the modernist culmination of art as religion, as put by a contemporary theologian, Don Cupitt:

> I have chosen to emphasize especially the case of religious art because nobody can deny, first that works of art are just human constructions, secondly that great religious art, such as the late paintings of Mark Rothko, can still be produced, and thirdly, that such works as Rothko's can be quite new and independent of existing religious groups, their teachings and their iconographies. I want to say that Rothko (for example: he is by no means the only one) just invented works of art that are great religion. Indeed, I maintain that the major artists of Modernism and after – roughly, since the mid-1860s – can be viewed as the prophets of a new religious order. From their dedication to their task, their creativity and their works many people now get the sort of charge that earlier generations once got from icons and the cult of saints.[8]

Mircea Eliade, as well, sees a religious quality in all art, which, I think, is not unrelated to his general view of art's striving for the pure experience of "the first time".[9] This reflects the inward direction of contemporary art and its psychological character, its problematics on subjectivity and the self, anything that could lead to the possibility of a transformed consciousness and a questioned sense of self, a first step towards the search for the sacred:

> The great majority of artists do not seem to have 'faith' in the traditional sense of the word. They are not consciously 'religious'. Nonetheless we maintain that the sacred, although unrecognizable, is present in their works.[10]

Eliade, interestingly enough, recognized that modern art has become the main manifestation of the *coincidentia oppositorum*, the bridge between the conscious and the unconscious part of the self. Without this bridge the modern irreligious man may not be able to experience the sacred:

> After the 'second fall' (which corresponds to the death of God as proclaimed by Nietzsche) modern man has lost the possibility of experiencing the sacred at the conscious level, but he continues to be nourished by his unconscious.[11]

Nevertheless, although it can be reasonably argued that the contemporary religious artistic movement is largely indebted to the spiritual trajectory of modernism, with Rothko perhaps as one of the finest examples, the metaphysical basis of art is quite different in postmodernity. The return of the sacred traditions posed a very serious question for the artist: could art be non-denominational, "independent of existing religious groups, their teachings and their iconographies",[12] or does it have to align itself with one of these traditions? It seems that many contemporary artists do the second, or more accurately, that contemporary religious art is made by people who have chosen to express their religiosity and their art is very much based on "existing religious groups, their teachings and their iconographies".

This has not been an easy choice for everyone. John Tavener was gradually drawn to the Eastern Orthodox Church to the degree that he has stated that if the circumstances in his life were different and he had not married his present wife, he would probably be an Orthodox monk.[13] Perhaps the most decisive shift in his art and life occurred after a stroke in 1980. The stroke damaged a small part of his temporal lobe, and it is common for people who have had such a stroke to experience "temporal lobe attacks", i.e. continuing disturbances of the affected area. Tavener's physician, Dr David Thomas, commented on temporal lobe attacks:

> In neurological circles it has been put forward that St Paul had some sort of a temporal lobe event on the road to Damascus, when he had that amazing visionary experience. And that some of his behaviour subsequently was attributable to this event. A number of features are common to temporal lobe attacks. They can produce hyper-religiosity, and people often write a lot. They write letters and diaries to the Corinthians and all the rest of it. A schizophrenic will get auditory hallucinations: voices telling him what to do. Whereas in a temporal lobe attack, the hallucination will be more commonly of a visual nature. And it can be musical, of course: music is thought to be from the right temporal lobe, and that's where we think John had this problem [no amount of temporal attacks, however, could produce a composer] without a pre-existent matrix of compositional creativity.[14]

In spite of the medical description of what happened to John Tavener, or what may have happened to St Paul, we must not forget that events like that may be said to express the will and the action of God, instead of being random accidents that produce random hallucinations. They are the exception to the rule, however, and even if the account of the temporal lobe attacks helps us understand Tavener's personality and creativity, it says little about the people who embraced his music, most of whom did not have similar physical or metaphysical experiences. Yet, this incident provides an insight into Tavener's psyche, and creativity. His turn to a traditional Church could be related to his medical condition, but it is of interest to us only insofar as it describes his dedication and the

experiential nature of his faith. It is more interesting, from another perspective, to observe that the sacred found its expression, for many common people, in the art of an artist graced with temporal lobe attacks.

Postmodern art followed the de-constructive and re-constructive mode of postmodern philosophy in its attempt to break our concept of art and the world as we know it, and then create it anew, re-evaluating our cultural biases. Eliade sees something of a ritual dimension in this.

> All the modern artistic movements seek, consciously or unconsciously, the destruction of the traditional aesthetic universes, the reduction of 'forms' to elementary, germinal, larval states in the hope of re-creating 'fresh worlds'; in other words, these movements seek to abolish the history of art and to reintegrate the auroral moment when man saw the world 'for the first time'.[15]

What contemporary art often provides is a sanctuary for the senses. Yet, although a great part of art is dissipating into the background, there also exists another artistic trend, which stresses the involved role of the reader/viewer and his sometimes tortuous, active discovery of meaning. Unfortunately, this has often been the recipe for highbrow intellectualist art, but the premise is that the artist produces not a set of meanings, but a field of possible interpretations that rely on the reader's input and degree of participation. The input of the author is limited to the questions rather than the answers he provides. Works like that may be likened to a spiritual quest.

In that sense, contemporary art has assumed a role traditionally held by religion and the church, containing whatever was left of the sacred in a secular world, and not only as a result of the inherent search for a moral basis of life, as the Nietzschean writing we saw earlier implies. As Diane Apostolos-Cappadona writes, art "has become *the* religious initiatory ritual of modern culture".[16] The films of Andrei Tarkovsky may be seen as another example of an artistic initiatory difficulty whose task is to communicate the unspeakable or even (in films such as *The Sacrifice*) the super-rational. Tarkovsky's films are sometimes difficult to follow on a narrative level, and they certainly seem to ignore, or even consciously oppose, the conventions of commercial cinema. This means that the viewer has to look actively for a meaning, make connections and interpretations as the film plays; it is not possible to just sit back and take the story in, as it is with mainstream cinema, because the conventions that adulterate the immediacy of the archetypal experience expressed in the films have been removed. Furthermore, Tarkovsky often seems to try to elicit a personal participation from the viewer, using several techniques to that end (sudden gaze of the characters into the camera, a "personal" address as it were, images of the earth and old, abandoned houses that can stir, or rather resonate with, personal memories of the "old" and "familiar" for

many viewers, a dream-like quality where the viewer is urged to see with dream-like perception, i.e. "from the inside", etc.), and his ultimate message cannot be measured by the words that one could use to describe what his films "are really about" (love, self-sacrifice, the feeling of being connected to the earth), but by the depth he gives to those words. It is noteworthy that one of the films with which Tarkovsky started his career, approaches the mystery of the sacred in art, focusing on the most famous Russian religious artist (*Andrei Rublev*, 1966).

Eliade saw the work of the Romanian sculptor Constantin Brancusi as a case where the aesthetic experience can lead to the religious experience. Eliade identified a connection between the present and a primordial, archaic, "sacred" past in Brancusi's work, and he was fascinated by his ability to capture a sacred understanding of the stone he used for his sculpting, even though his work was, formally speaking, following the abstractionism of the twentieth century.

The return of the artist to his materials has been interpreted as a regeneration of the religious feeling after the "death of God", albeit in a different way. The *gnosis* that opposes both official values and the traditional churches became the research framework for modern art, seeking to experience what was lost as religious thought was withdrawn from theology to philosophy. Not unlike ancient pagans, Eliade claims, contemporary artists discovered the soul of things, "cosmic hierophanies: substance as such incarnates and manifests the sacred".[17]

This view is supported by the New Age fascination with crystals, stones, and pre-Christian mythologies. Art, especially sculpture, has a special place in the fashionable return of paganism, because it was drawn to it by the need to re-discover the sacred in the very materials that give it substance. Insofar as art is based on the direct experience of the reader/viewer, its experiential quests for the sacred could not be identified with the official values and the traditional churches, at least within the context of post-Nietzschean modern society. On the other hand, our religious mythology cannot be disposed of so easily. It is not inaccurate to observe that a great part of Christianity has lost much of its ritual character, especially in Protestant America, which is why art had to recover these values as the major practice with access to the unconscious. In the cases, however, where Christianity maintained its mystical character, we see a regeneration of sacred art from within religion. The religious art of John Tavener and Arvo Pärt, for instance, contradicts Eliade's generalization about the return of paganism in postmodern society.

Eliade, however, developed his views having realized the importance of the immediacy of the experience of the sacred. If the religious cannot accommodate this immediacy, the aesthetic will certainly try to do so. Eliade's observation would be indisputable if the development of

religious consciousness depended on the history of humanity alone, if it were placed solely in human hands. One may argue, on the other hand, that religious events and religious consciousness are also affected by the Holy Spirit, the ever-present hypostasis of God among humans, regardless of whether one actually believes in God and the Holy Spirit as entities independent of humankind, or whether one wants to identify them as the archetypal religious part of the subconscious psyche. In both cases we are talking about powers beyond humanity's consciousness will and control. Regeneration of the religious feeling and the rediscovery of the experience of the sacred can only be fulfilled according to the psychological/religious matrix of our own past, as Jung repeats in several of his works. Even if the Church is stagnant or corrupt, the religious consciousness it corresponds to must forge its expression based on its own images and tradition.

A new generation of artists, mostly musicians, have done exactly that, having combined contemporary art and traditional religion. The present study has alluded to this generation in many places, and if so much importance has been given to the artistic trend this generation expresses, it is not so much because the artists have presented something unprecedently brilliant, or because they forged a revolutionary artistic paradigm, but mainly because of the unexpected response their work received, as we shall see. The phenomenon of the success of religious post-minimalism transcends art criticism and has to be seen as a social, as well as artistic, event. The thought and the poetics of some of these artists will be presented here in some detail.

One of the most well-known pieces written by a post-minimalist composer is *Symphony No. 3*, opus 36 (1976) by Henryk Gorecki. The 1992 recording of *Symphony No. 3* (Nonesuch records, with Dawn Upshaw singing, and David Zinman conducting the London Sinfonietta), stayed for eight months at the top of *Billboard* magazine's classical sales chart, and remained in the top ten for two years. Furthermore, it held a spot in Britain's pop top ten chart. It is estimated that at least 750,000 records of this particular recording have been sold so far.[18] Still, *Symphony No. 3* is a strange musical piece that does not yield easily the secrets of its success.

Formally speaking, there is not much innovative thought in the piece, especially in relation to the experiments of the sixties and seventies, when a generation of composers, following the groundbreaking example of John Cage, expanded the limits of music as much as possible. What is really different, however, with a piece like Gorecki's *Symphony No. 3*, cannot be found in the music sheets alone, but in the kind of rapport the work builds with its audience. Music, like all arts, can be seen as a language that communicates ideas, feelings, or even things that cannot be described in words, but like any language, it can be broken down to

reveal its grammar and syntax. Going beyond conventional semiotic analysis, however, we have to include all stages of communication in this examination, instead of trying to decipher a message with a specific content that is not affected by the conditions and circumstances of its delivery.

The death of the author had, in a way, become standard part of musical language after John Cage. His music expresses a reaction to the centuries-old rift between the professional artist and the music connoisseur. The grammar and syntax of music was becoming increasingly more complex after the Middle Ages, and the study of music eventually became an intellectual affair, whereas most great composers of the past had no formal guidelines to adhere to or rebel against (music theory in its present form is a much later concept), and their taste, rather than their education, was primarily shaping their work and their poetics. Cage can be seen as the last "intellectual" composer, as his work put into practice the idea of the death of the work of art. The Serialists, composers that represent the intellectual extent of modernism, had developed music into a structure whose "inner life" (a term used by Josiah Fisk, which will prove to be quite helpful in this analysis) was out of reach for most audiences. It is difficult even for musicians to follow the structure of Serialist works, and Cage put forth works with similar texture, but with no structure whatsoever, based on randomness instead of calculation, proving that "structure was always unheardable. And if it was unheardable, then it was unnecessary."[19] The work of art completed a full circle and began consuming itself. The artist, at the same time, attempted to distance himself from the work of art as much as possible:

> Those involved with the composition of experimental music find ways and means to remove themselves from the activities of the sounds they make. Some employ chance operations derived from sources as ancient as the Chinese *Book of Changes* or as modern as tables of random numbers used also by physicists in research. Or, analogous to the Rorschach tests of psychology, the interpretation of imperfections in the paper upon which one is writing may provide a music free from one's memory and imagination.[20]

Cage and his age were quite important, because they taught audiences to treat music as a texture without a specific message that had to be extracted. This is where we first encounter art with intentionally "no inner life". In his critical, deconstructive crusade, however, he could go no further and discover a new role for music, a new, different beginning after the death of the work of art. The next step, if there would ever be one, had to build on the premise that music has nothing to say – at least nothing that could correspond to a verbal message or even a conscious thought – and that the structure of music would be the last thing the audience would be interested in.

This is exactly what happened with the group of composers Fisk identifies as the representatives of the "New Simplicity" movement (Gorecki, Pärt, Tavener). The mystifying *Symphony No. 3* has no structure to talk about. This does not just mean that its structure is very simple, but that there is a deliberate attempt to keep the structure to such a simple level that it becomes virtually inaudible. The beat and the key are always clear; there are no spectacular chord changes, no surprising orchestrational effects.

Fisk mentions two anecdotes that demonstrate the deliberately simple character of Gorecki's music.[21] Gorecki could not make up his mind about a passage in his *String Quartet No. 1*. He thought that the original passage was "too easy" and he replaced it with a new passage in which there was some thematic development instead of "mere repetition". Yet, after the Kronos Quartet had learned the new version, Gorecki decided that he preferred the original "repetition". This was seen by some critics as "a masterly change of mind", an intentional self-containment for the sake of formal simplicity. Fisk mentioned one more anecdote:

> Asked at a public forum about the form of one of his pieces, Gorecki turned cosmic. Saying 'What is form?' he went to the piano and played a soft chord, let it die away, and delivered his Yoda-like clincher: 'That is a form'.[22]

Symphony No. 3 starts with a simple pattern, played by the double basses, which is then repeated by other string instruments as a simple canon, at a higher pitch, for about twelve minutes. There is no development of the pattern, however; no interaction among the instruments. Fisk, in his analysis of the symphony, distinguishes between the expectations of the "naïve ear", the rhythmic and harmonic conventions, and the expectations of the "experienced ear", a series of breaks from the simple pattern that gives the piece its meaning.[23] The expectations of the "naïve ear" in a piece like Beethoven's *Symphony No. 5* are fulfilled by the continuity of the rhythmic pattern and the tonal harmony, whereas the "experienced ear" will recognize that the initial melody is somehow transformed. The development of a theme is, in traditional musical terms, a dialogue between the expectations of the audience and the answers provided by the piece. Little by little, the supporting ("naïve") structure changes so that the audience cannot tell how or when this change took place, and is thus engaged in an aural game, but the meaning of the piece is clearly stated.

Let us pause for a moment and review the significance of "meaning" in something as abstract as music. One way to approach the ideas, feelings and symbols that a musical piece tries to convey is to treat everything as information. From what we have discussed above, we may follow Leonard Meyer in his definition of meaning:

Musical meaning arises when an antecedent situation, requiring an estimate of the probable modes of pattern continuation, produces uncertainty about the temporal-tonal nature pattern of the expected consequent.[24]

This can be compared to a scientific definition of information:

Information is a measure of one's freedom of choice in selecting a message. The greater this freedom of choice, and hence the greater the information, the greater is the uncertainty that the message actually is some particular one. Thus greater freedom of choice, greater uncertainty, greater information go hand in hand.[25]

From this juxtaposition we see that both musical meaning and information use a field of uncertainty in order to be communicated. Serialism and atonality, similarly, developed as fields of great uncertainty, but the process of multiple probabilities can be traced at least as far back as the development of harmony and counterpoint in the late Middle Ages. Conversely, the spiritual "New Simplicity" proposes a sonic fundamentalism, a reduction of uncertainty to the necessary, and the only uncertainty we are left with is the uncertainty one feels facing the sacred. No significant information as such, is to come from within the piece. Music is there only in order to bring one to a halt before an inward spiritual path. Even closer to the cultural roots of Tavener and Pärt is something written by a theologian who connects the religious music of the New Simplicity and traditional Christian prayer: "When you pray, you yourself must be silent. You yourself must be silent; let the prayer speak."[26]

New Simplicity music seems to ignore the rules of the aural game of information, and to show little or no interest in the development of a theme. There is very little information to be passed along, and even the information that is allowed is just enough so that the powerful note of silence is avoided, so that there can be language with no communication. The basic rules that constitute a musical form are followed, but the intent is not the same. Gorecki is not interested in sophisticated structures, and the only thing that changes as the symphony is played is the texture of the sound, as more and different instruments enter what seems to be a sonic monologue. In this sense the New Simplicity owes a lot to Cage and his experiments. Both kinds of music refuse to communicate a message, but there is a conspicuous difference between them: there is virtually no dedicated audience that listens to Cage's intellectual experimentations for other than educational purposes, whereas Gorecki, Tavener and Pärt have enjoyed unexpected commercial success. Audiences were impressed by what they described as the "emotional content" of *Symphony No. 3*, yet the emotion, or any other feeling for that matter, is not to be found in the symphony itself. Once more, we are reminded of Cage's *4'33"*, four minutes and thirty-three seconds of silence, where the audience supposedly becomes aware of its own

presence in the concert hall. The concept is similar, although Cage's intellectualism did not recognize that silence is a very powerful note, and his piece was, ultimately, not without a message. Gorecki, on the other hand, provides a basic structure and no development, so that the audience is not aware of the silence that it is really subjected to, and is, without realizing it, left to interact with the sole presence: the sonic experience.

Similar formal analyses can be made for pieces like Pärt's *Passio Domini Nostri Jesu Christi Secundum Joannem* and Tavener's *The Protecting Veil*. Both those pieces, like Gorecki's *Symphony No. 3*, have had immense commercial success, yet as Fisk put it "what comes out of your CD player on 'Scan' is not much different from what comes out on 'Play'."[27]

What I attempted in the few previous pages is a brief description of the phenomenon of "New Simplicity" music. A formal analysis still cannot explain the response to this music. In order to penetrate the mystery further, we would need to extend our exploration of the phenomenon beyond the analysis of the form.

Fisk points out that "it's hard to get very far into the New Simplicity without encountering religious aspects".[28] Indeed, all three composers mentioned above share a strong religious character, although each of them maintains his individual approach to religion. Gorecki is also motivated by a feeling of (Polish) nationalism, but this is not identifiable in his music, which seems to adopt a universal character instead. As for Tavener and Pärt, their music seems to be written solely for religious purposes. Tavener, especially, has placed himself at the service of the Orthodox Christian Church as a composer.

There is yet one more detail concerning the music of New Simplicity. In spite of innumerable references to "medieval monks, or Greek soldiers surrounded by Saracens"[29] and the analyses the composers themselves sometimes offer (cf. Tavener's stress on the importance of Byzantine modes and its drones[30]) the character of the music seems to be, in many ways, much closer to New Age than to veritable pre-Renaissance music. This may not be as evident in a textual analysis of the music itself, which could be formally similar in many ways to both medieval and New Age music, but in the part of music both the New and the New Simplicity value and depend on: the texture and quality of the sound. Of course, one could argue that the quality of sound was important for medieval music as well, but in spite of several medieval sources that comment on the sound of the voices of the singers, for instance, we cannot have a clear idea about what was the sound perception of the time, or what was the importance of the sound texture. Very often we can observe huge differences in matters of sound quality and interpretation within only one

generation, something we can realize only now, with the help of mechanical reproduction. The music is the same, the directions to the musicians or the actors may be similar, yet no contemporary singer wants to sound like Maria Callas, and no contemporary actor wants to play like Sarah Bernhard. How can we comment on the sound quality of medieval hymns? It is much safer to say that there could be a similarity between the medieval and the contemporary perception of sound quality, but that would be rather coincidental, whereas there is more reasonable evidence to identify the similarities between the New Simplicity and the New Age. Furthermore, we do not have any evidence that the texture and the quality of the sound in medieval music was as great an issue as it is for the New Simplicity; today there is something to differentiate the desired quality of sound form, popular music or traditional classical, and the New Simplicity, as well as the New Age, has made it a point to compare itself with the other kinds of music on the level of the sound, and produce a sound which will stand out in comparison to the norm. Pärt's *Passio* and the thick sound produced by voices that move together in the same rhythm, ignoring contrapuntal development altogether, and the ambient music of Brian Eno, for instance, sacrifice their "inner life", the outdated message of the artist-creator, in favour of a particular sonic environment, to recall McLuhan's famous observation, "the medium is the message". Arvo Pärt has coined an interesting term to describe the clarity and simplicity of his style after the mid-seventies: "tintinnabuli", from the Latin for bells, and "tintinnabulation":

> Tintinnabulation is an area I sometimes wander into when I am searching for answers – in my life, in my music, in my work. Complex and many-faceted only confuses me and I must search for unity. Everything that is unimportant falls away. Tintinnabulation is like this. Here I am alone with silence. I have discovered that it is enough when a single note is beautifully played. This note, or a silent beat, or a moment of silence comfort me.[31]

An additional reason to claim that the New Simplicity is closer to the New Age than to veritable medieval culture is that certain cultural and spiritual choices of the representatives of the new classical trend, a certain cultural flexibility, would not be as possible in the Middle Ages. We see that many people today choose the culture and the tradition they want to be aligned with, which would not have been so easy in the past. It would be unthinkable for a medieval monk to "choose" his spiritual tradition, but the New Age, on the other hand, has provided a spiritual pastiche consisting of things as diverse as holistic environmentalism, a revival of Gnostic and Mystical beliefs, wide acceptance of the law of karma and reincarnation, as well as a revival of traditional religions, a general syncretism of Western, native American, Eastern and Oriental

ideas, all of which can be accepted pantheistically, separately, or in various combinations. Within this framework a conversion such as Tavener's would be among the least shocking ones. That should not be taken as a criticism to what can be a genuine conversion, a discovery of spiritual meaning in one's life, regardless of whether one chooses to leave one's given religion, but certainly this possibility, one of the most interesting ways the West can discover the East, was provided to a great degree by the New Age.

Still, there is a great difference between the "pop" and the "classical" versions of New Simplicity (the mainstream New Age and the New Classical), but this difference has little to do with form and traditional semiotics. The only account we may have for the success of such "boring" pieces of music as the classical New Simplicity pieces (genuine New Age is also repetitive, but intentionally relaxing and pleasing to the ear) is their religious orientation and atmosphere. The "New Pop", if we are allowed the expression, is based on pleasure, whereas the "New Classical" is based on the return of the sacred, generally speaking, of course.

As far as the artists themselves are concerned, this entire quest as to why certain kinds of art are successful and what is the relationship of the New Pop with the New Classical is, to say the least, irrelevant. John Tavener writes about the artist who decides to work within a sacred tradition:

> For an artist to work in a sacred tradition he must first believe in the divine realities which inform that particular tradition. This is a *sine qua non*: not, of course, a guarantee for great art, but a *sine qua non*. Secondly, he must know the traditions of the art he works in. He must know the tools, so that he can work with material that is primordial, and therefore not *his*; not his expression, but the tradition working through him.[32]

Against all the observations discussed above on the nature of the music of New Simplicity and the formal kinship to the New Age, Tavener claims that sacred music of any age should not sound very differently.[33] In a sense he is right; the form and the instruments may change, the tacit conventions may change, but what ultimately differentiates the sacred from the profane is always the same. Nevertheless, Tavener is at a loss for words when it comes to describing this difference in mundane terms: "What makes a great icon? I believe that it is the Holy Spirit working through the painter. I can say no more. It is a mystery."[34]

This deserves a pause in our examination. To deny the effect of the Holy Spirit in sacred art is to deny the sacred character of this art. The sacred is not a question of style, or a recipe for commercial success. If we proceed further in the examination of the thought of the religious artist, we have to keep in mind that "our" reality, judged by the cold, scientific

gaze of the academic who cannot accept a conjecture without sufficient evidence and proof, may not be the only possible one; it may not even be the "higher" or "real" one. Placing a modicum of faith in scientific research, however, we have to accept that the exploration of the numinous and those who serve it may offer an understanding or a relative insight to the ways the Holy Spirit works among humans, an understanding of the way mundane reality is transformed into sacred.

To return to Tavener's comment, regardless of whether we take the effect of the Holy Spirit into account or not, we see that the artist himself puts it beyond him to understand intellectually what motivates him as an artist, and what, ultimately, makes his art great. This is a break from the modernist past, and a good example of what was discussed earlier concerning the transformation (or absorption) of the opposition between the world and the earth into the opposition between the sacred and the profane. Post-medieval art, which was largely based on rational concepts as to what art is, completed its trajectory by nullifying reason and calculation (as a principle) within art. This means that the artist cannot use his art in order to illuminate the enigmatic earth, because the basis of that which was used to reveal the truth brought forth by the earth is no longer of any use to art. The artist of the sacred, on the other hand, leaves his technical preparation, his education, ideas and formal frameworks, outside the creative process, and abandons himself to the hands of God.

Of course, with reason out of the way things do not get easier; rather the opposite. The artist has to employ a different guide in his exploration, and, like the iconographers who fasted and prayed before and during their work, he has to connect the materials of his art to the religious archetypes that exist in the unconscious.

It is unfortunate, from one point of view, but certainly understandable, that the artists themselves cannot always interpret their work satisfactorily, in a way that would explain its success or its groundbreaking innovations. Very often one could suspect that the innovations identified by the artists, which are usually supposed to be imperceptible to the audience, are not perceived by the artists either. When Tavener considered the application of iconography to contemporary music, he was speaking of the sacred "tones" or modes of the Orthodox Church and the power of the *ison* (drone, "eternity note"), but we can be sure that most of Tavener's audience, including many musicians, cannot recognize the Byzantine modes at all. Moreover, Tavener has often used techniques reminiscent of Cage's random structure, which can certainly not be recognized by any audience. In works as *To a Child Dancing in the Wind*, *Icon of Light*, *Orthodox Vigil Service*, he employs a technique colloquially known as the "magic square" or (as Tavener, rather mistakenly, calls it) a "Byzantine palindrome". Based on an ancient Latin palindrome (SATOR AREPO TENET

OPERA ROTAS), one can start with five notes (arbitrarily corresponding to the letters S, A, T, O, R) and develop a twenty-five note musical palindrome.[35] It has to be admitted that a twenty-five note palindrome is inaudible as such; the use of such an ancient tool may have its effect on the artist, who is trying to distance himself from the composition of the music, not for the same reasons as the modernists and the Cage school did, but in order for the ego of the artist to withdraw, and let the self be blessed by the creative force of the Holy Spirit. It should be noted here that the palindrome as a technique is reminiscent of the serialists (Boulez, Babit) and the twelve-tone composers (Schönberg, Berg, Webern) rather than of the Cage school, but it is hard now to separate such techniques from the pursuit of randomness and the critique of intellectualist structure the Cage school attached to them.

The music of New Simplicity composers uses next to rudimentary musical theory, and even the use of the Byzantine modes is rather liberal, and does not demonstrate great formal discipline. As we have seen already, the quality of the sound is far more important than the notes themselves. Ivan Moody, a Byzantine psaltis (chanter) as well as a composer in the style of New Simplicity, has drawn an analogy between medieval icons and contemporary sacred music. In his article "The Mind and the Heart: Mysticism and Music in the Experience of Contemporary Eastern Orthodox Composers",[36] he treats both of them as mystical expressions. Rather boldly, but perhaps illuminating the kinship of medieval and contemporary art more satisfactorily than other composers talking about their work, he identifies some techniques or devices common to contemporary music and to iconography:

> Pärt's treatment of the text [of *Passio*] is deliberately 'cold', that is to say, his word setting is like that of the most syllabic kind of Gregorian chant, and therefore on the surface 'inexpressive'. Such austerity leads to a different form of listening and, as one must suppose was the composer's intention, to the contemplation of higher things. In this one may find a parallel with the deliberately flat, geometrical style of icon painting... Time is suspended, and that is another important element of mysticism. In an icon there is no perspective, that is to say, it is not situated in reality. Similarly mystical music must suspend real time in order to create its own 'two-dimensional' level into whose metaphysical simplification the initiate may enter in order to understand the multi-dimensional mystery thus presented.[37]

Furthermore, Moody differentiates strongly between minimalism and the repetition as used by his contemporary composers of the sacred. Minimalism, Moody argues, does not share the mystical aspirations of the New Simplicity. Indeed, minimalism has an intellectual, rather than spiritual, aura about it, with its repetitions being the statements of "minimal change", and was, ultimately, very much interested in form and structure. Moody, on the other hand, is interested in the ways music can be a

vehicle for mysticism, in a way similar to iconography. As such, music is not directed towards the mind or the heart alone, but towards their unity, "the mind going into the heart, so that you pray no longer with the mind – Orthodox monks incline their heads towards their hearts when they pray. That interests me."[38]

Interestingly, the unity and opposition of the mind and the heart, which interests contemporary composers so much, seems to correspond to many other oppositions that explain the existence of art. This is yet another conception of art as *coincidentia oppositorum*. The religious connotations, however, are particularly remarkable, for two reasons: firstly, because they corroborate the earlier observations about the transformation of the "worldly" opposition (the world and the earth) into a "sacred" one (the sacred and the profane); secondly, and more interestingly, the work of art has been finally seen as secondary to what it is inspired by. Tavener meditates on the icon, which is "beyond art, because it plunges us straight into liturgical time and sacred history",[39] and Moody goes even further when he writes that

> we must be 'used' by theology, 'used' by tradition. Mission of the sacred artist in the contemporary world is the effecting of a re-entrance into sacred tradition. Such an artist is concerned with the sacramental as opposed to the aesthetic, even when it is the case that he has to work 'in the world', outside the framework of the Church; when his art has to become 'paraliturgical'.[40]

Something more about this function of religious art is expressed by Tavener's comments on the concept of the *temenos*. Tavener sees the role of art as something that can connect us to our primordial origins – not unlike religion. The "primordial consciousness that lies dormant in all of us"[41] can be addressed by sacred art, although its return is, essentially, a religious event. Both Tavener and Moody see a connection between this return and the concept of *gnosis*, the mystical knowledge of the paradise lost. A serious problem with contemporary society, which has been discussed in many places in this study, is the disassociation of the inner self and social reality, although, as Tavener argues repeatedly, true *gnosis* has been maintained in the tradition of the Church. The primordial sacred gnosis as far as the whole of society is concerned, however, has been replaced by "an insane, technological, psychological, intellectual culture".[42]

A sign of the secularization of what used to be a world organized according to sacred principles, which is immediately relevant to this discussion, is the elevation of art to the status of religion in contemporary society. A major gallery or museum has all the signs of a great shrine: we lower our voices when we enter, we contemplate the exhibits in admiration and silence, and we generally employ a different kind of attention when faced with the exhibits, even if they do not differ significantly from

the reproductions we have at home (besides, it is not unusual for muse-
ums to exhibit reproductions of unique or fragile artefacts). The space of
art is sacred, and appropriate rules of conduct which, presumably, surpass
the rules of civic politeness, can be found in the art gallery and the mu-
seum, the opera house and the concert hall, the ballet, and the theatre.
This is perhaps best expressed in a passage from André Malraux's *The
Voices of Silence*:

> The gestures we make when holding pictures we admire (not only masterpieces) are
> those befitting precious objects; but also, let us not forget, objects claiming venera-
> tion. Once a mere collection, the art museum is by way of becoming a sort of shrine,
> the only one of the modern age; the man who looks at an *Annunciation* in the
> National Gallery of Washington is moved by it no less profoundly than the man who
> sees it in an Italian church. True, a Braque still-life is not a sacred object; neverthe-
> less, though not a Byzantine miniature, it, too, belongs to another world and is
> hallowed by its association with a vague deity known as Art, as the miniature was
> hallowed by its association with Christ Pantocrator.

> In this context the religious vocabulary may jar on us; but unhappily we have no
> other. Though this art is not a god but an absolute, it has, like a god, its fanatics and
> its martyrs and is far from being an abstraction.[43]

The "ray of hope" for Tavener against this secularization of the world
and the replacement of religion by art is that eternal truth has been for-
gotten but not lost. The connection to our primordial origins can still be
repaired. The sacred space, the *temenos* of the present, has been taken
over by secular art, but sacred art can reclaim its *temenos*. Tavener thinks
that it serves the spiritual work of the Church when the *temenos* is moved
back to the cathedrals and the churches. This does not mean "to popular-
ize, but to allow sacred art to breathe gently on the ancient stones. Let
the great medieval cathedrals of England be used to breathe back the
medieval thought or gnosis that formed them."[44]

All this is especially important from the point of view of the death of
art. The need for a transcendence of the work of art was recognized and
realized by contemporary artists who, ultimately, see the structural centre
of their art to be beyond art, even beyond mundane reality. In that sense
we are reminded of the coincidence of the birth of art during the fall of
the angels, according to the book of *Enoch*, and the end of art in the
Revelation, just before the marriage of the Lamb and the Woman. Both
ends of this trajectory are outside the history of the conscious, but the
aim of religion is to take us from the one end to the other, from the Fall
to Redemption, and it is in this capacity that art, which once was a sym-
bol of the human ego (and, for that reason, a symbol of man's self-con-
sciousness and self-exploration, as well), becomes a spiritual tool. As John
Tavener put it:

I am neither philosopher nor theologian, but my work – my work of repentance that may or may not lead me towards a sacred act – can only be judged on how near the music that I write comes to its primordial origins. This, I have come to see and believe, is my task. This is my work within the area from which I must continue to dig and labour, to try and find again something of the immeasurable magnificence, simplicity, and magisterial beauty and power that emanates from God, Who is the Source of Everything.[45]

Conclusion

This study attempted to bring together a number of ideas and problems from various parts of the academic spectrum. The first chapter ("A Religious View of the History of the Arts") examined two different kinds of relationship between art and religion, and the way they developed from Jewish art and Greek tragedy to the Byzantine icon and the medieval Cathedral. An effort was made to connect the development of art to a number of theological ideas that could interpret it from a theological and psychological point of view.

The second chapter ("Anti-Leonardo") focused more closely on some basic religious and social issues that are indicative of the advancement of the Renaissance paradigm, and showed how much art accompanied or preceded them. In that, we saw how much art since the Renaissance is interwoven with the social and religious framework of the post-medieval West.

In Chapter 3 we discussed some of the ideas that describe the withdrawal of the Renaissance paradigm, and its extension to modernism. Again here, we saw how much the practice of art is inseparable from the profound issues that define our culture, spiritually, philosophically and sociologically. Furthermore, the emergence of a paradigm where religion has a more central role, with similarities with, but also differences from the medieval world, was briefly discussed.

Finally, in Chapter 4 we examined contemporary religious art, some of its problems and some of the views of its representatives. As it has been mentioned in several places, what elevates this kind of art into a far-reaching sociological phenomenon is not only its penetrative scope and the review of artistic problems that have been with us since the Middle Ages, but also its great commercial impact, including a wide popular acceptance, something quite unusual for classical art.

What are we left with at the end of this study? We began with a general question and a hypothesis: What lies at the end of formal art history, which we are experiencing at the age of postmodernity? – The death of art as we know it, and its reincarnation as a spiritual practice.

We have to admit that this question and the proposed hypothesis can be pursued from many more different angles, in the fields of art criticism, philosophy, sociology and theology. It is not possible to exhaust this issue in a single study; on the contrary, it could become a source for a lifetime of research. Nevertheless, there should be enough in the present study to substantiate the death of art and the spiritual revival connected with it

as a valid hypothesis, especially from the perspective of theology and psychology. Following the example of Jung, who maintained that the object of psychology is not essentially different from the object of religion, I have allowed for theological thought to be heavily informed by psychological observation. This is especially evident in the first chapter ("A Religious View of the History of the Arts"), where the metaphor of the mirror, as it appears in the writings of Lacan, became a key concept for the theological interpretation of Christian art and, ultimately, the yardstick for a comparison between Eastern and Western art.

The metaphor which, I think, illustrates an even stronger connection among theology, psychology and art criticism, however, is expressed in the observation of the birth and the death of the arts in the first and the last book of the Christian Bible, the book of Genesis and the book of Revelation, discussed in the beginning of Chapter 1. It is this metaphor, I think, which more than any other shows the extent of the identification of art with civilization, and at the same time views the withdrawal of art as a step forward in our spiritual evolution.

This should not be taken as a fundamentalist view that would attempt to discredit art and diminish its importance. Quite the contrary, according to this biblical connection of the fate of humanity and the arts, it seems that art is essential for our life outside Paradise, in the same way religion is. Religion, as well, has no reason of existence at the beginning or at the end; it is obsolete when man has a direct relationship with God.

Still, the present hypothesis of the death of art cannot be taken as an imminent prediction of the end of civilization or the end of religion. Obviously there are many levels of death, or withdrawal of art. Besides, according to the views that have been put forth in this study, the condition we are about to witness, when the death of the author and the death of the work of art become complete, would be a reprise of only the medieval art paradigm, an "undoing" of Renaissance so to speak. It has to be noted, however, that this "undoing" cannot deny the value of the last five centuries, and in that sense it is not possible to return to the medieval world. The end is not the same as the beginning. The kind of criticism, however, that plays a role in what we observe as the death of art has been directed almost exclusively at the Renaissance paradigm. Yet, according to the view that holds the phenomenon of art, as well as religion, to be consequences of the Fall, and obsolete in the *pleroma* of time, it is possible to experience many other levels of death of art in the future, until we render symbolic thought and language obsolete, and until we see God "face to face", and not "enigmatically through a mirror", something that would coincide with a complete annihilation of art.

It is important to note, however, that at least we can register this mechanism now, and we can visualize its end. In a sense this is not an

entirely new concept in the history of philosophy. As we saw in Chapter 3, perhaps the earliest references to the idea of the death of art in the way it was examined here within Western philosophy can be found in the philosophy of Hegel, but it is possible to locate such ideas in even older philosophical traditions. The concepts of "death of art" or "death of writing" or "death of thought", accompanied by the respective spiritual re-birth signified by each "death", with an ultimate point perhaps being the "death of existence", meaning from a theistic point of view the end of separate existence of man away from God, and his return to Paradise, sound very similar to the ideas of the neo-Platonists. The ἐπιστροφή of Plotinus is such a concept shared, albeit with differences, by pagan and Christian philosophers such as Origen, Proclus and Dionysios the Areopagite.

The concept of ἐπιστροφή was preserved within Christian tradition, and this is probably one reason why the phenomenon of "death" could fit so easily within the framework of religious tradition. For people like John Tavener, for instance, there are no negative connotations in what we described as "death of art", as we saw. What was important for Tavener was the return of the *temenos* and the re-sacralization of art. The shift between the rift of the world and the earth as it appears in the philosophy of Heidegger, and the rift between the sacred and the profane as it appears in the writings of Eliade, was of no concern to traditional religious art, which had never accepted the metaphysics of modernity. A kind of coincidence between the way art was developing and traditional spirituality (although, as we saw in Chapter 4, contemporary spirituality in art owes a lot to the New Age as well) allowed people like Tavener, Moody and Pärt to express both worlds at the same time, or, in other words, to witness the ἐπιστροφή of art at its medieval spiritual level – keeping in mind that in Christian thought as it is found in Fathers of the Church such as Maximus the Confessor, the end of such a trajectory cannot be exactly the same as its beginning.

From everything we have seen in this analysis, it seems that a study of the development of art is a study on the development of consciousness, if this concept could include the conscious as well as the unconscious part of the self. Art is always defined by a paradoxical dichotomy, the world and the earth, the sacred and the profane, the I and the Other. The evolution of art marks the evolution of the *coincidentiae oppositorum* as it is understood and experienced personally and collectively. Art draws from the known and the unknown (or the suspected) at the same time, and it translates the ineffable mystery into direct experience, the same kind of inexplicable experience one has in front of a great work of art. It is precisely this capacity of art, which in Nietzschean terms anticipates the next step, as we saw in Chapter 4, or accommodates the presence of the

divine, as we saw in Chapter 1, which makes it an exceptional vehicle for the dichotomies of the human fate, regardless of whether they are measured in terms of social or spiritual progress. It remains to be seen how the evolution of consciousness described by the event we registered as "the death of art" will be manifested in the years to come.

Notes

Chapter 1

1. Genesis 4:21.
2. It is interesting to note here that the concept closest to our notion of the Evil in Buddhist thought is the Maya, a word that can be liberally translated as "duality", "non-unity". The introduction of Devil as adversary in the history of humans, and the Fall from Paradise, have the effect of a lost unity and the deliberation of an "as if" reality, something quite essential in the ontogenesis of art.
3. Apocalypse 18:22.
4. Cyril Mango, *Byzantium: The Empire of the New Rome* (London: Phoenix, 1980), 33.
5. Song of Songs 2:5.
6. Comments found in Jacob Neusner, *Symbol and Theology in early Judaism* (Minneapolis: Fortress Press, 1991), 119.
7. The most modern version of *The Book of J* is translated by David Rosenberg and interpreted by Harold Bloom (New York: Grove Weidenfeld, 1990).
8. Richard Courtney, *The Birth of God: The Moses Play and Monotheism in Ancient Israel* (New York: Peter Lang, 1997), 40.
9. Courtney, op. cit., 43.
10. Courtney, op. cit., 16.
11. Bloom, *The Book of J*, 22.
12. Courtney, op. cit., 42.
13. Ernest Nicholson, *The Pentateuch in the Twentieth Century: The Legacy of Julius Wellhausen* (Oxford: Clarendon Press, 1998).
14. Courtney, op. cit., 41. Original emphasis.
15. Aristotle, *Poetics* 6, 1449b, 24–28.
16. Cf. Plato's *Crat.* 423cd, *Republic* 399ac, 401a, *Polit.* 306d, *Laws* 655d, 668a, 795e, 798d, 814e.
17. Plato, *Republic*, Book 10: *Theory of Art*.
18. "Our thoughts and arguments are imitations of reality (*Timaeus* 47dc, *Critias* 107bc), words are imitation of things (*Crat.* 423e-424b), sounds are imitations of divine harmony (*Timaeus* 80b), time imitates eternity (*Timaeus* 38a), laws imitate truth (*Polit.* 300c), human governments are imitations of true government (*Polit.* 293e, 297c), devout men try to imitate their gods (*Phaedrus* 252cd, 253b, *Laws* 713e), visible figures are imitations of eternal ones (*Timaeus* 50c), etc." W. J. Verdenius, *Mimesis: Plato's Doctrine of Artistic Imitation and its Meaning to Us* (Leiden: E.J. Brill, 1962), 16–17.
19. Plato, *Meno* 91d, *Republic* 397d, 401c, 597e, 598e.
20. Plato, *Io* 534cd.
21. Verdenius, op. cit., 8–9.
22. Hubert Dreyfus, *Michel Foucault: Beyond Structuralism and Hermeneutics* (Chicago: University of Chicago Press, 1982), 343.

23. David Altshuler and Linda Altshuler, "Judaism and Art", in Diane Apostolos-Cappadona, ed., *Art, Creativity, and the Sacred: An Anthology in Religion and Art* (New York: Continuum, 1996), 160.

24. Carl Kraeling, *The Synagogue: Excavations at Dura-Europos* (New York: Ktav, 1979) (reprint), 351–52.

25. Erwin R. Goodenough, *Jewish Symbols in the Greco-Roman Period*, ed. Jacob Neusner (Princeton: Princeton University Press, 1988), xxv.

26. Goodenough, op. cit., xxvi.

27. Charles Murray, "Art and the Early Church", *Journal of Theological Studies*, NS, 28, part 2 (October 1977): 301–45.

28. Altshuler and Altshuler, "Judaism and Art", in Apostolos-Cappadona, op. cit., 156–57.

29. Goodenough, op. cit., 32.

30. Leonid Ouspensky, *Theology of the Icon* (Crestwood, NY: St Vladimir's Seminary Press, 1992).

31. Fr Stamatis Skliris, *En Esoptro* (Athens: M. Grigoris, 1992), 232.

32. Photis Kontoglou, *Ekfrasis tis Orthodoxou Iconographias* (Athens: Astir, 1960), éè´-êá´.

33. Hans Belting, *Likeness and Presence: A History of the Image before the Era of Art* (Chicago: University of Chicago, 1994), xxi.

34. Belting, op. cit., 16.

35. Belting, op. cit.

36. *Vita s. Stephani iunioris*, PG 100, 1172.

37. Theophanes Continuatus, *Corpus Scriptorum Historiae Byzantinae* (Bonn, 1828–97), 139ff.

38. *De inani gloria*, ed. A.-M. Malingrey, *De Lazaro*, ii, PG xlviii, 986, *De Lazaro*, vi, PG xlviii, 1034-1035.

39. Sixth Session, Mansi 13:252C.

40. Ouspensky, op. cit., vol. 1, p. 11.

41. Homily 19, *On the Forty Martyrs*, PG 31:509A.

42. St Nilus of Sinai, *Letter to Prefect Olympiodorus*, PG 79, 577–80.

43. Robin Cormack, *Painting the Soul: Icons, Death Masks and Shrouds* (London: Reaktion Books, 1997), 172.

44. Photis Kontoglou, *Pros Hagiographon Evangelon Mavrikakin* (Athens: Armos, 1997), 50.

45. L. Petit, ed., *Le typikon du monastère de la Kosmosotira près d'Aenos* (Constantinople: Izvestia Russk. Arkheol. Instituta, 1908), vol. 13, 17ff, paragraph 9.

46. Kontoglou, *Ekfrasis tis Orthodoxou Iconographias*, op. cit., 75.

47. Cited in Yannis Tsarouchis, *Ego eimi ptohos kai penes* (Athens: Kastaniotis, 1988), 115–16.

48. Pavel Florensky, *Iconostasis* (Crestwood, NY: St Vladimir's Seminary Press, 1996), 80.

49. Boris Uspensky, *The Semiotics of the Ancient Icon* (Lisse, Belgium: Peter de Ridder Press, 1976), 16.

50. Uspensky, op. cit., 16.

51. Uspensky, op. cit., 32.

52. Petit, op. cit., vol. 13, 17ff, paragraph 9.

53. Uspensky, op. cit., 39.

54. Uspensky, op. cit., 45.

55. Belting, op. cit., 18. Dionysios of Fourna was an artist who lived between c. 1670 and c. 1746. It seems that for some time he worked at Mount Athos. He emerged as a traditionalist who praised old masters such as Manuel Panselinos and wrote the *Manual* in order to communicate to other painters his hard-learnt expertise. Cormack, op. cit., 29.

56. Uspensky, op. cit., 68.

57. Boris Uspensky mentions a quite unusual miniature from the Book of the Czars of the sixteenth century. The Grand Prince Vasili Ivanovic's taking of the monastic vows on his deathbed is depicted by a doubled representation which resembles a representation of two men lying side by side in a single bed: the prince is shown first without his crown in the process of kissing an icon, and then again with his crown, as if having already kissed the icon. Uspensky, op. cit., 52–53.

58. P. Florensky, "Molennye ikony prepodobnogo Serjia", *Zurnal Moskovskoj patriarxii* 9 (1969): 80, cited in Uspensky, op. cit., 21. Original emphasis.

59. Uspensky, op. cit., 21.

60. This passage, believed by Zizioulas to be authored by Maximus the Confessor, belongs to the *Scholia in Ecclesiastical Hierarchy* specifically to chapter 3, paragraph 3:2 of Dionysios' *Ecclesiastical Hierarchy*, and can be found in Paul Rorem and John Lamoreaux, *John of Scythopolis and the Dionysian Corpus: Annotating the Areopagite* (Oxford: Clarendon Press, 1998), p. 174.

61. Andrew Louth, *Maximus the Confessor* (London: Routledge, 1996), 67.

62. John D. Zizioulas, *Being as Communion* (London: Darton, Longman and Todd, 1985), 100.

63. Uspensky, op. cit., 34.

64. Ibid.

65. Uspensky, op. cit., 36.

66. Jacques Lacan, *Écrits: A Selection* (New York: Norton, 1977), 1–7.

67. Lacan, op. cit., 4.

68. Lacan, op. cit., 55–56, 139–40, 304–305.

69. One would have to bear in mind that the gender-specific language stems from the male perspective in the Freudian studies. Although the mirror stage itself is common to males and females, the subsequent Oedipal/Electra stage is manifested in different ways in the two genders. Unfortunately, to employ gender-neutral language at this point would be too risky.

70. Freud himself in his works *Totem and Taboo*, and *Moses and Monotheism* explains away the religious instinct as the inherited memory of the members of the primordial community who rebelled against the rule of a dominating father, overthrew him and consumed his body. After a series of social re-organization, the memory of the father returned as the memory of the Father God, who reminded the members of the tribe of their lost unity.

71. George Bataille, *Theory of Religion* (New York: Zone Books, 1973).

72. 1 Corinthians 13:12.

73. The relevant passages are collected in O. Kern, *Orphicum Fragmenta* (Berlin, 1963), 209.

74. Comments by A. H. Armstrong in his translation of Plotinus' *Ennead* (Loeb Classical Library, Harvard University Press, 1984), VI, 73.

75. Plato, *Timaeus* 46 A–C.

76. Athanasius, *Contra Gentes* 8.

77. Athanasius, *Contra Gentes* 34.

78. Gregory of Nyssa, *On the Soul and the Resurrection*, trans. C. P. Roth (Crestwood, NY: St Vladimir's Seminary Press, 1993), 78.

79. "Ο εωρακώς εμέ εώρακε τον πατέρα," John 14:9.

80. Carl Gustav Jung, *Aion* (Princeton: Princeton University Press, 1969), 36–71.

81. Tertullian, *Adv. Marcion.*, II, xvi, in Migne, Patrologia Latina, vol. 2, col. 304: "Et haec ergo imago censenda est Dei in homine, quod eosdem motus et sensus habeat humanus animus, quos et Deus, licet non tales quales Deus."

82. Origen, *Contra Celsum*, VIII, 49, in Migne, Patroloigia Graeca, vol. 11, col. 1590.

83. Origen, *De Principiis*, I, ii, 8, in Migne, PG, vol. 11, col. 156.

84. Origen, *In Genesiem homilia*, I, 13, in Migne, PG, vol. 12, col. 156.

85. Origen, *Selecta in Genesium*, IX, 6, in Migne, PG, vol. 12, col. 107.

86. Origen, *In Genesiem homilia*, I, 13, in Migne, PG, vol. 12, col. 155.

87. Origen, *De Principiis*, IV, 37, in Migne, PG, vol. 11, col. 412.

88. Andrew Louth, *The Origins of the Christian Mystical Tradition* (Oxford: Clarendon, 1981), 146–51.

89. Augustine, *De Trinitate*, IX.V.8.

90. Augustine, *Enarrationes in Psalmos*, XLVIII, Sermo II, in Migne, PL, vol. 36, col. 564.

91. Origen, *Contra Celsum*, VIII, 49, in Migne, PG, vol. 11, col. 1590.

92. Jung, op. cit., 39.

93. 1 Cor. 15:48.

94. Augustine, *Retractationes*, I, xxvi, in Migne, PL, vol. 32, col. 626.

95. Carl Gustav Jung, *Psychological Types* (Princeton: Princeton University Press, 1971), 12.

96. Tertullian, *De carne Christi*, 5.

97. Jung, *Aion*, op. cit., 71.

98. Louth (1996), 37.

99. Evagrius, *Logos Praktikos* 64, 648.

100. Gregory of Nyssa, *Commentary on the Song of Songs*, sermon 4, in Migne, PG, 832D–833C.

101. Gregory of Nyssa, *On Virginity*, in Migne, PG, vol. 46, 369B–376B.

102. Genesis 3:21.

103. Maximus the Confessor, *Difficulty 10*, 31c, trans. Andrew Louth, in Louth, op. cit., 132.

104. Ysabel de Andia, *Symbol and Mystery*, unpublished paper.

105. Exodus 33:20.

106. Ouspensky, op. cit., 130–31.

107. Ouspensky, op. cit., 131.

108. Ouspensky, op. cit., 140–41.

109. Mircea Eliade, *A History of Religious Ideas* (Chicago: University of Chicago Press, 1985), vol. 3, p. 122.

110. De Vitray-Meyerovitch, *Rumi*, p. 41. Cited in Eliade, op. cit., vol. 3, 147.

111. *Mathhnawi*, 4, 745–46, translated by Marjan Molé in *La danse extatique en Islam*, p. 239. Cited in Eliade, op. cit., vol. 3, 146.

112. Mango, op. cit., 277–79.

113. Cf. Henry Maguire, *The Icons of their Bodies: Saints and their Images in Byzantium* (Princeton: Princeton University Press, 1996), 178–80, 192.

114. Maguire, op. cit., 180.

115. Maguire, op. cit., 178.

116. The Patriarch of Constantinople Athanasius in the fourteenth century wrote in a letter to the emperor comparing the congregation to the women at Christ's tomb: "Your subjects…will witness with compassionate souls what was done by the men of that time through an inhuman and murderous impulse, and share the sorrow of the ever-Virgin mother of God…and they should not simply depart, just as a spectator interested in watching divine spectacles, but should rather remain and 'bring precious ointments,' in the hope that they may see the stone rolled away." *Epistula LXXI; The Correspondence of Athanasius I*, 178.

117. Belting, op. cit., 265.

118. Song of Songs 5:2.

119. *Letters* II, 140 (PG 79, 260A, 261D); II, 214 (312C); III, 273 (520C); III, 278 (521BC).

120. Kallistos Ware, "The Jesus Prayer in St Diadochus of Photice", in George D. Dragas, ed., *Aksum/Thyateira: A Festschrift for Archbishop Methodios* (London: Thyateira House, 1985), 557.

121. Ware, op. cit., 560–61.

122. Eliade, op. cit., vol. 3, 217–18.

123. Eliade, op. cit., vol. 3, 218.

124. Ouspensky, op. cit., vol. 2, 237–39.

125. Bishop Kallistos Ware, *The Power of the Name: The Jesus Prayer in Orthodox Spirituality* (Oxford: SLG Press, 1986), 22.

126. Ware (1986), 23.

127. Ware (1986), 17.

128. Richard Kehoe OP, "The Scriptures as Word of God", *The Eastern Churches Quarterly* 8 (1947), supplementary issue on 'Tradition and Scripture', 78.

129. Quoted in John B. Dunlop, *Staretz Amvrosy: Model for Dostoevsky's Staretz Zossima* (Belmont, MA: Nordland Pub. Co., 1972), 22.

130. Ware (1986), 17–18.

131. Ware (1986), 18.

132. Ouspensky, op. cit., vol. 2, 261.

133. Christian Metz, *The Imaginary Signifier: Psychoanalysis and the Cinema* (Bloomington: Indiana University Press, 1982), 48–49.

134. Cf. Eliade, op. cit., vol. 3, 220.

135. Eugène Emmanuel Viollet-le-Duc, *Discourses on Architecture* (Boston: James R. Osgood and Co., 1875), vol. 1, 264–65.

136. M. Kilian Hufgard, *Saint Bernard of Clairvaux: A Theory of Art Formulated from his Writings and Illustrated in Twelfth-Century Works of Art* (Lewiston: Edwin Mellen Press, 1989).

137. Hufgard, op. cit., 136–37.

138. Hufgard, op. cit., 137.

139. Jung, *Psychological Types*, op. cit., 8–66.

140. Émile Mâle: *Religious Art from the Twelfth to the Eighteenth Century* (Princeton: Princeton University Press, 1949), 62.

141. Mâle, op. cit., 65.

142. Cited in Mâle, op. cit., 66.

143. Belting, op. cit., 278.

144. Mâle, op. cit., 67.

145. Mâle, op. cit., 68.

146. Cited in Mâle, op. cit., 70.

147. Mâle, op. cit., 71.

148. Ibid.

149. Carl Gustav Jung, *Answer to Job* (Princeton: Princeton University Press, 1969), 4.

150. Simply put, the argument holds that even one who denies the existence of God knows what is meant by the term, namely, "a being greater than which none can be conceived". Such a notion cannot exist only in the mind, however, for to exist in the mind and in reality is greater than to exist only in the mind. Therefore, there must necessarily be in reality a being greater than which none can be conceived.

151. Émile Mâle, *The Gothic Image: Religious Art in France of the Thirteenth Century* (London: Fontana, 1961), 133.

152. Origen, *De Principiis*, IV, in Migne, PG, vol. 11, col. 363.

153. Mâle, op. cit., 132.

154. Mâle, op. cit., 209.

155. Mâle, op. cit., 212–13.

156. Kontoglou, *Ekfrasis tis Orthodoxou Iconographias*, op. cit., 11–16.

157. Ouspensky, op. cit., vol. 2, 231–51.

158. Ouspensky, op. cit., vol. 2, 253–85.

159. Ouspensky, op. cit., vol. 2, 261.

160. Olivier Clément, *Byzance et le Christianisme* (Paris, 1963), 709.

161. Eliade, op. cit., vol. 3, 98–99.

162. Bernard of Clairvaux, *Apologia* 12, 29.

163. Ouspensky, op. cit., vol. 2, 275–85.

164. Ware (1986), 18.

Chapter 2

1. Leonid Ouspensky, *Theology of the Icon* (Crestwood, NY: St Vladimir's Seminary Press, 1978), vol. 2, 336.

2. Michael Baxandall, *Painting and Experience in Fifteenth Century Italy* (Oxford: Oxford University Press, 1988), 40.

3. Cited in Baxandall, op. cit., 41.

4. Ibid.

5. Baxandall, op. cit., 43–45.

6. Ouspensky, op. cit., 331.

7. Ouspensky, op. cit., 334.

8. Joseph Vladimirov, *Letter of a Certain Iconographer Joseph to the Iconographer of the Tsar, the Wise Simon Theodorovich (Ushakov)*, p. 33. Cited in Ouspensky, op. cit., 333.

9. Ouspensky, op. cit., 336.

10. Ouspensky, op. cit., 334.

11. G. N. Dmitriev, *Art Theory in Ancient Russian Literatur*, 108–10. Cited in Ouspensky, op. cit., 334–35.

12. Ouspensky, op. cit., 335.

13. Ibid.

14. Paul of Aleppo, *Journey*, book 9, chapter 3, p. 136. Cited in Ouspensky, op. cit., 336.

15. James Strachey, "Editor's Note", in Sigmund Freud, *Leonardo da Vinci and a Memory of his Childhood* (Harmondsworth: Penguin, 1963), 8–9.

16. Ouspensky, op. cit., 292.

17. Ouspensky, op. cit., 292–93.

18. Ouspensky, op. cit., 400.

19. Paul Evdokimov, *The Art of the Icon: A Theology of Beauty* (Redondo Beach: Oakwood Publications, 1990), 249.

20. *Stoglav*, chapter XLI, cited in Ouspensky, op. cit., 291.

21. *Stoglav*, chapter XLIII, cited in Ouspensky, op. cit., 294.

22. Ouspensky, op. cit., 294–95.

23. Ouspensky, op. cit., 292.

24. *Acts of the Great Council of Moscow of 1666-1667* (Moscow, 1893), chapter 43, entitled "On the Iconographers and the Lord Sabaoth", cited in Ouspensky, op. cit., 371.

25. Ouspensky, op. cit., 397.

26. Exodus 3:14.

27. However, this is not so bad, and it is possible to assume, from a soteriological point of view, that the devil did not exactly lie when he urged Adam and Eve to eat the forbidden fruit of knowledge, in order to become gods. It seems that this happened in the reverse order, that is, God decided to become human, in several stages, the last of which we have not yet experienced. The examination of the psychodynamics between God and humans by Jung show exactly this; Jung would find this almost sudden and unexpected turn to religion very timely, precisely at the end of the Pisces aion.

28. Homily 10, 7.

29. John O'Malley, *Praise and Blame in Renaissance Rome: Rhetoric, Doctrine, and Reform in the Sacred Orators of the Papal Court, 1450–1521* (Durham, NC: Duke University Press, 1979), 139.

30. Origin, *De Principiis* II, 3.

31. Ibid.

32. *Ecclesiastical History* I, 2.

33. *Ambigua*, in Migne, PG, 91, 1379.

34. St Symeon the New Theologian, "First Ethical Discourse" in Alexander Golitzin, *On the Mystical Life: The Ethical Discourses*, vol. 1 (Crestwood, NY: St Vladimir's Seminary Press, 1995), 44.

35. A reference to 1 Corinthians 11:3: "the head of every man is Christ, the head of the woman is man, the head of Christ is God".

36. Song of Songs, Sermon VI, 6.

37. Émile Mâle, L'art religieux de la fin du moyen âge en France (Paris, 1922), 147.

38. Carl Koch, in Staatliche Kunsthalle Karlsruhe, Hans Baldung Grien, Exhibition catalogue (Karlsruhe, 1959), 17.

39. Steinberg, op. cit., 6.

40. Mircea Eliade, A History of Religious Ideas, vol. 3 (Chicago: University of Chicago Press, 1985), 185.

41. Leo Steinberg, "The Sexuality of Christ in Renaissance Art and in Modern Oblivion", October (Summer, 1983), 1–203.

42. Caroline Walker Bynum, Fragmentation and Redemption: Essays on Gender and the Human Body in Medieval Religion (New York: Zone Books, 1991), 92.

43. Bynum, op. cit., 116–17.

44. Ennead IV, 8.

45. Girolamo Savonarola, Prediche sopra Ezechiele, ed. R. Ridolfi (Rome, 1955), 1:343.

46. Ennead V 8, 9.

47. J. P. Sartre, The Psychology of the Imagination (London: Methuen, 1972).

48. Gerard Watson, "Imagination and Religion in Classical Thought", in James P. Mackey, Religious Imagination (Edinburgh: Edinburgh University Press, 1986), 33.

49. John Dillon, "Plotinus and the Transcendental Imagination", in Mackey, op. cit., 56.

50. Mackey, op. cit., 55–64.

51. Quoted in Mary Warnock, Imagination (London: Faber and Faber, 1976), 28.

52. Dillon, op. cit., 57.

53. Ennead I 4, 10, 7ff.

54. Quoted by Solmi 1908, cited in Freud, op. cit., 99.

55. Gilles Deleuze and Félix Guattari, Anti-Oedipus: Capitalism and Schizophrenia (New York: Viking Press, 1977), 8–16.

56. St Theodore Studite, Second Refutation on the Holy Icons, 4.

57. R. Muther, Geschichte der Malerei, 3 vols. (Leipzig, 1909), vol. 1, p. 314.

58. St Theodore Studite, First Refutation on the Holy Icons, 12.

59. This is an idea widely accepted in the field of developmental psychology, with studies such as the ones by Jean Piaget and Erik Erikson supporting it.

60. However, I do not believe that the social or the economic conditions are the cause of such a transformation, or at least I do not believe that it is fruitful to view the situation from this angle. I would prefer to see them as parts of a wider transformation that is reflected on both the spiritual and the material world. Its origin (spiritual or material) is a matter of personal conviction; however, I think it is quite obvious that in such an analysis the two sides cannot be examined separately.

61. Manos Hadjidakis, 1925–94.

62. Henry Maguire, The Icons of their Bodies: Saints and their Images in Byzantium (Princeton: Princeton University Press, 1996), 5–47.

63. Maguire, op. cit., 16.

64. Sylvester Syropoulos, Vera historia, 109, in Cyril Mango, The Art of the Byzantine Empire, 312–1453 (Toronto: University of Toronto Press, 1986), 254.

65. Hans Urs von Balthasar, *The Glory of the Lord: A Theological Aesthetics*, vol. 5 (San Francisco: Ignatius Press, 1991), 260.

66. Balthasar, op. cit., 260–61.

67. Balthasar, op. cit., 261.

68. Ibid.

69. Giordano Bruno, *Eroici Furori* I, 4, p. 1123.

70. Eliade, op. cit., vol. 3, 254.

71. Balthasar, op. cit., 260.

72. Donald M. Lowe, *History of Bourgeois Perception* (Chicago: University of Chicago Press, 1982), 9.

73. Lowe, op. cit., 10. Lowe based his analysis on M.-D. Chenu, chapter 3 of *Nature, Man and Society in the Twelfth Century*, ed. J. Taylor and L. K. Little (Toronto: University of Toronto Press, 1998); M. L. Colish, Introduction to *The Mirror of Language* (New Haven: Yale University Press, 1968); Carolly Erickson, *The Medieval Vision* (Oxford: Oxford University Press, 1976).

74. Michel Foucault, *The Order of Things* (New York: Random House, 1970), 29.

75. Lowe, loc. cit.

76. Andrew Louth, *Maximus the Confessor* (London: Routledge, 1996), 31.

77. Foucault, op. cit., 18.

78. Foucault, op. cit., 19.

79. Foucault, op. cit., 21.

80. Foucault, op. cit., 23.

81. Michael Clanchy, *From Memory to Written Record: England 1066–1307* (London: Edward Arnold, 1979), 202–30.

82. Clanchy, op. cit., 212.

83. D. L. Douie, *Archbishop Pecham*, p. 113, n. 2, in Clanchy, op. cit., p. 213.

84. Foucault, op. cit., 60.

85. Lowe, op. cit., 11.

86. André Bazin, "The Myth of Total Cinema", in Gerald Mast, Marshall Cohen and Leo Braudy, eds, *Film Theory and Criticism* (Oxford: Oxford University Press, 1992), 35.

87. Ernst Gombrich, *Art and Illusion: A Study in the Psychology of Pictorial Representation* (Oxford: Phaidon, 1960).

88. Gombrich, op. cit., 57.

89. Gombrich, op. cit., 71–72.

90. Cited in Gombrich, op. cit., p. ix.

91. Ibid.

92. Cited in Norman Bryson, *Vision and Painting: The Logic of the Gaze* (New Haven: Yale University Press, 1983), 20.

93. Bryson, op. cit., 33–35.

94. Bryson, op. cit., 35.

95. Walter Benjamin, "The Work of Art in the Age of Mechanical Reproduction", in *Illuminations* (London: Jonathan Cape, 1970), 219–53.

96. Benjamin, op. cit., 226.

97. Ibid.

98. Ibid.

Chapter 3

1. Cf. Hans Belting, *The End of the History of Art?* (Chicago: University of Chicago Press, 1987).

2. The discussion of critical hagiography and, more specifically, St Jerome's literary criteria, has been based on Michel Foucault's "What is an Author?" in Michel Foucault, *Language, Counter-memory, Practice* (Oxford: Basil Blackwell, 1977), 127–29.

3. Foucault, op. cit., 124.

4. Foucault, op. cit., 126.

5. Roland Barthes, *Image, Music, Text* (London: Fontana Press, 1977), 144.

6. Jean-François Lyotard, *The Postmodern Condition: A Report on Knowledge* (Minneapolis: University of Minnesota Press, 1984), 79–82.

7. Barthes, op. cit., 148.

8. Barthes, op. cit., 146.

9. Foucault, op. cit., 124.

10. Marshall McLuhan, *Understanding Media* (New York: McGraw-Hill, 1964), 36–45.

11. Gianni Vattimo, *The End of Modernity* (Baltmire, MD: Johns Hopkins University Press, 1988), 52.

12. Umberto Eco, *The Open Work* (New Haven: Harvard University Press, 1989), 172.

13. Ibid.

14. Vattimo, op. cit., 51.

15. Eco, op. cit., 178.

16. Eco, op. cit., 177.

17. It is noteworthy that Debussy *did* have long discussions and a long friendship with a strange character, a nightclub pianist by the name of Erik Satie, who, although he had always been thought of as a second-rate composer, influenced most of the major artists of his generation, including Picasso.

18. Kuhn, Thomas, *The Structure of Scientific Revolutions*, University of Chicago Press, 1962.

19. Max Planck, *Scientific Autobiography and Other Papers* (New York: Philosophical Library, 1949), 33–34.

20. Eco, op. cit., 176.

21. Eco, op. cit., 177.

22. Vattimo, op. cit., 52.

23. Eco, op. cit., 180–216.

24. Posted on his web page at http://www.chass.utoronto.ca:8080/~chatzis. Most extracts further on are taken from his essay *Ritual versus Performance: The Future of Concert Music*, at http://www.chass.utoronto.ca:8080/~chatzis/ritual.htm.

25. Ibid.

26. Ibid.

27. Ibid.

28. Ibid.

29. Ibid.

30. Vattimo, op. cit., 52.

31. Vattimo, op. cit., 53.

32. Vattimo, op. cit., 56.

33. C. Greenberg, "The Avant-Garde and Kitsch", in G. Dorfles, ed., *Kitsch: The World of Bad Taste* (New York: Universe Books, 1969).

34. Vattimo, op. cit., 56.

35. Vattimo, op. cit., 60.

36. Vattimo, op. cit., 61.

37. Vattimo, op. cit., 61–62.

38. Andrew Louth, *Discerning the Mystery: An Essay on the Nature of Theology* (Oxford: Clarendon, 1983), 2.

39. Italo Calvino, *The Uses of Literature* (New York: Harcourt, Brace, Jovanovich, 1986), 109.

40. Calvino, op. cit., 109–10.

41. Martin Heidegger, *Basic Writings*, ed. David Farrell Krell (London: Routledge, 1977), 172.

42. Ibid.

43. Vattimo, op. cit., 63.

44. Heidegger, op. cit., 185.

45. Michel Foucault, *The Order of Things* (New York: Random House, 1970), 3–17: Chapter 1: *Las Meninas*.

46. Included in M. Heidegger, *Basic Writings*, ed. David Farrell Krell (London: Routledge, 1977).

47. Mircea Eliade, *The Sacred and the Profane* (New York: Harcourt, Brace & Co., 1957), 21.

48. Eliade, op. cit., 23. Original emphasis.

49. Heidegger, op. cit., 168.

50. Ibid.

51. Eliade, op. cit., 29.

52. Heidegger, op. cit., 167.

53. Pavel Florensky, *Iconostasis* (Crestwood, NY: St Vladimir's Seminary Press, 1996), 44.

54. Eliade, op. cit., 13. Original emphasis.

55. Mircea Eliade, "The Sacred and the Modern Artist", *Criterion* (Spring 1964), 23–24.

56. Mircea Eliade, "Divinities: Art and the Divine", in *Encyclopedia of World Art*, vol. 4 (1969), 382.

57. Diane Apostolos-Cappadona, "To Create a New Universe: Mircea Eliade on Modern Art", *Cross Currents* (Winter 1982–83), 408.

58. Eliade, "The Sacred and the Modern Artist", op. cit., 22.

59. Apostolos-Cappadona, op. cit., 410.

60. Eliade, (1969), p. 22. Original emphasis.

61. Eliade, (1969), p. 23.

62. Letter by René Magritte to Michel Foucault, in Michel Foucault, *This is not a Pipe* (Berkeley, CA: University of California Press, 1983), 57.

63. The title of Hans Belting's book, *Likeness and Presence: A History of the Image before the Era of Art* (Chicago: University of Chicago Press, 1994).

Chapter 4

1. Hans Theodore David and Arthur Mendel, *The Bach Reader* (New York: W. W. Norton, 1966), 40.

2. Anton Webern, *Towards a New Music*, 30, in Leonard B. Meyer, *Music, the Arts, and Ideas* (Chicago: University of Chicago Press, 1967), 263.

3. Friedrich Nietzsche, *The Will to Power* (New York: Vintage, Random House, 1967), 452.

4. Ibid.

5. Sigmund Freud, *The Future of an Illusion* (New York: Norton, 1989), 17.

6. Gianni Vattimo, *The End of Modernity* (Baltimore, MD: Johns Hopkins University Press, 1988), 96.

7. Michel Foucault, *The Order of Things* (New York: Random House, 1970), 217–21, 356–73.

8. Don Cupitt, *Radicals and the Future of the Church* (London: SCM Press, 1989), 25–26.

9. Mircea Eliade, *The Quest* (Chicago: University of Chicago Press, 1969), 66.

10. Mircea Eliade, "The Sacred and the Modern Artist," *Criterion* (Spring 1964): 23.

11. Ibid.

12. Cupitt, op. cit., 25–26.

13. Commentary on religious and secular music at the Faculty of Music, University of Toronto, April 1995.

14. Geoffrey Haydon, *John Tavener: Glimpses of Paradise* (London: Victor Gollancz, 1995), 142.

15. Eliade, *The Quest*, op. cit., 65–66.

16. Diane Apostolos-Cappadona, "To Create a New Universe: Mircea Eliade on Modern Art", *Cross Currents* (Winter 1982–83): 411.

17. Eliade, *No Souvenirs*, in Apostolos-Cappadona, op. cit., 416.

18. Josiah Fisk, "The New Simplicity: The Music of Gorecki, Tavener and Pärt", *The Hudson Review* 47, no. 3 (Fall 1994): 399.

19. Fisk, op. cit., 398.

20. John Cage, *Silence*, 10, in Meyer, op. cit., 68–69.

21. Fisk, op. cit., 407.

22. Fisk, op. cit., 407–408.

23. Fisk, op. cit., 400.

24. Meyer, op. cit., 11.

25. Warren Weaver, "Recent Contributions to the Mathematical Theory of Communication", in Claude Elwood Shannon, *The Mathematical Theory of Communication* (Urbana: University of Illinois Press, 1963), 108–109.

26. Tito Colliander *The Way of the Ascetics* (London: Hodder and Stoughton, 1960), 79.

27. Fisk, op. cit., 403.

28. Fisk, op. cit., 405.

29. Fisk, op. cit., 411.

30. John Tavener, "The Sacred in Art", *Contemporary Music Review* 12, part 2 (1995): 50.

31. Arvo Pärt, from the note to the recording of *Tabula Rasa* by Wolfgang Sandner, in Jamie McCarthy, "An Interview with Arvo Pärt", *Contemporary Music Review* 12, part 2 (1995): 59.

32. Tavener, op. cit., 49.

33. Tavener, op. cit., 50.

34. Ibid.

35. Haydon, op. cit., 161–65.

36. Ivan Moody, "The Mind and the Heart: Mysticism and Music in the Experience of Contemporary Eastern Orthodox Composers", *Contemporary Music Review*, vol. 14, parts 3–4 (1996): 65–79.

37. Moody, op. cit., 69.

38. John Tavener, in Moody, op. cit., 66.

39. Tavener, op. cit., 50.

40. Ivan Moody, "Music as Sacred Art", *Contemporary Music Review* 12, part 2 (1995): 33.

41. Tavener, op. cit., 51.

42. Ibid.

43. André Malraux, "The Voices of Silence", cited in Nicholas Wolterstorff, "Art, Religion, and the Elite: Reflections on a Passage from André Malraux", in Diane Apostolos-Cappadona, ed., *Art, Creativity, and the Sacred: An Anthology in Religion and Art* (New York: Continuum, 1996), 262.

44. Tavener, op. cit., 51.

45. Tavener, op. cit., 52.

Bibliography

Apostolos-Cappadona, D. "To Create a New Universe: Mircea Eliade on Modern Art", *Cross Currents* (Winter 1982–83): 408–19.

Apostolos-Cappadona, D., ed. *Art, Creativity, and the Sacred: An Anthology in Religion and Art*. New York: Continuum, 1996.

Balthasar, H. U. von *The Glory of the Lord: A Theological Aesthetics*. 7 vols. San Francisco: Ignatius Press, 1991.

Barthes, R. *Image, Music, Text*. London: Fontana Press, 1977.

Bataille, G. *Theory of Religion*. New York: Zone Books, 1973.

Baxandall, M. *Painting and Experience in Fifteenth Century Italy*. Oxford: Oxford University Press, 1988.

Belting, H. *The End of the History of Art?* Chicago: University of Chicago Press, 1987.

——— *Likeness and Presence: A History of the Image before the Era of Art*. Chicago: University of Chicago Press, 1994.

Benjamin, W. *Illuminations*. London: Jonathan Cape, 1970.

Bloom, H. *The Book of J*. New York: General Publishing, 1990.

Bryson, N. *Vision and Painting: The Logic of the Gaze*. New Haven: Yale University Press, 1983.

Bynum, C. W. *Fragmentation and Redemption: Essays on Gender and the Human Body in Medieval Religion*. New York: Zone Books, 1991.

Calvino, I. *The Uses of Literature*. New York: Harcourt, Brace, Jovanovich, 1986.

Clanchy, M. *From Memory to Written Record: England 1066–1307*. London: Edward Arnold, 1979.

Clément, O. *Byzance et le Christianisme*. Paris: Puf, 1963.

Colish, M. L. *The Mirror of Language*. New Haven: Yale University Press, 1968.

Colliander, T. *The Way of the Ascetics*. London: Hodder and Stoughton, 1960.

Cormack, R. *Painting the Soul: Icons, Death Masks and Shrouds*. London: Reaktion Books, 1997.

Courtney, R. *The Birth of God: The Moses Play and Monotheism in Ancient Israel*. New York: Peter Lang, 1997.

Cupitt, D. *Radicals and the Future of the Church*. London: SCM Press, 1989.

David, H. T. and Mendel, A. *The Bach Reader*. New York: W. W. Norton, 1966.

Deleuze, G. and Guattari, F. *Anti-Oedipus: Capitalism and Schizophrenia*. New York: Viking Press, 1977.

Dorfles, G., ed. *Kitsch: The World of Bad Taste*. New York: Universe Books, 1969.

Dreyfus, H. *Michel Foucault: Beyond Structuralism and Hermeneutics*. Chicago: University of Chicago Press, 1982.

Eco, U. *The Open Work*. New Haven: Harvard University Press, 1989.

Eliade, M. *The Sacred and the Profane*. New York: Harcourt, Brace & Co., 1957.

——— "The Sacred and the Modern Artist". *Criterion* (Spring 1964): 22–24.

——— "Divinities: Art and the Divine". In *Encyclopedia of World Art*, vol. 4 (1969).

——— *The Quest*. Chicago: University of Chicago Press, 1969.

——— *A History of Religious Ideas*. 3 vols. Chicago: University of Chicago Press, 1985.

Erickson, C. *The Medieval Vision*. Oxford: Oxford University Press, 1976.

Evdokimov, P. *The Art of the Icon: A Theology of Beauty*. Redondo Beach: Oakwood Publications, 1990.

Fisk, J. "The New Simplicity: The Music of Gorecki, Tavener and Pärt". *The Hudson Review* 47, no. 3 (Fall 1994): 345–94.

Florensky, P. *Iconostasis*. Crestwood, NY: St Vladimir's Seminary Press, 1996.

Foucault, M. *The Order of Things*. New York: Random House, 1970.

———— *Language, Counter-memory, Practice*. Oxford: Basil Blackwell, 1977.

———— *This is not a Pipe*. Berkeley, CA: University of California Press, 1983.

Freud, S. *Leonardo da Vinci and a Memory of his Childhood*. Harmondsworth: Penguin, 1963.

———— *The Future of an Illusion*. New York: Norton, 1989.

Golitzin, A. *On the Mystical Life: The Ethical Discourses*, vol. 1. Crestwood, NY: St Vladimir's Seminary Press, 1995.

Gombrich, E. *Art and Illusion: A Study in the Psychology of Pictorial Representation*. Oxford: Phaidon, 1960.

Goodenough, E. R. *Jewish Symbols in the Greco-Roman Period*, ed. Jacob Neusner. Princeton: Princeton University Press, 1988.

Gregory of Nyssa *On the Soul and the Resurrection*, trans. C. P. Roth. Crestwood, NY: St Vladimir's Seminary Press, 1993.

Haydon, G. *John Tavener: Glimpses of Paradise*. London: Victor Gollancz, 1995.

Heidegger, M. *Basic Writings*, ed. David Farrell Krell. London: Routledge, 1977.

Hufgard, M. K. *Saint Bernard of Clairvaux: A Theory of Art Formulated from his Writings and Illustrated in Twelfth-Century Works of Art*. Lewiston: Edwin Mellen Press, 1989.

Jung, Carl G. *Aion*. Princeton: Princeton University Press, 1969.

———— *Answer to Job*. Princeton: Princeton University Press, 1969.

———— *Psychological Types*. Princeton: Princeton University Press, 1971.

Kehoe, Richard OP, "The Scriptures as Word of God", *The Eastern Churches Quarterly* 8 (1947), supplementary issue on 'Tradition and Scripture'

Kern, O. *Orphicum Fragmenta*. Berlin, 1963.

Kontoglou, P. *Ekfrasis tis Orthodoxou Iconographias*. Athens: Astir, 1960.

———— *Pros Hagiographon Evangelon Mavrikakin*. Athens: Armos, 1997.

Kraeling, C. *The Synagogue: Excavations at Dura-Europos*. New York: Ktav, 1979.

Kuhn, T. *The Structure of Scientific Revolutions*. Chicago: University of Chicago Press, 1962.

Lacan, J. *Écrits: A Selection*. New York: Norton, 1977.

Louth, A. *The Origins of the Christian Mystical Tradition*. Oxford: Clarendon, 1981.

———— *Discerning the Mystery: An Essay on the Nature of Theology*. Oxford: Clarendon, 1983.

———— *Maximus the Confessor*. London: Routledge, 1996.

Lowe, D. M. *History of Bourgeois Perception*. Chicago: University of Chicago Press, 1982.

Lyotard, J.-F. *The Postmodern Condition: A Report on Knowledge*. Minneapolis: University of Minnesota Press, 1984.

Mackey, J. P. *Religious Imagination*. Edinburgh: Edinburgh University Press, 1986.

Maguire, H. *The Icons of their Bodies: Saints and their Images in Byzantium*. Princeton: Princeton University Press, 1996.

Mâle, É. *Religious Art from the Twelfth to the Eighteenth Century*. Princeton: Princeton University Press, 1949.

—— *L'art religieux de la fin du moyen âge en France*. Paris, 1922

—— *The Gothic Image: Religious Art in France of the Thirteenth Century*. London: Fontana, 1961.

Mango, C. *Byzantium: The Empire of the New Rome*. London: Phoenix, 1980.

—— *The Art of the Byzantine Empire, 312–1453*. Toronto: University of Toronto Press, 1986.

Mast, G., M. Cohen and L. Braudy, eds. *Film Theory and Criticism*. Oxford: Oxford University Press, 1992.

McCarthy, J. "An Interview with Arvo Pärt". *Contemporary Music Review* 12, part 2 (1995): 55–64.

McLuhan, M. *Understanding Media*. New York: McGraw-Hill, 1964.

Metz, C. *The Imaginary Signifier: Psychoanalysis and the Cinema*. Bloomington: Indiana University Press, 1982.

Meyer, L. B. *Music, the Arts, and Ideas*. Chicago: University of Chicago Press, 1967.

Moody, I. "Music as Sacred Art". *Contemporary Music Review* 12, part 2 (1995): 23–34.

—— "The Mind and the Heart: Mysticism and Music in the Experience of Contemporary Eastern Orthodox Composers". *Contemporary Music Review*, vol. 14, parts 3–4 (1996): 65–79.

Murray, C. "Art and the Early Church". *Journal of Theological Studies*, NS, 28, part 2 (October 1977): 301–45.

Muther, R. *Geschichte der Malerei*. 3 vols. Leipzig, 1909.

Neusner, J. *Symbol and Theology in early Judaism*. Minneapolis: Fortress Press, 1991.

Nicholson, E. *The Pentateuch in the Twentieth Century: The Legacy of Julius Wellhausen*. Oxford: Clarendon Press, 1998.

Nietzsche, F. *The Will to Power*. New York: Vintage, Random House, 1967.

O'Malley, J. *Praise and Blame in Renaissance Rome: Rhetoric, Doctrine, and Reform in the Sacred Orators of the Papal Court, 1450–1521*. Durham, NC: Duke University Press, 1979.

Ouspensky, L. *Theology of the Icon*. 2 vols. Crestwood, NY: St Vladimir's Seminary Press, 1992.

Petit, L., ed. *Le typikon du monastère de la Kosmosotira près d'Aenos*. Constantinople: Izvestia Russk. Arkheol. Instituta, 1908.

Planck, M. *Scientific Autobiography and Other Papers*. New York: Philosophical Library, 1949.

Sartre, J. P. *The Psychology of the Imagination*. London: Methuen, 1972.

Savonarola, G. *Prediche sopra Ezechiele*, ed. R. Ridolfi. Rome, 1955.

Shannon, C. E. *The Mathematical Theory of Communication*. Urbana: University of Illinois Press, 1963.

Skliris, S. *En Esoptro*. Athens: M. Grigoris, 1992.

Staatliche Kunsthalle Karlsruhe. *Hans Baldung Grien*, Exhibition catalogue (Karlsruhe, 1959).

Steinberg, L. "The Sexuality of Christ in Renaissance Art and in Modern Oblivion". *October* (Summer 1983): 1-203.

Tavener, J. "The Sacred in Art". *Contemporary Music Review* 12, part 2 (1995): 19–54.
Taylor, J. and Little, L.K., eds. *Nature, Man and Society in the Twelfth Century*. Toronto:
 University of Toronto Press, 1998.
Tsarouchis, Y. *Ego eimi ptohos kai penes*. Athens: Kastaniotis, 1988.
Uspensky, B. *The Semiotics of the Ancient Icon*. Lisse, Belgium: Peter de Ridder Press,
 1976.
Vattimo, G. *The End of Modernity*. Baltimore: Johns Hopkins University Press, 1988.
Verdenius, W. J. *Mimesis: Plato's Doctrine of Artistic Imitation and its Meaning to Us*.
 Leiden: E.J. Brill, 1962.
Viollet-le-Duc, E. E. *Discourses on Architecture*. Boston: James R. Osgood and Co.,
 1875.
Ware, K. "The Jesus Prayer in St Diadochus of Photice". In *Aksum/Thyateira: A Festschrift
 for Archbishop Methodios*, ed. George D. Dragas, 557–68. London: Thyateira
 House, 1985.
———— *The Power of the Name: The Jesus Prayer in Orthodox Spirituality*. Oxford: SLG
 Press, 1986.
Warnock, M. *Imagination*. London: Faber and Faber, 1976.
Zizioulas, J. D. *Being as Communion*. London: Darton, Longman and Todd, 1985.

Index

Printed in the United States
77904LV00002B/244-291

9 781845 531706